LEGENDS & LORE

=== *of the* ===

TEXAS CAPITOL

Mike Cox

THE
History
PRESS

Published by The History Press
Charleston, SC
www.historypress.net

Copyright © 2017 by Mike Cox
All rights reserved

First published 2017

Manufactured in the United States

ISBN 9781467137584

Library of Congress Control Number: 2017931822

DEDICATION

This isn't the only book I've dedicated to my granddad L.A. Wilke (1897–1984), but this one especially is for him. The first time I ever saw the capitol was when he took me there when I was a little boy in the early 1950s. As I stood wide-eyed in the rotunda taking in the dome above, he told me that his father—my great-grandfather—had been one of the workers who helped build the capitol back in the 1880s. Granddad was proud of that, and so am I. While Granddad never got around to writing the book on the capitol's history that he had hoped to, he did lay the metaphorical foundation for my writing career. So now it's come full circle.

CONTENTS

CONTENTS

PREFACE

Like most Austinites, I was still asleep early that morning of February 6, 1983. But then my phone rang. The capitol was on fire.

At the time, I covered the police beat for the *Austin American-Statesman*. I had an arrangement with the Austin Fire Department (AFD) that a dispatcher would call me at home anytime a major fire broke out, but Larry BeSaw, a friend and former newspaper colleague who worked as assignment editor for one of the local television stations, called me first. AFD might have called later, but by that time, I was already on my way downtown.

Driving toward the capitol in my personal vehicle, I could see its familiar lighted dome as I headed north on MoPac Boulevard from far South Austin toward downtown. All looked perfectly normal, so I began to think I'd be back in bed soon. Getting closer, however, I saw black smoke coming from the big, red granite statehouse. Having covered plenty of fires over the years, I knew the significance of that: black smoke meant live fire untouched by water.

When I got to the capitol, I found it ringed by flashing red lights coming from what seemed like every fire truck in Austin, with more equipment rolling up. The incident had already gone from two to four alarms and soon reached an unprecedented all-out level the department referred to as a general alarm. In other words, it was bad.

I spotted Assistant Fire Chief Brady Poole, ranking officer on the scene, and checked in with him for a quick rundown on the situation. He said a fire had started in the lieutenant governor's apartment behind the

Senate chamber on the second floor of the huge building's east side. His firefighters were having a hard time getting water on it, and the fire had begun to spread through the crawl space created with the installation of modern offices in the then nearly century-old structure. I stayed close to Poole so I could keep up.

As word began to spread that the capitol was burning, more and more people began showing up. Soon, newly inaugurated governor Mark White, awakened by all the sirens and flashing red lights just across Eleventh Street from the governor's mansion, joined the onlookers and got his own briefing from Poole. Austin mayor Carol Keeton McClellan, wearing a jogging suit, arrived next. Soon, Lieutenant Governor Bill Hobby showed up. He had not been in his apartment, but his daughter and three friends had been. Eighteen-year-old Kate Hobby had gotten out okay along with two of her guests, but the third friend was dead of smoke inhalation.

I had been talking with the governor, who I had known since he was secretary of state, when Poole interrupted to tell him that he needed to mobilize as much state manpower as he could to begin emptying the capitol of anything that could be saved, from files to works of art. We might not be able to stop this, the assistant chief said in so many words. Hearing that, the mayor began crying. A longtime Austinite, I knew how she felt. While the capitol belongs to all Texans, those of us who grew up with the statehouse tend to be pretty proprietary about it.

In my case, I remember going to the capitol for the first time as a kindergartener. I still have a photograph that my late granddad L.A. Wilke took of me sitting on one of the Civil War–era cannons on the capitol grounds.

Granddad's father, a second-generation German Texan named Adolph Wilke, had been one of many laborers involved in the construction of the capitol back in the 1880s. (I hasten to add that he was among the paid workers, not one of the convicts pressed into service by a cost-conscious state government.)

As I stood there that cool morning watching smoke continue to pour from the building, I couldn't help but flip through my many memories of the capitol. There was that Sunday in the early 1950s when I was barely five. Granddad worked for the Texas Good Roads Association, which had a post office box in the old Capitol Station, long since closed. But back then, years before its quasi-privatization, the U.S. Post Office Department delivered mail twice daily, Monday through Saturday. Even on Sundays, postal workers placed mail in post office boxes. The Good

Roads Association subscribed to the Houston, Dallas and San Antonio newspapers, and Granddad had come to the capitol to pick up the Sunday editions. Somehow I got separated from him and, with growing alarm, began wandering the long, empty corridors yelling for him as loudly as I could. Had I known then that many believe the place is haunted I would have been even more terrified. I wandered around the capitol for a tearful ten or fifteen minutes before Granddad finally found me.

Ten years later, my first for-pay job was in the capitol. I worked in the Senate as an assistant sergeant-at-arms (a glorified page) during the 1965 regular legislative session and again in the 1967 session. Later that year, I began a newspaper career that often had me at the capitol covering stories, including the 1974 Constitutional Convention that came within three votes of passing a new state charter for the first time in nearly one hundred years. Of course, Texas voters still would have had to approve it, but back then, they probably would have.

Now, I was covering the fire that threatened to destroy the capitol. As night turned to cloudy morning, firefighters finally got the blaze under control. Problems with hot spots continued for a while, but they had saved the building. Later that day, in the *American-Statesman*'s busy newsroom, I turned in my stories and headed home to get some sleep. For a while, I'd thought I'd be writing the building's figurative last chapter. Instead, it proved to be just another of its many stories.

Over the years, from my granddad and others, I've heard quite a few interesting tales about the capitol, and those became the genesis of this book. Granddad had always been intrigued by the capitol because of his father's role in helping to build it, and he had his own memories as well. In fact, in the early 1950s, he decided to do a book on the capitol. He did a considerable amount of research but never got around to writing it. (Fortunately, I inherited his files.) He envisioned a definitive history, but this book is not intended as an overall history of the iconic building—that would take a much larger volume, maybe even two volumes to really do it right. Nor can this book relate every story connected to the capitol. All I can do is tell some of the more interesting tales. Even so, in reading this collection, I think you'll wind up with an overall sense of how Texas ended up with such a magnificent capitol.

—Mike Cox

Prologue

THE OLD MAN

We shape our buildings and they shape us.
—Winston Churchill

Just as he'd been doing every day for years, Al Eck left his small West Avenue house on the edge of downtown and despite his stiff knees walked east on Twelfth Street to the capitol. Strolling through the park-like grounds with a pocketful of pecans for his squirrel friends—he had names for many of them—made a nice start on the day. But for the still-alert ninety-year-old, coming to the capitol had special meaning.

As a youngster in the early 1880s, he had watched the red granite capitol rise stone by stone, column by column and floor by floor. He had seen the naked iron framework fitted into place to support the huge building's iconic dome, and on February 26, 1888, he had posed with a group of construction workers and Austin residents for a photograph in front of the capitol with the *Goddess of Liberty* before laborers raised the statue atop the nearly finished building.

Now, everyone else in the often-published image lay long dead. So far as Eck or anyone else knew, he was the last living person who had a hand in building Texas's still-imposing statehouse. At the height of the mammoth construction project, more than one thousand workmen and some four hundred convicts had been on the contractor's payroll. Nearly double that number had drawn wages for their labor or trade skills at one time or another during the six-plus years it took to complete the massive

structure designed to accommodate the Lone Star State's government for centuries to come.

What Eck and so many others had built wasn't perfect and never became perfect. Its roof perennially leaked no matter how many times it got fixed; corners in regard to design and material specifications had been cut to minimize the impact on the state treasury or the builders; not all the structure's angles were plumb or measurements exact; heavy chunks of etched ceiling glass had fallen onto the Senate floor and more. Even so, every time Eck's dimming eyes looked up at the capitol, he felt a sense of pride. When completed, it had been the seventh-largest building in the world, taller even than the Capitol in Washington, D.C. Now, more than seventy-five years after its dedication, the statehouse still dominated Austin's modest skyline, its grand scale both symbolic of Texas's extraordinary size and the forward-thinking nature of its people.

As the years passed, to some extent, Eck had come to think of the building as *his* capitol. He knew its every corner. And for the hundreds of state employees who worked inside the sprawling building, from stenographers to the uniformed capitol security guards, as well as the lawmakers who showed up every two years determined to either pass or defeat certain legislation, Eck's time-creased countenance had become the figurative face of the capitol's past. Not only had he been around for all of the building's history to date, whenever newspaper reporters wrote stories related to the capitol or its periodic maintenance-remodeling issues, they turned to Eck for context. On top of everything else, folks simply found the good-natured Al—no one used his last name—a pleasure to be around.

Born on April 10, 1874, in Cedar Falls, Iowa, Alvin Astor Eck arrived in Austin with his family in 1879. His father, Leonard T. Eck, had earlier immigrated to the United States from Germany. Once settled in Texas's capital city, the elder Eck bought a jewelry and mercantile business at 101 East Sixth Street, and the family lived upstairs. Later, he had a business at 1200 South Congress Avenue, the first commercial building in South Austin. Having made a fair living, Eck bought land in western Travis County, where in 1900 he became postmaster of the small community of Teck, named in his honor.

By the time his father died in 1925, Al Eck was married to a schoolteacher and contributed to his family's support as a state maintenance employee whose salary had started at nine dollars a week. That was back when Saturday was just another workday, and each day ran twelve hours. He rose from laborer to electrician, boilermaker, supervisor and, finally, building

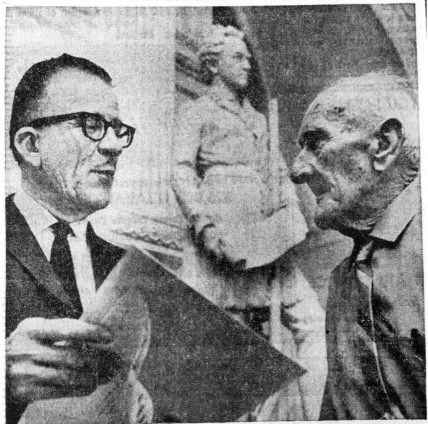

Tuesday, April 11, 1967

CONGRATULATIONS — Alvin A. Eck of Austin, right, is presented a Texas House resolution congratulating him Monday on his 93rd birthday. Eck is one of the last living persons who worked in the construction of the present State Capitol and also installed the first electrical wiring and did other work on the building, including helping Elizabeth Ney, the famed Texas artist, in the sculptures of Sam Houston and Stephen F. Austin at the front of the building. Rep. Will Smith, left, discusses the proclamation with Eck.

Al Eck (*right*), pictured here receiving a legislative proclamation in 1967, saw the old capitol burn and helped with the construction of the new one. *Author's collection.*

engineer at the capitol. He later worked at the state's deaf school before finally retiring.

"I put the first electric lights in the capitol…and worked about 30 men doing it," he told an *Austin American-Statesman* reporter at a birthday party thrown by his friends at the capitol in April 1964. "Then we put in the high

pressure steam system and that took about 200 men. Back in those days they didn't hand you a set of blueprints....You had to use this," he said, tapping his head. In addition, Eck had climbed to the top of the capitol to wire the *Goddess of Liberty* for a light bulb in the star she holds. When the bulb burned out, he said, no one replaced it.

Not only had Eck watched the capitol go up and spent a career helping to maintain it, but as a boy he had also stood among the onlookers as the previous statehouse burned down. That happened in the fall of 1881, when Eck was seven. As black smoke billowed into the cloudy sky and word spread almost as rapidly as the flames that the 1853-vintage limestone capitol was on fire, Eck ran uphill from his family's house on Sixth Street to watch as volunteer firemen futilely battled the blaze and, when they gave up on that, joined state officials and bystanders in trying to rescue government documents and other public property from the doomed building. More than eight decades later, Eck still owned a dime he had found in the capitol ruins after the fire, one side of the silver coin blackened by the intense heat of the blaze.

From the ashes of that fire, almost literally, would rise the new capitol. Planning had already been underway for a much larger, much grander new statehouse, but the loss of the old capitol added urgency to the process. Only eighty-three days after the fire, state officials broke ground for a capitol that would truly be worthy of Texas. And the method that the state had come up with to finance its construction was as innovative as the new statehouse would be impressive: rather than strain an already anemic treasury, the state would swap three million acres of land to pay for it. Whether the state or the builders got the better deal is still being debated among historians, but Texas got a fine new capitol.

For Eck and most Texans then and now, the capitol has never been merely a government building. It and the Alamo stand unquestionably as the state's two most historically significant structures, a pair of beloved architectural icons—at least for most Texans.

Beyond the role it plays in housing the constitutional functions of state government, Eck understood that the capitol amounted to a giant museum of Texas history and culture. Its artwork, historical artifacts and the monuments that surround it tell the ongoing story of Texas. Eck played a part in that, too.

In 1901, famed sculptress Elisabet Ney hired Eck to help her with the marble statues of Stephen F. Austin and Sam Houston she had been commissioned to sculpt for the capitol foyer.[1] He worked twelve-hour days

six days a week for two dollars a week until the two life-size works were completed and dedicated in 1903, an event he attended.

"She did the chipping, and I did the polishing on those statues," he said. "It took a lot of work with a pumice stone to get that soft marble from Virginia where it looked just right."

When he first went to work for the eccentric European-born artist, he said, "I was scared to death of her....She was a very big woman who talked like a man and wore bloomers." That apprehension lasted for the first week, but after that, he said, "We got to be friends. She was a wonderful woman."

Starting with his ninetieth birthday, a party in Eck's honor became an annual capitol event. "I'll come back here as long as I can," Eck said as that first gathering wound down that spring day in 1964. True to his promise, he was back in the capitol for his ninety-first, ninety-second and ninety-third birthday observances. That year, 1967, the House of Representatives passed a resolution congratulating him on yet another birthday. Representative Will L. Smith of Beaumont presented him the signed document as they posed for a "grip and grin" newspaper photo in front of Ney's statue of Texas colonizer Stephen F. Austin.

Eck attended two more birthday parties at "his" capitol before he died on January 27, 1970, less than three months before his ninety-sixth birthday. "The Grand Old Patriarch of the Capitol is dead," the *Texas Public Employee* magazine soon declared.[2] But the building that had been such an important part of his life endures, as do its many stories.

WHY THE CAPITOL'S NOT IN TEHUACANA

Hard to spell and harder to pronounce, the East Texas town of Tehuacana could have been the capital of Texas, not Austin.

In a democracy, all elections are important, but early Texans went to the polls twice to determine the location of the state's capital. If the outcome either time had been different and another community chosen as the seat of government, it could have turned Austin into a virtual ghost town, certainly not the major metropolitan area it became.

Though President Mirabeau B. Lamar had chosen what would become Austin as the site of the Republic of Texas's capital in 1839, that decision had never been 100 percent popular. First president Sam Houston, for one, considered the Buffalo Bayou city named in his honor much more suitable for the seat of government than frontier Austin. But despite the unsuccessful attempt in 1841 by the man known as the Hero of San Jacinto to seize the republic's archives and remove them to Houston, Austin survived as the capital city, continuing as capital in 1845 when Texas joined the Union as the twenty-eighth state.[3]

Five years after statehood, in Texas's first federal census, enumerators found only 629 people living in Austin. Actually, even that decidedly modest head count represented a decline of 26.5 percent since 1840. Most of its residents lived in the original one-mile-square town site first surveyed by Edwin Waller, the town's first mayor.

What reenergized Austin happened on perhaps one of the most important but least-remembered dates in its history: March 4, 1850. On

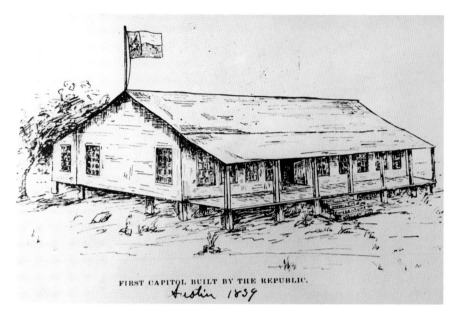

FIRST CAPITOL BUILT BY THE REPUBLIC.

Sketch of the capitol in use when Texas voters decided to keep the seat of government in Austin. *Author's collection.*

that date, two days after celebrating the fourteenth anniversary of Texas's independence from Mexico, Texas voters went to the polls to decide if Austin should continue as the state capital. Anyone with business or other ties to Austin knew that the town would likely never be more than a backwater county seat if it lost its status as home of the state's government, modest as that was at the time.

The front page of the February 16, 1850 issue of the *Texas State Gazette*, Austin's only newspaper, devoted nearly two columns of type to a circular setting forth the various arguments to keep the capital in Austin. Headlined "To the Voters of Texas," the pro-Austin piece was signed "Very Respectfully" by the "Citizens of Austin." Austin's mono-media campaign brief began:

> *In the exercise of one of your most sacred privileges, the responsible duty will devolve upon you on the first Monday of March ensuing, to determine where the Seat of Government of this State shall be located for the next twenty years. Before casting your suffrage upon a question replete with so much vital importance to the present interest and future welfare of the State, it behooves you to lay aside every sectional feeling and party prejudice, to scrutinize with care every argument for and against the different places put*

in nomination, and to weigh with caution every consequence, whether for good or for evil, that may result from your determination.

The other towns on the ballot were Huntsville (Walker County), Palestine (Anderson County), Tehuacana (Limestone County) and Washington-on-the-Brazos (Washington County). All lay in the more populated eastern half of the state, Austin being the outlier by far. But while the capital was then Texas's westernmost town of any consequence, the article pointed out that the community sat practically in the center of the state.

"It may be argued, however, that although Austin is central with regard to territory, it is not so with regard to population—and this is true AT PRESENT," the article went on. Clearly, Austin's civic boosters believed the state would continue to grow. As new immigrants arrived and the frontier advanced westward, Austin would become more and more convenient to the state's citizenry.

The second major argument advanced by the Austin committee had to do with economics. It would take tax dollars, and likely a tax increase, to move all the government records, stores and personnel from Austin to some new location. Also, a new statehouse and other public buildings would have to be built at the new capital city.

The final point the newspaper piece made in Austin's favor was that a more eastern capital would heighten the chance that Texans might opt to cleave their state into two or more separate states, a possibility allowed in Texas's terms of admission to the Union. Such a division, some feared, "would hazard a fatal blow to the interests of the whole South upon the question of slavery."

Ending with an appeal to "true Texians," the piece urged voters not to be swayed "by the sectional prejudices of those who desire to remove the seat of Government through selfish motives, but, on the contrary, by a sincere and an ardent desire to promote the interest of the whole State from the North to the South, and from the East to the West."

In a brief editorial on an inside page, the newspaper expressed its confidence that Austin would remain the capital. Indeed, the editor wrote, "the claims and advantages of our place are so evident as to render it unnecessary" to belabor the point at length. "Let the friends of Austin but go to the polls, and our opinion is, that she is safe on the first ballot."

Over in Limestone County, early settler and prime community mover John Boyd really wanted to see the capital removed to his town. Its hard-to-pronounce name was Tehuacana (Ta-wok-can-uh), a corruption of the

Tawakonis Indian tribal name. Boyd, who had served in the first Congress of the Republic of Texas, had obtained the land grant encompassing future Tehuacana in 1835. After the town developed, he became its first postmaster in 1847. Two years later, he succeeded in getting Tehuacana on the capital-selection ballot.

What Boyd did not know was that for such a small town, Austin had a cabal of strategically minded movers and shakers with vested interests who understood that there were other ways to remove the epidermis from a feline when it came to ensuring election results. Accordingly, they set into motion what could be called the El Paso Plan.

"A short time before the election," Travis County clerk and Austin's unofficial chronicler Frank Brown wrote, "the people of Austin raised several hundred dollars to defray expenses and dispatched an old citizen of the town, Mr. William Cockburn, to El Paso [County], in order to secure the support of those people for Austin."

In 1850, traveling six hundred miles from Austin to Texas's westernmost county amounted to a long, water-scarce and dangerous trip mostly through hostile Indian country. That Cockburn got there with his scalp intact is impressive, but it is hard to imagine that it would have cost him several hundred dollars to do so when a pound of coffee could be purchased for less than forty cents, beef brought eleven cents a pound and even a good rifle only ran twenty dollars. Considering those metrics, it can be conjectured but likely never proven that Cockburn spent some of the funds that had been entrusted to him by the good people of Austin on "educating" El Paso County's electorate. Vote-buying would be a more realistic, if harsher, term.

In the end, voters statewide agreed with the arguments set forth by Austin's boosters. By a two-to-one margin over Tehuacana, garnering 7,679 votes, Austin retained its status as capital city. Even so, Tehuacana came in second with 3,142 votes and Palestine got 1,854 votes, 460 of them home folks. Huntsville netted 1,216 votes, Washington-on-the-Brazos 1,143 and miscellaneous write-in towns got 24 votes between them.

Interestingly, according to Brown's contemporary report, 754 of the Austin votes came from El Paso County. Only three El Paso County residents voted for Palestine, and no one put their mark next to Tehuacana, Huntsville or Washington-on-the-Brazos. "The El Paso vote decided the question in favor of Austin," Brown wrote. Intriguingly, a decade after hundreds of El Paso County residents made their will known in the capital election, the 1860 census showed only forty-three people actually lived there. Clearly, "old citizen" Cockburn was one heck of a lobbyist.

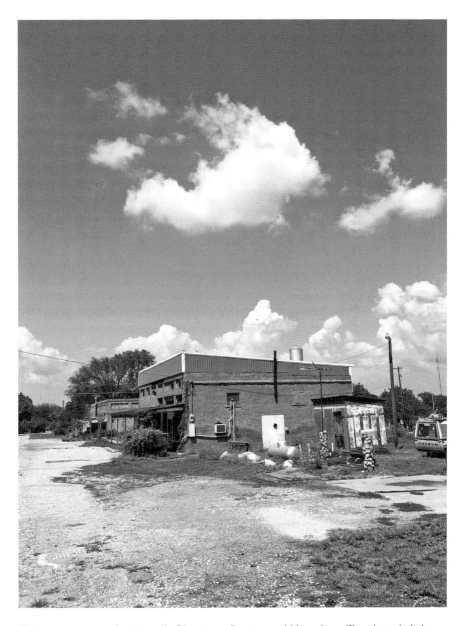

Tehuacana, a near–ghost town in Limestone County, could have been Texas's capital city. This is how it looks today. *Photo by the author.*

To put the importance of this election in perspective, in barely a decade, both Tehuacana and Washington-on-the-Brazos had practically vanished. The same thing could have happened to Austin, though its status as the seat of Travis County would have kept it barely alive. Of course, in mandating the election, the legislature had given the public some wiggle room by stipulating that the capital question be taken up by voters again in 1870.

Assured of at least two decades of stability, Austin soon began its first boom. "Upwards of 100 residences have been completed in the last four months," the *Texas State Gazette* reported in the spring of 1851. "This is, if providence should hold out, agoing to surpass eney citty [*sic*] in the west," Austinite William Holt wrote to an acquaintance in Mississippi.

"Austin has a fine situation up on the left bank of the Colorado," Frederick Law Olmsted wrote after a visit in 1854. "Had it not been the Capitol [*sic*] of the state…it still would have struck us as the pleasantest place we had seen in Texas. It reminds one somewhat of Washington; Washington, *en petit*, seen through a reversed glass." Still, Texas's young capital city fell a little short of paradise. "There is a very remarkable number of drinking and gambling shops," Olmsted continued, "but not one book store."

Following the Civil War, Reconstruction delayed the second election on Austin's status as the state capital, but the matter finally went to the voters again in 1872. In an election held November 5–8 that year (voters had to be given ample time for travel to the polls), 63,377 Texans agreed that Austin should be the permanent seat of government. Houston, this time the second-place contender, got 35,143 votes, while 12,776 citizens cast their ballot for Waco; 101 other voters wrote in their preference for various other cities, including 10 who thought the Brazos County seat of Bryan should be the capital. This time, Tehuacana had not even made it to the ballot.

Four years later, the Constitution of 1876 made Austin's status as the seat of state government part of Texas's organic law. Assuming future generations do not tamper overmuch with the state's charter, Austin will be the capital of Texas for as long as there is a Texas.

HALF A WATERMELON ON A CORN-CRIB

The story of a civil engineer from San Antonio who earned less than the value of a good mule for designing a new capitol for Texas and whose efforts came to nothing shows that cheaper is not always better, at least in the construction of public buildings.

Since statehood, the legislature had continued to meet in the original wooden capitol raised by the late Republic of Texas, but lawmakers realized they badly needed a new building.[4] The electorate having approved Austin's continuation as the capital, on November 11, 1851, the Senate adopted a resolution asking that Governor Peter Hansborough Bell "obtain from some competent architect or master builder, a plan of a building for a State Capitol." The statehouse, the resolution stipulated, should be constructed of brick or stone "on as cheap a plan as practicable."

Three days later, François P. Giraud, a civil engineer in San Antonio, received a letter from the Governor's Office asking if he might be interested in the project. Interested indeed, Giraud left for Austin by stagecoach almost immediately. Meeting with the governor, he later recalled, he "was told…to make a plan for something [in the way of a statehouse] which would be a credit to the State."

Born of French immigrant parents in Charleston, South Carolina, in 1818, Giraud had been in Texas since 1847. Sent off to school at Mount St. Mary's College in Maryland, he went on to study engineering and architecture in Paris. Putting his skills to use after returning to Texas, in San Antonio, he designed some of that city's landmark churches, as well as the early buildings

at St. Mary's University and the Ursuline Academy. In 1849, he became San Antonio's city engineer. His credentials were unimpeachable.

Giraud remained in Austin about a week, "getting the necessary information respecting quarries &c," before returning to San Antonio to begin drawing plans for "a fire proof building...with an iron dome... estimated to cost $355,000."

The engineer apparently stayed so busy that he neglected to keep the governor up to date on his progress. On December 20, executive department secretary Charles A. Harrison wrote to Giraud, "Some of our Honorable Senators are becoming fidgetty [sic] about the plan and estimate for the State Capitol. I therefore told His Excellency that I would write to you by this Evening's Mail on the subject." Harrison, who must have met Giraud's family when he came to Austin to talk with the governor, added, "I hope Mrs. Giraud and family as well as yourself enjoy good health. I request you to present my best remembrances."

Five days into the new year, on January 5, 1852, Harrison wrote Giraud somewhat less cordially that "the Senate are [sic] very anxious to obtain as soon as possible the plan and Estimates for the Erection of the State Capitol. Please answer this by return mail and oblige."

Giraud finally delivered his drawings three days later, but the "fidgetty" Senate soon decided it did not like Giraud's vision of a new capitol. And Giraud definitely did not like the Senate's reaction to his $350 bill for services rendered.[5] The body appropriated only $100 in payment. A year later, in a petition arguing for payment of the rest of his fee, the Alamo City engineer wrote, "The Senate appropriated...$100 for my plan of a building costing $355,000 and then voted $500 for the plan of a building which was to cost only $100,000." Giraud's claim went to the Senate Finance Committee, which forwarded it to the Select Committee—which declined to pay the bill.

No copies of the original 1853 capitol plans are known to have survived into the modern era, but this is a vintage drawing of the statehouse's exterior. *Courtesy of Ken Wukasch.*

The San Antonio engineer and the State of Texas both would have been better off if the Senate had opted for Giraud's plan. As Giraud later pointed out in his defense, Texas ended up spending five times as much money to buy plans for a cheaper building. Those drawings came from one John Brandon, a carpenter. Even Brandon later admitted he earned $500 for a $60 plan.

On April 21, 1852—the twelfth anniversary of the Battle of San Jacinto, which had ensured Texas's independence from Mexico—the state awarded the capitol construction contract to the low bidders, "Messrs. Moore and McGehee" of nearby Bastrop. As construction proceeded, Brandon's plan, which had taken him only three days and three nights to complete, got modified as the builders took shortcuts. Allegations later arose that some of the money saved in the construction of the capitol did not make it back to the state treasury, but nothing ever came of a legislative investigation into the matter.

A young man named Wende, a recent immigrant from Germany, was a journeyman bricklayer and stonemason paid fifty dollars per month by the contractors who built the new capitol. "The building started in the Spring of last year and, with the auxiliary buildings, which are also of stone, will take until Easter of this year," Wende's wife, Agnes, wrote her cousin in 1854. "Much is spent on it because it is meant to be the same as in Berlin the 'Session' Building….I believe Austin will become, in time, a Posen and Berlin."

But when completed at a final cost of $175,000, the new Texas Capitol stood not as a striking monument to the Lone Star State but as an example of the metaphorical two-headed calves sometimes given birth by a committee: a Greek Revival structure lacking any classical grace. One writer later derisively said the capitol—with a dome too small for the three-story building it sat on—looked like "a corn-crib with the half of a large watermelon on top of it." In addition to the statehouse having been built by workers following a low-cost, unimaginative set of plans, some of those laborers might not have been operating at peak efficiency. For instance, one of the stonemasons on the project, J.W. Hendrickson of Salado, was better known by his nickname—"Whiskey Jack."

Not only did the new capitol look plainer than a wart on a hog's snout, but also the shoddy construction resulted in structural issues ranging from unsightly cracks to serious concern for the building's very ability to remain standing. After requesting a report on the condition of the state's buildings in 1874, Governor Richard Coke read what he and any other sentient person could tell just by looking: "All the public buildings, except perhaps, that

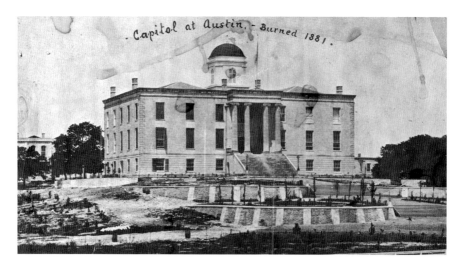

An early photo of the limestone capitol, the first government building to stand at the head of Austin's Congress Avenue. *Author's collection.*

which is used by the Supreme Court, are in a very dilapidated and unsafe condition." If state officials did not think much of their capitol, Austin's population of Mexican free-tail bats found it an excellent roosting place. "The odor around the building is almost unbearable," the *Austin Statesman* observed, presumably referring to accumulated bat guano and not the political doings that occurred inside the statehouse.

Sooner or later, Texas would need a capitol that better matched the size and grandeur of the state it would serve.

3

THE GREAT TREASURY RAID

When the bell atop Austin's First Baptist Church began clanging that moonlit Sunday evening of June 11, 1865, the town's civilian home guardsmen knew it signified trouble, not a call to worship.

With hundreds of battle-hardened ex-Confederate soldiers swarming the town of four thousand, none of the volunteers found it surprising that a need for their services had arisen. But the nature of the emergency would rock the war-weary state.

When the Civil War effectively ended with General Robert E. Lee's surrender on April 9, Texas rapidly descended into near anarchy. Only one Confederate general refused to lay down his arms: Joseph Orville Shelby. Soon he and what remained of his "Iron Brigade" of Missourians headed for Texas. Hoping the South might rise again, Shelby and four-hundred-plus soldiers marched toward Austin en route to Mexico, where they hoped to regroup and at some point resume fighting.

Most Texas officials, unsure if they would be hanged as traitors by the Federals or merely told to go and sin no more, preferred not to find out and vacated their offices. Only the lieutenant governor and two financial officials, Comptroller Willis E. Robards and Treasurer Cyrus H. Randolph, opted to stay in Austin.

"Confederate soldiers, without officers or order, are coming in every hour, and there is nothing but plunder and sack going on—and the citizens are as bad as the soldiers," Amelia Barr wrote in her diary on May 25. Eight days later, she noted, "Everything in confusion…and there is no law."

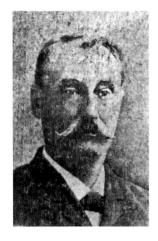

Fred Sterzing helped thwart the raid on the state treasury. *Author's collection.*

But newly discharged Confederate cavalry captain George Freeman had taken it upon himself to organize a thirty-man home guard to help preserve the rule of law in the capital city.

Shortly before nine o'clock on the night of June 11, Nathan Shelley, who had served as state attorney general before joining the Confederacy, received word that some forty armed men had broken into the unguarded two-story treasury, a free-standing building just northeast of the capitol. Shelley located Freeman to tell him something was afoot. Easing through the shadows toward the capitol, they soon heard the sound of metal striking metal coming from the nearby treasury. Fully grasping the situation, Freeman ran to spread the alarm.

Confederate veteran Fred Sterzing heard hurried footsteps followed by someone knocking on the door and yelling that the treasury was being looted. He raced to the Dieterich Building, where the local armory occupied the second floor. Al Musgrove, who had served in the Confederate military with Freeman and Sterzing, heard the alarm, too. He and other members of Freeman's company also rushed to the armory.

Nineteen volunteers removed rifles from their stacks, fixed bayonets and formed up on Congress Avenue in front of the building. From there, Freeman led the small company to the Baptist church across from the capitol. At his command, the guardsmen charged toward the three-story limestone statehouse. Lookouts posted by the bandits fired at them before retreating into the capitol, but no one got hit.

Freeman's men entered the building without encountering further resistance, and from there, they sprinted to the adjacent treasury building. With the approach of the volunteers, the men inside the treasury bailed out the north door clutching hats, shirts and tied-off trousers filled with coins.

Hearing all the commotion, Johanna Domschke, a German immigrant who lived across the street from the treasury, warily stepped outside. She saw bright flashes and heard the sharp reports of rifles and pistols. As she watched, wind raised her apron and a stray bullet punched a hole in the garment, barely missing her. Despite the danger, she stayed outside and observed the bandits as they fled on horseback.

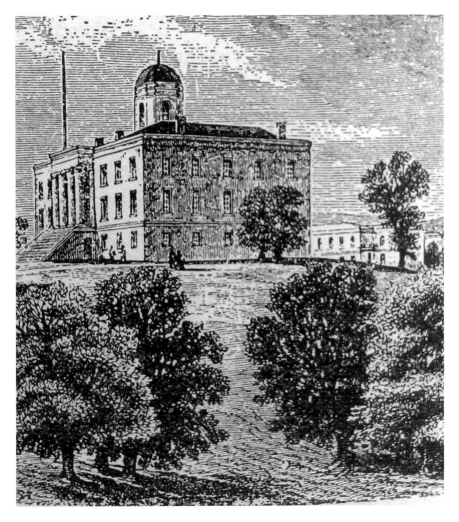

Engraving of the old capitol circa 1860. On June 11, 1865, bandits raided the treasury behind it and escaped with $17,000 in coins. *Author's collection.*

Freemen and three men started upstairs to the second floor. He and his brother took one set of stairs and Sterzing and Musgrove the other. The rest of the volunteers surrounded the building. But only one intruder remained inside. As the home guardsmen reached the top of the stairs, the man started firing at them.

According to Musgrove, the bandit "came…into the hallway. In one hand was his hat filled with silver and his six-shooter in the other." Musgrove and Sterzing both fired, one of the bullets hitting the robber in the stomach. The

man retreated into the vault room, and Musgrove stuck his pistol through the door to fire again. But before he could pull the trigger, the man cried, "Don't shoot….I am mortally wounded."

Still covering the man, Musgrove watched as he "came out bent almost double and fell to the floor," whiskey-smelling blood oozing from his wound. The man no longer posing a threat, Musgrove hurried to look out a window and saw the bandits galloping away. His men dismounted and outnumbered, Freeman decided not to give chase.

Inside the vault room, scattered coins, negotiable bonds, worthless Confederate States of America cash and other financial instruments covered the floor. The robbers had used pickaxes to punch holes in the backs of two large safes so they could get to the money.

Meanwhile, some of Freeman's men carried the wounded man to the Swisher Hotel. Musgrove recognized the bandit as a drunk he had seen in town a few hours earlier. "As he passed me he said, 'It's about time for the boys to meet, isn't it?'" but Musgrove had paid no attention to the remark.

Freeman's company kept the treasury under guard that night. Leaving some of his men behind, shortly after daylight he led a posse in pursuit of the bandits. They soon discovered that the raiders had split into two parties to make following them harder. One trail led northwest and another ran north. Riding each, all the volunteers found were a few dropped coins.

Alex Campbell, the gut-shot robber, died hard. While refusing to name his colleagues, to his last breath he profanely upbraided his fellow bandits as cowards.

One night shortly after the raid, someone broke into Sterzing's room. Awakening to see a man standing over him with a knife, he struggled with the intruder before he escaped. Sterzing snapped off a shot but missed. The same night, someone found Comptroller Robards bound and gagged. Sterzing recalled years later that the city had feared another attempt on the treasury, but nothing else happened.

Not only did Austin lack sufficient law enforcement to keep the peace, but it also had no newspaper to report the crime. Later, the *Galveston News* ran an item noting, "It is the universal belief of the citizens that the robbers…had been waiting to lay blame on Shelby's men when they arrived there."

Freeman wrote U.S. Army major F.W. Emory in Galveston a letter summarizing the raid. He said his men had saved about $30,000 in specie and U.S. coupons and hundreds of thousands of dollars in liabilities to the state. "This service was voluntary and without expectations of reward," he declared.

A final audit showed the treasury held $1,753,000 in railroad bonds, $475,000 in U.S. Treasury bonds, $384,000 in (worthless) Confederate notes, $90,000 in comptroller's certificates, $25,000 in state warrants and $27,525 in specie. It is generally believed $17,000 in coin had been taken, which in modern dollars would be worth $2.7 million.

Until occupying Federal troops reached Austin in July, Freeman's men continued to guard what remained of the state's public funds. They also tried to identify the bandits, but no arrests were ever made, the robbers apparently keeping their secret the rest of their lives.

Some thought it suspicious that Governor Pendleton Murrah left town with General Shelby soon after the raid, but it seems more likely that he fled in fear of Federal prosecution.

Shelby vigorously denied that he or any of his men had any involvement in the break-in. Perhaps protesting too much, he threatened to torch the town if residents persisted in spreading that rumor. Another possibility is that some of Shelby's men undertook the treasury robbery on their own, but former treasury defender Joe Owens insisted years later that "such was not the case." He said Shelby's command had not even reached Austin until the day after the robbery.

Circumstantial evidence points to John Rapp, a rebel soldier originally from Missouri who had been living in Austin, as being the mastermind of the raid. In 1861, Rapp joined the Confederate army and took part in two bloody battles in New Mexico before returning to Texas in the summer of 1862. Rapp's final discharge came in May 1865, just days prior to the treasury raid. Having been wounded and captured earlier in the war, it's plausible that he felt such a strong sense of entitlement that he and his comrades decided to help themselves to some hard currency.

Thirty years passed before Rapp's name surfaced in the press as a likely suspect. The revelation came in 1897 when General Shelby's death prompted some newspapers to publish excerpts from a sensational and largely inaccurate account of his career written by his adjutant, John N. Edwards. In the book, Edwards claimed Shelby's men had mitigated the treasury raid, not Freeman's volunteers. That falsehood riled Freeman and others who had risked their lives that night. Freeman wrote to the Galveston newspaper to blast Edwards and so did Joe Owens.

Owens indirectly suggested the raid had been led by Rapp, and Edwards had mentioned him in his book: "Operating about the city was a company of notorious guerrillas led by Captain Rapp." Longtime Austin lawyer W.M. "Buck" Walton called Rapp a hot-tempered heavy drinker.

No one came right out to say Rapp had been the ringleader, but one of Freeman's men reported that a raider had called out to Rapp by name during the mêlée following their discovery in the treasury. And the woman who nearly got shot during the raid said she recognized Rapp among the bandits.

Another person who might have been involved in the robbery became one of the Wild West's most noted characters: gambler, gunman and gadabout Ben Thompson. Near the end of the Civil War, Thompson had recruited a company of men to protect the Texas settlements from hostile Indians. Rapp became captain and Thompson his lieutenant.

Thompson disappeared from Austin right after the raid. Returning in July, he soon got arrested for another offense but escaped and fled to Mexico. A final piece of circumstantial evidence against both Thompson and Rapp concerns Alex Campbell, the raider killed in the robbery. Records show he also had been a member of the Rapp-Thompson company, an outfit that had about as bad a reputation as its leader.

Even though the historical record is quite clear that the bandits made off with much of the state's money, the raid is likely what inspired the later legend that a treasure in gold lies buried under the oldest tree on the capitol grounds. But anyone who paid attention in their Texas civics class understands that state lawmakers—ever eager to cut government spending and hold down taxes—would have had the whole twenty-five acres dug up if they believed there was really treasure to be found in the vicinity of the capitol.

As for the nineteen heroes who interrupted the looting of the state's coffers, in 1909, the Texas House adopted a resolution extending the legislature's thanks to the defenders of the state treasury that summer night forty-three years earlier. However, no monetary award for the surviving volunteers would be forthcoming. And the State of Texas is still short $17,000—plus more than a century and a half of compounded interest.

4
CAPITOL WHODUNITS REAL AND FICTIONAL

Members of the Thirteenth Legislature worked through a routine day on February 19, 1873, meeting in the then twenty-year-old limestone statehouse at the head of Congress Avenue. Most of the debate in the House of Representatives that day had centered on a proposed state finance bill, which the members eventually tabled by a fifty to thirty-one vote. That done, lawmakers in the lower chamber accepted a couple written communications, gave permission to a special railroad committee to submit three different reports, referred a bunch of memorials to committee and adjourned for the day.

Representative Louis Franke of La Grange, whose District 7 included Fayette and Bastrop Counties, looked forward to supper and a beer before a committee meeting he would be chairing later that evening. Though hungry, after the Speaker's gavel ended the day's proceedings, he stayed at his desk for a while to take care of some writing. Then he went to the House sergeant-at-arms' office to collect his per diem. With $260 worth of $5 bills in his pocket, he walked out the south door of the capitol to finally get something to eat. After his meal at an establishment on Congress Avenue, he pulled the wad of money from his pocket and peeled off a $5 greenback to cover his bill. He didn't notice that someone was watching the transaction with unusual interest.

About 7:30 p.m., a clerk who worked for the department of education ran into the statehouse and asked if anyone knew a Mr. Franke, saying he had been hurt. Assistant sergeant-at-arms N.C. Reeves hurried outside, as did

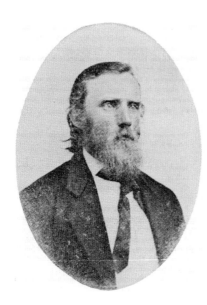

Representative Louis Franke posed for this portrait shortly before he was robbed and murdered at the capitol. *Author's collection.*

several House members and a senator. They found Franke sitting at the foot of the steep steps descending from the building's entrance. He was bleeding from two head wounds and appeared to have a broken leg.

"He said he had been knocked down and robbed," Reeves later said.

Not fully rational, Franke at first said that one of his legislative colleagues had attacked him with a stick. But his money was missing, and two suspicious-looking heavyset men had been seen hanging around the entrance to the capitol shortly before the incident. Now they were nowhere around.

Two House members carried the semiconscious legislator to the rented room he shared with fellow House member Gustav Hoffman from New Braunfels and summoned Dr. B.E. Hadra. The doctor found Franke in a lot of pain. He noted several cuts and bruises, a significant wound above his eye and an even nastier wound to his temple that had "produced a depression of the skin." In other words, the lawmaker's skull had been crushed by a blunt object.

The doctor and an associate could do little more than inject morphine to relieve the moribund man's pain. At 4:30 a.m. on February 20, Franke died. Before he did, he came to long enough to say he had been attacked and robbed by two men he did not know.

Born to a prominent family in Germany in 1818, Franke (he had Anglicized his name from Ludwig Carl Ferdinand Francke) immigrated to Texas in 1845, arriving in Galveston in January 1846. He settled in Washington County and stayed there until shortly after the Mexican War broke out. In October 1846, he joined the Texas Volunteers under Captain Shapley P. Ross and served for a year. As the war wound down, he left federal service and enlisted in the Texas Rangers under Captain Henry E. McCulloch. His company operated from a camp on Hamilton Creek near what is now Burnet, west of Austin. After his term of enlistment with the Rangers ended, the adventurous German went to

California at some point following the discovery of gold there in 1849. By early 1854, he was back in Texas, where he married a young woman in Fayette County. As his family grew, he made a living as a farmer and music teacher. After serving two years as a Fayette County commissioner, in November 1872, he ran for a seat in the House of Representatives and gained election.

"The deceased was much respected and beloved for his kindly and generous qualities, both of head and heart," the *Dallas Herald* noted. "He had no enemies. Upright in all his dealings, genial in deportment, a good friend, a loving husband, a kind father and an exemplary Christian, he has passed away without a stain on his record, to that higher House."

Later on the morning of Franke's death, his shocked legislative colleagues listened to the House chaplain pray for their slain colleague's family and then quickly passed a resolution calling for appointment of a joint committee to "make a thorough and searching investigation into the tragedy."

Meanwhile, local law enforcement officers had briefly detained a man who had suspicious dark spots on his shirt. But the spots turned out to be paint, not blood, and he was released. One newspaper reported he was "a very innocent inoffensive fellow." The newspaper continued, "There is no clue to the scoundrel who committed this hellish deed."

Calling the killing a "hellish deed" was not journalistic hyperbole. One of the thugs who accosted the lawmaker had apparently used a large rock to hit him on the head. When Franke fell, judging by the blood found on the limestone steps leading up to the capitol, he had tumbled down them. In the process, he broke his thigh.

Reeves said in a written statement that he had seen two men outside the capitol about fifteen minutes prior to the attack. Two others also noticed the men. "The description of the men seen by them leads me to believe them the same I saw sitting on the steps as I passed up at a quarter past seven o'clock," the assistant sergeant-at-arms said. "I could not identify the men, as there was not light sufficient to distinguish their features."

Following a memorial service in the House chamber on February 21, a long entourage of state and local officials escorted a carriage bearing the metal coffin holding the representative's body down Congress Avenue to the train station for the sixty-five-mile trip to La Grange. From the depot there, his remains were taken to the Franke family cemetery on his farm near the small community of Black Jack Springs.[6]

"The murderers of Mr. Frankee [the number of Es in the victim's name varied in the written accounts of the crime, but he and his family used only

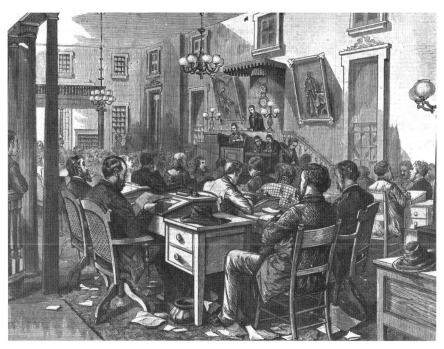

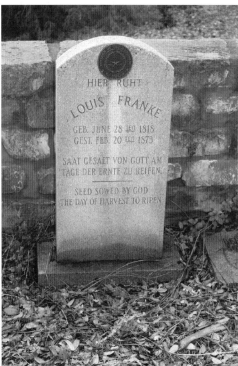

Above: Engraving from *Leslie's Illustrated Weekly* showing the legislature in action in the old limestone capitol. *Author's collection.*

Left: The remains of the murdered House member rest in this private family cemetery in Fayette County. *Courtesy of Gary McKee.*

one]," the *Austin Daily Statesman* speculated, "intended to kill and rob Mr. Rhodes, Sergeant-at-Arms of the House. Mr. Rhodes had drawn the money of a large number of members on that day, and even after dark had several thousand dollars left upon his person not delivered."

Another newspaper reported that Rhodes had $28,000 in cash that day, a huge sum for that era. By the time Franke received his share, Rhodes had dispersed all but about $4,000.

Austin law enforcement did not distinguish itself in the Franke case. In addition to the hapless painter they rousted, at least two other men were questioned as potential suspects, but they were released. As the *Dallas Herald* reported: "So far [the]…assassins have not been discovered, nor is there any good reason to believe they will be, from the bungling manner the authorities have adopted to ferret out the perpetrators. The cool deliberation and audacity displayed stamp the murderers as professionals; yet, men are arrested who neither have the motive nor the nerve to commit the deed, while doubtless the guilty ones are coolly looking on and enjoying the farcical examinations." Despite a $5,000 reward offered by the state, the robbery-murder remained unsolved.

The legislature did take one piece of decisive action in response to the crime: almost immediately after the representative's murder, it approved installation of two large gas lamps at the foot of the capitol steps, two lamps in the lower hall of the building and one at the south gate of the capitol grounds. The lamps were to be kept lit from dark "until eleven o'clock each night during the remainder of the present session of the Legislature."

During the construction of the present capitol, rumor spread among the laborers and tradesmen that one of their co-workers had been murdered. "There was a carpenter working on the building whose wife chose that site for his murder," bricklayer Gustave Birkner wrote in his unpublished memoir. "She sent arsenic in his tea and poisoned him one noon."

If such a crime occurred, it did not make the newspapers. But Birkner said the contractor kept the lid on news of any mishaps or unsavory incidents on the job site. "If anything happened on one end of the building, we wouldn't hear of it if we were working on the other side," he wrote. "Many of the workers were superstitious…so the contractors and bosses definitely discouraged any talk about them."

Eleven years after the capitol's dedication, another member of the legislature died under suspicious circumstances. Representative S.P. Evans of Sherman died in Austin on March 19, 1899, during that year's regular legislative session.

"A rumor is prevalent on the streets that [Evans] was murdered," a Sherman newspaper reported on April 12 that year. "The bruises on his face and contusion on the back of his head indicate foul play and it is now believed he was the victim of an assault between the capitol…and his hotel the night before his illness was announced. A quiet investigation has been in progress, but so far no incriminating evidence has been found."

But the same day the afternoon *San Antonio Light* pooh-poohed the murder story as having originated "from a wild-eyed news monger." The Alamo City newspaper reported, "Speaker [James S.] Sherrill…stated that before Evans' death he had heard rumors of a bruise on the head and made a thorough investigation. He learned that Evans had fallen on his head striking against a box. The wound was only slight. Nobody here believes the Sherman story." The *San Antonio Express* said Evans had tripped a few days before his death and struck his head on stone curbing but that it had nothing to do with his death.

The story dropped from the news after that. Today, determining cause of death is a relatively easy procedure in most cases. If a doctor performed an autopsy on Evans, that fact went unreported. However the North Texas lawmaker died, the House and the Senate each recessed for a time in his honor.

The most sensational murders in the capitol occurred only in the vivid imagination of Texas novelist Bill Crider, who used the statehouse as the setting for his 1992 whodunit *Texas Capitol Murders*. In that well-reviewed page-turner, a young cleaning woman is found strangled in a trash hamper in the basement of the capitol. The medical examiner's autopsy showed she had been pregnant. The day after that shocking discovery, a second body is found in a men's restroom. This time the victim is a male legislative staffer.

The governor asks for a Texas Ranger investigation (which in real life would not be necessary since the Rangers have primary jurisdiction on state property), and the state lawman who takes on the case, according to a review in *Publisher's Weekly*, finds "a varied assortment of suspects ranging from right-to-lifers to political time-servers, naive coed capitol guides to powerful lobbyists." As the novel nears is denouement, a third person dies violently. The reviewer concluded that the retired college professor's 329-page book, with its "neatly detailed setup, twisting plot and colorful cast of characters… will keep readers riveted." And, unlike the real murder that happened on the capitol grounds in 1873, the killer in Crider's book does not escape justice.

MR. FLEMING OF COMANCHE

On a hillside shaded by tall evergreens overlooking Spokane, Washington, is Greenwood Memorial Terrace, a garden-like cemetery established in 1881. More than thirty thousand people lie buried there, including one James Richard Fleming.

His gravestone is a simple rectangle of two-tone granite, a smaller pink stone fitted into a larger gray slab, bordered with concrete. Other than his name, the only other information on the marker is his date of birth and death, "1847–1904." And the date of his birth is wrong by a year. The website findagrave.com lists nine "Famous Interments" in this cemetery, but Fleming's grave is not one of them.

The Spokane cemetery is a peaceful enough place to end up, but by all rights, Fleming's remains ought to be in the Texas State Cemetery in Austin under a much more imposing monument, one that places his story in historical context. After all, when all the many dusty layers of the capitol story are swept away, the genesis of the Texas Capitol traces to this decidedly unremembered man.

Born on September 10, 1848, in Feliciana, Kentucky, he later moved with his family to Tennessee, where he grew up. When bitter sectional rhetoric boiled over into secession and the Civil War in 1861, at only thirteen, Fleming enlisted in the Confederate army, serving under General Nathan Bedford Forrest.

A couple years after the war, in 1867, Fleming decided to move to Texas. He settled in Columbus, where he bought the town's newspaper, the *Columbus*

Times. He published the *Times* for a year before selling it so he could focus on reading the law. After passing the bar exam on March 16, 1870, he married Mary McLeary Grace that November 1—her twenty-second birthday—and they moved northwest across the state to Comanche County. His legal services not always in demand, he further provided for his family through merchandizing and banking.

In the summer of 1875, by then well integrated into the Comanche community, he was elected as a delegate to the ninety-member Constitutional Convention set to convene in Austin on September 6. With Reconstruction ended, the convention was mostly about two things: restricting the power of state government (particularly the governor) and keeping a tight rein on state spending. Delegates even refused to pay for a stenographer to record the proceedings.[7]

So far as is known, Fleming left no diary revealing his thought processes at the time, but at some point during the first month or so of the convention, the gentleman from Comanche had an idea. Maybe having to spend so much time in the poorly built 1853 capitol had something to do with it. Anyone could see that Texas needed a new statehouse, but the state was more than $3 million in debt. Fleming had read the comptroller's report on the state's finances. With a national financial depression gripping the nation, projected tax revenue would cover only half the state's budget. Given the financial and political climate, a tax increase was out of the question.

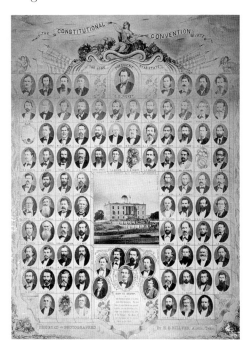

This photo montage of members of the 1875 Constitutional Convention hangs in the capitol that their resolution helped make possible. *Author's collection.*

However, Texas did have plenty of public land, some forty-eight million acres. Likely from his study of the law, the twenty-seven-year-old lawyer had at least some familiarity with the federal Land Ordinance of 1785 and the nation's next major measure dealing

with public land, the Pacific Railway Act of 1862 and its successors. A component of the first law had to do with leveraging public land to fund public education, while the acts passed during the Civil War set aside part of the public domain to help pay for the nation's first transcontinental railroad. Also, Fleming knew the Republic of Texas had issued land scrip to secure loans and land bounties to pay its soldiers and that starting in the 1850s the state had offered public land for infrastructure development and to induce railroad construction. Perhaps inspired by the federal laws and his awareness of the various ways Texas had used its land in lieu of money, on November 1—his fifth wedding anniversary and the forty-ninth day of the convention—Mr. Fleming of Comanche offered for consideration this resolution: "Resolved, That the Committee on Public Lands and Land Office be requested to consider the propriety of setting apart five million acres of the public domain for the purpose of building a State capitol, and to report by ordinance or otherwise."

Convention president Edward B. Pickett quickly referred Fleming's resolution to committee, but that day's convention journal has nothing more to say of the matter. Still, the process had begun. On November 11, delegate W.H. Stewart of Galveston offered essentially the same resolution, although his version shaved two million acres off Fleming's suggested appropriation. Stewart's resolution went to the committee on state affairs, which on November 17 reported favorably on the proposal.

Chaired by former Texas Ranger John S. "Rip" (Rest in Peace) Ford, the committee made this observation in its report:

> It is evident that within a few years repairs and changes will be required… upon the capitol and other public buildings, and, in order to accomplish these objects, an outlay of money will be made. As a measure of economy, it may be proper and expedient to erect these buildings anew, so that they more appropriately represent the augmented population of the State.

In addition to his Ranger service, Ford was a trained physician, lawyer and onetime newspaper editor. Clearly, it was the doctor in him that composed the committee's report. While written in a complicated way, the meaning came through: given the cost of repairs, and the growth of the state, it would make more sense to build a new capitol than try to fix the old one.

Accordingly, the six-member committee offered this proposed wording as a section of the new Constitution:

Three million acres of the public domain are hereby appropriated and set apart for the purpose of erecting and constructing a new State capitol and other necessary public buildings, at the seat of government; said lands not to be sold until ten years after the adoption of this constitution; and the Legislature shall pass suitable laws to carry this section into effect.

Delegate George McCormick tried to get the allotment increased to ten million acres, while another delegate sought to lower the acreage to only one million, but neither effort gained traction and the convention voted forty-eight to four to include the section as written in the proposed constitution. The following February, Texas voters ratified the Constitution, a long and complicated state charter that remains the organic law of Texas.

Back in wild and wooly Comanche, where in 1874 a prolific killer named John Wesley Hardin shot and killed a sheriff's deputy and then managed to elude an entire company of Rangers (in the aftermath, the good people of Comanche did at least lynch Hardin's brother and a few others), Fleming decided to seek election as judge of the Twelfth District Court. "Mr. J.R. Fleming will be one of the best district judges of Texas," the *Austin Statesman* said on January 20, 1876, "and Comanche is properly solid in his support. He won deserved honors for his ability and integrity while a member of the Constitutional Convention."

Fleming won the election and went to work. A letter from Comanche published on October 1, 1878, in the *Waco Daily Examiner* praised the judge, noting that "the law is rigidly enforced." The anonymous correspondent, who signed his dispatch "Fascination Fledgy," noted that Fleming was the state's youngest district judge and had succeeded in suppressing "the mob law in this district, overcoming the evils resulting from the factional feuds which for a time run [*sic*] riot over this country."

Journal of the proceedings of the 1875 Constitutional Convention reproduced delegate J.R. Fleming's resolution that proposed setting aside five million acres to fund a new state capitol. The amount of land later was reduced to three million acres. *Author's collection.*

The young judge's reputation continued to grow. "The newspapers say that [Fleming] is one of the coming great men of Texas," the *Austin Statesman* reported on March 27, 1879. "He is eloquent, learned and brave, and pure in both public and private life."

While busy helping to bring law and order to his part of Texas, Fleming surely read with satisfaction that on February 20, 1879, the legislature had passed a bill creating a board to spearhead the building of a new capitol. Made up of the governor, comptroller, treasurer, attorney general and land commissioner, the board was authorized to hire a superintendent "who is a skilled architect" and two commissions to get the job done.

Fleming remained on the bench until 1880, when he moved to Cisco in Eastland County and soon partnered with two other men in a real estate and land title business. Three years later, voters sent him to the Senate to represent District 29. While in Austin, Fleming got to see a new capitol slowly taking shape where the old one had stood. As he had first envisioned, in exchange for the promise of three million acres, the structure was being built by a group of Chicago businessmen who came to be referred to as the Capitol Syndicate, "syndicate" at that time being essentially a synonym for "corporation." (The state had thrown in another fifty thousand acres to pay for surveying the land.)

As a member of the Senate, Fleming read the capitol board's reports and other documents pertaining to the project. Chicago businessman Abner Taylor, along with Amos C. Babcock and brothers John V. and Charles B. Farwell, formally known as Taylor, Babcock and Company, had won the contract to build the capitol.[8]

In 1889, Fleming moved to San Antonio, where he was appointed to oversee the sale of the foundering San Antonio and Aransas Pass Railway Company as master of chancery. He relocated to Houston in 1894, the same year he served as a delegate and temporary chairman of the state Democratic convention in Dallas. It being a national election year, he also represented Texas at the national democratic convention in Cleveland. Two years later, in 1896, Fleming and his wife left Texas for Spokane, Washington. After he died there of Bright's disease on May 25, 1904, at fifty-five, his widow returned to Texas. She settled in Fort Worth and lived another ten years.

Descendants of several score key figures involved in the planning, financing and construction of the capitol can truthfully boast that their forebears had a role in bringing about the state's Texas-size statehouse, but it all traces back to an idea the honorable James Richard Fleming of Comanche had in 1875.

THE MAN WHO BURNED DOWN
THE CAPITOL

Shortly before noon on November 9, 1881, the wind blew out of the north in Austin, and a light rain fell from a sky as gray as an old Confederate army coat. With the norther dropping the temperature, maybe the porter sweeping the floor in the attorney general's office on the capitol's first floor had in mind warming up the room. Or perhaps Henry McBride just wanted to get rid of a basket of wastepaper the easy way, by stuffing the trash into the heating stove.

Whatever his intention, McBride moved on to the next room, pushing his broom. Soon he smelled smoke. Running back into the room where the stove sat, he saw flames coming from the wall around the chimney pipe. As he watched in astonishment, the fire quickly spread. All he could do was run for his life.

A writer for *Texas Siftings* walking home for lunch noticed wisps of smoke coming from one of the windows of the limestone statehouse. "That's the way those State officials waste firewood," he thought, or at least so he claimed in a tongue-in-cheek article he later wrote. "There they are toasting their sinful shins before fires in which they waste enough wood to do a respectable family for a week."

But soon the fire bell atop city hall began ringing. The number of clangs informed the volunteer firefighters—rushing to the hall to get their equipment—that the fire was in the eighth ward, downtown Austin.

Though the limestone capitol had been a bonfire waiting to happen, Governor Oran M. Roberts, remembering the 1865 looting of the state's

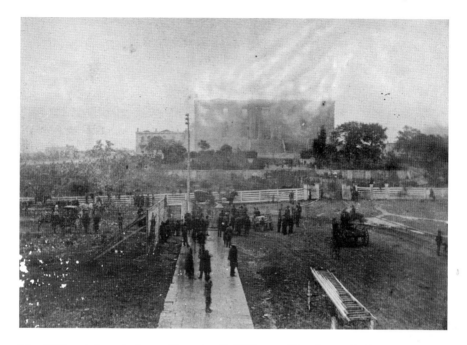

The 1853 capitol caught fire on November 9, 1881, expediting the state's plans to build a new, grander statehouse. *Author's collection.*

treasury, feared history was repeating itself. Holdup men must have started a fire in the capitol to divert attention, he thought. The governor quickly ordered several Texas Rangers camped on the capitol grounds to go guard the vault. The only enemy on this day, however, was the natural consequence of fuel, oxygen and an ignition source.

"It was a thrilling scene," the next edition of *Texas Siftings* reported. The writer continued:

> *The fire's demon cruel tongues licked the fair proportions of the historic pile, while huge volumes of black smoke poured from the doomed building, and settled over the fair city…like a sable funeral pall, enveloping in its somber folds the spires and domes that glitter on the several hills of the Capital City…while the toot, toot, toot of the fire engine, and the hoarse profanity of the enthusiastic volunteer firemen, seemed a solemn and appropriate dirge as the old sarcophagus crumbled.*

Low water pressure at the nearest hydrant, which sat seven hundred feet from the statehouse due to the fact that two previous sessions of the

legislature had not seen fit to appropriate money for fire hydrants on the capitol grounds, prevented the volunteer firefighters from putting much more than a light mist on the blaze. In less than two hours, only a blackened limestone shell remained of the Texas statehouse.

"The architectural monstrosity…at the head of Congress Avenue is no more," the *Texas Siftings* summarized. "The venerable edifice that bore such a striking resemblance to a large size corn crib, with a pumpkin for a dome… took fire on Wednesday."

Though newspaper reaction to the loss of the capitol varied from near indifference to open sarcasm, many government records dating to the days of the Republic of Texas burned in the fire. Geologic samples and a collection of cultural artifacts, including shields and lances seized by Indian-fighting Texas Rangers, also went up in smoke. One of the items was a coat of mail dating from Spain's reign over Texas in the 1700s. The item had been removed by rangers from the dead body of a Comanche headman known as Iron Shirt, one of his forbears apparently having relieved a Spaniard of the protective wear years before. In addition, eight thousand books lining the shelves of the state library had been incinerated. The loss of the library alone was placed at $40,000, a huge sum for the day.

Soon after the fire, rumor spread about as fast as the flames that had consumed the building that the building had been deliberately torched by someone wanting to destroy land records to cover up an extensive real estate fraud. Since Texas land records were kept in the free-standing general land office, not the capitol, state officials did not take the arson theory particularly seriously. Clearly, the fire had been an accident, and a more thorough investigation later backed that up.

Like a long-smoldering ember, the conspiracy theory rekindled ninety-four years later when *Dallas Morning News* columnist Frank X. Tolbert wrote a piece that made it seem like a fait accompli that an arsonist had touched off the blaze, which in turn had the unintended effect of expediting construction of the present capitol. According to Tolbert, "A rancher in Leon County was trying to claim 20,000 acres of land with forged titles. He 'aged' the phony papers by leaving them on coffee grounds and then slipped them in the county records." Knowing the authentic records were filed in Austin, he and several of his ranch hands rode to the capitol, managed to set it afire without being seen and immediately made a near horse-killing ride back to his ranch. Soon, the crooked cowman must have learned to his chagrin that the capitol did not hold any land records. Tolbert said the

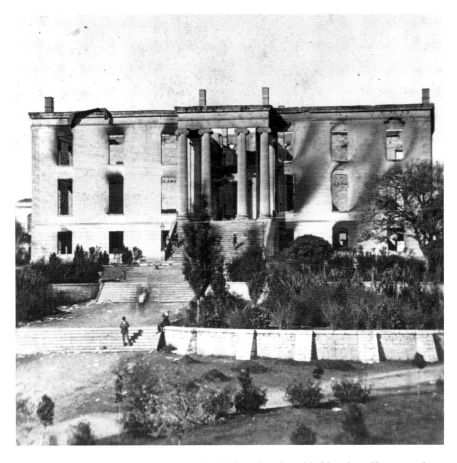

Flame-scarred ruins of the limestone capitol. Many irreplaceable historic artifacts were lost in the 1881 fire. *Author's collection.*

scoundrel failed to hold on to the Leon County land he claimed but never faced prosecution.

"You'll not find in any history…an account of the Leon County land thief's scheme for burning down the capitol," Tolbert crowed. And in that he was correct, but the colorful folklore he offered his readers was not.[9]

Assuming the burning of the statehouse was truly Henry McBride's fault (he never denied the dubious honor, but a tinner's shoddy installation of the stove pipe played a bigger role), the fire did not cost the porter his job. In fact, he stayed on the state payroll for fifty years, possibly the longest-ever tenure of a state worker in Texas. His last day on the job came in 1931, half a century after the capitol fire.

When McBride died at seventy-six on April 8, 1936, the Associated Press, which like the rest of the mainstream media in Jim Crow days did not normally report the natural passing of African Americans, distributed a four-paragraph story noting the death of "the negro who indirectly caused construction of Texas' massive granite capitol."[10]

In truth, though McBride might have accidentally started the fire, state officials already had been planning for a new capitol, a grand structure that would be a much more fitting home for the government of the nation's largest state. Ironically enough, the capitol board charged with overseeing the building of a new statehouse had been meeting in the House chamber of the old capitol when the fire broke out. (Before fleeing the building, members hurriedly gathered up all the proposed designs for the new capitol then under consideration.) Since the new capitol was to be erected where the old one stood, the fire might even have saved the state a little money in wrecking costs.

What would replace the old capitol would be a world-class building, a structure comparable to the Capitol in Washington and bigger than the houses of the German Reichstag or Great Britain's Parliament.

THE FORGOTTEN CAPITOL

The temporary capitol of Texas, built in 1883 to house state government while the present capitol was under construction, cost the state $50,000. Eighty-nine years later, the state spent almost the same amount to dig up its ruins.

After the 1853 capitol burned in 1881 and after considering several options, the state contracted for construction of a temporary statehouse on the southwest corner of Eleventh Street and Congress Avenue as soon as possible. Ever frugal, the state stipulated that as much of the stone from the old capitol as possible be used in the stop-gap statehouse. While state officials awaited the temporary building's completion, they worked in the smaller two surviving antebellum government buildings near the ruined capitol, as well as in borrowed space at the Millett Opera House, the Travis County Courthouse and even the county jail. After its completion in 1883, the hastily built three-story government building remained in use until the new capitol opened in 1888. After the state moved into the present capitol, the temporary statehouse was used to house Austin High School, and the third floor of the building was rented to individual tenants.

History seemingly repeated itself on September 30, 1899, when fire broke out in the temporary building. Low water pressure again hampered firefighters, and the building was reduced to rubble. A large crowd gathered to watch as it went up in flames, but no one considered it a great loss. Many townspeople figured it would have fallen down anyway, sooner or later. The stones were salvaged and used in other structures across the city. The lot

After the 1853 capitol burned, the state built a temporary capitol on the cheap. Even though construction was delayed after part of it collapsed during a storm, it served as the statehouse for five years. *Author's collection.*

where the temporary capitol had stood remained vacant until 1912, when the state landscaped the area and made it into a park. The park continued in use until after World War II, when the grass was ripped up and the land paved for use as a parking lot.

In 1969, officials looking down on the property from the overcrowded 1931-vintage highway department building at Eleventh and Brazos Streets envisioned a new agency headquarters going up on the site. The highway commission authorized the department's executive director to proceed with planning a new building, which the agency intended to fill the entire block between Tenth and Eleventh Streets. In 1971, responding to protests that the new building would not only be overly pretentious and costly, but it would also necessitate the destruction of the old Lundberg Bakery (in the National Registry of Historic Places) at 1006 Congress Avenue, the legislature directed the department to rethink its plans.

While that review proceeded, highway department archaeologists undertook an extensive excavation of the temporary capitol site. Plans for

a new building ended up getting scrapped, and the highway department is still in its eight-story Art Deco building across from the capitol. But the body of historical information collected by the archaeologists remains. It was compiled into a 221-page report, released by the agency in 1972.

The dig at the old capitol was the largest project newly hired department archaeologist Frank Weir had undertaken up to that point in his career. Among the things Weir and his colleagues brought to light with their digging—both in the ground and in archival sources—was that some corner cutting went into the building of the temporary capitol. "The original specifications called for a concrete floor several inches thick on the first floor," Weir said. "But when we dug it up, we found only a thin layer of concrete on top of gravel mixed with a little cement."

That procedure saved someone money.

"Politics was no different back then than now," Weir smiled.

The foundation of the building, the investigation showed, had not been very stable. "An architect who looked at the work said he was surprised that the building stood," Weir said. In fact, while the building was still under construction in September 1882, a gust of wind from a thunderstorm collapsed the structure's northwest corner. That event resulted in a different kind of tempest: the contractor got the boot.

The building was finally finished, but the work was still nothing to write home about. Weir's study showed that many of the measurements of the excavated foundations did not match the measurements found in the original building plans. Two of the building's walls did not even meet at a ninety-degree angle.

Archaeologists found a wide selection of artifacts in and around the exposed building foundations. The objects ranged from an 1856-vintage Colt dragoon pistol (how the weapon got lost is open to the imagination) to an array of old bottles, several coins of various ages and even a few prehistoric flint projectile points.

Though architecturally insignificant and cheaply built, the temporary capitol saw a lot of history in its brief heyday. Lawmakers meeting in its second-floor legislative chambers passed a strong education law and a tough measure to stop barbed wire fence cutting, an issue of old ways versus new technology that claimed several lives and many miles of wire during what is known as the Fence Cutter's War. Two governors served within its walls: John Ireland (1883–87) and Sul Ross (1887–91). In 1883, the two-hundred-plus students who constituted the student body of the newly opened University of Texas attended classes in the building

Historical marker at the site of the 1883 temporary capitol at Eleventh and Congress, just across the street from the modern capitol. Some of the structure's foundation has been preserved. *Photo by the author.*

while the school's main building was under construction on the northern outskirts of town.

Perhaps the most unusual thing that ever happened at the temporary capitol took place in 1887, in the midst of what came to be called the Grass Lease Fight. The state's land board had passed resolutions setting the lease price for public land at eight cents an acre for land without water and twenty cents for land with water. Panhandle ranchers resented having to pay for what they considered their right to graze livestock on public land. During the dispute, which had ended up in court, cattle baron Charles Goodnight, along with land developer W.B. Munson and Austin attorney "Buck" Walton, placed $72,000 in cash into a wheelbarrow and had a porter push it up Congress Avenue to the capitol for deposit with the state treasurer. All three men wore six-shooters. In modern parlance, it was a publicity stunt.

The interim capitol also housed the capitol board, the three-member body that oversaw construction of the building that replaced the temporary statehouse. Members could look out their office window and watch the new statehouse going up, a structure—unlike the one in which they sat—that was intended to last a long, long time.

8

THE GRAVES ON CONVICT HILL

T he Travis County community of Oak Hill, long since absorbed by a fast-growing capital city, more appropriately should be known as Convict Hill after its most significant if largely forgotten landmark: the quarry that produced all the many tons of limestone used in building the capitol. As it is, that evocative place name survives only on green city street signs and as part of a suburban park's name.

What has lasted are lurid tales of bone-weary prisoners—balls and chains shackled to their legs—trying to escape only to be tracked down by bloodhounds and shot by their guards, lost graves, lingering ghosts and a mysterious cave. But the tens of thousands of commuters who sit near the historic site in traffic snarls every workday at what is now one of Austin's busiest intersections—and most local residents—have probably never heard the story of Convict Hill. Even a state historical marker put up in 1969 stands obscured by overgrown vegetation at a roadside park abandoned by the Texas Department of Transportation to make room for highway widening.

Of course, Oak Hill has always suffered from something of an identity crisis. First settled in 1856, it was known as Liveoak Springs. After the Civil War, local residents renamed it Shiloh for one of that conflict's bloody battles. By the early 1880s, the community was called Oatmanville, even though its post office had been named Oak Hill a decade earlier. In 1900, residents finally decided to drop Oatmanville in favor of Oak Hill.

People started calling the massive, cedar-covered limestone formation near the modern intersection of William Cannon Drive and US 290

Convict Hill (though its owners called it Quarry Hill) after the state prisoners who had been pressed into labor at the quarry in the early to mid-1880s. The subcontractor engaged in building the capitol's foundation and basement paid the state sixty-five cents a day per inmate to blast and chisel the limestone and load the large blocks onto rail cars.

No matter its importance in the history of the capitol, much of what remained of the quarry after operations ended in 1887 has been gnawed away to make room for roadway expansion and commercial development. In fact, were it not for a well-traveled thoroughfare nearby called Convict Hill Road and Convict Hill Quarry Park, the area's lasting contribution toward the capitol would be all but lost to memory. Compared with other aspects of the capitol story, the quarry gets short shrift in most histories, even though about one-third of the statehouse is built with limestone blasted and cut from the hill.

Indeed, at the height of quarrying operations in 1886, ten carloads of stone rolled daily by rail to the capitol construction site. More than 280,000 cubic feet of limestone from Oatmanville/Oak Hill went into the capitol for use in the building's foundation, basement and cross walls and as backing for exterior walls.

The Convict Hill story began with a statewide search for Texas stone for use in the planned new capitol. After spending more than $16,000

in inspecting fifteen potential limestone sources, capitol board commissioners decided to begin quarrying on one thousand acres near Oatmanville that would be leased from owner W.K. Beckett. The next order of business, once the paperwork had been signed, would be building a rail line from Austin to the site. In addition, the Capitol Syndicate had a large locomotive custom-built at the Baldwin Locomotive Works in Philadelphia to handle the job, a steam engine they fittingly named the *Lone Star*.

A still-visible drill mark at Convict Hill, where the limestone used in the capitol's foundation, basement and inner walls was quarried. *Photo by the author.*

On February 24, 1884, an excursion train packed with state

officials "and a large delegation of citizens of Austin" traveled from the depot downtown to the quarry site at Oatmanville. The *Austin Daily Statesman* said that the seven-mile trip took about an hour, likely because the cars had to be switched from the International and Great Northern Railroad tracks to the spur that had been extended to the quarry.

"At the [quarry] there was abundant evidence of good work," the newspaper reported. "Men and machinery were both at work getting out and shaping large boulders of stone, several hundred of which have been finished ready for the construction of the State Capitol."

When enough rock had been extracted from the hill, laborers ripped up the railroad tracks connecting the quarry with Austin. The seven saloons that had helped slake the thirst of the non-inmate quarry workers noticed a decided decline in business, and Oatmanville resumed its status as a sleepy little rural community until Austin began sprawling in its direction in the 1970s. Meanwhile, with the passage of time, what had been an industrial operation all about extracting cheap natural resources with the use of convict labor began to be romanticized.

With interest in history enjoying a brief spike due to the approaching U.S. bicentennial, in the mid-1970s, a writer for *Free & Easy*, a long-defunct throwaway tabloid published in Austin, interviewed Josephine McCullough, granddaughter of the original landowner. She had no specifics on convicts shot while trying to escape but did confirm that some of the inmates had died during an influenza outbreak.[11]

"Nobody in my family ever talked about dangerous criminals living in the community," she said. "Nobody talked about how they were treated cruelly. It sounds real bad when you say there wasn't a doctor on the grounds, but the fact was there wasn't a doctor in Oak Hill at all, then."

In 2014, a blogger with an interest in Oak Hill history interviewed retired county employee James Wier about the history of the area. As a youngster, he had heard stories about the quarry from Oak Hill old-timers.

Later owned by Buster Thomas and Skeeter Hudson, the quarry continued in operation into the early 1960s. By then, the city of Austin was slowly growing in the direction of Oak Hill, a process that picked up momentum with each decade. As late as the early 1980s, however, two distinct piles of stones left over from the capitol quarrying operation remained atop the hill. Local lore had it that the rock cairns marked the hasty burial sites of convicts who died at the quarry a century before. Where there are graves, even if they never existed, soon there arise ghost stories. With house foundations about to be poured on the spot in 1985, developer Nash Phillips/Copus Inc. paid for

an archaeological survey to determine if there really were graves on the hill, improbable as it seemed that even prisoners would simply be buried under a pile of rocks. The study revealed that the cairns had once supported an array of wooden derricks used to lift stone from the quarry. Chemical analysis of soil samples taken from under the stone features proved no human remains existed at either spot. There were no graves.

"There was a cave there where the prisoners stayed at night," Wier said. "They had wooden bunk beds and straw mattresses. There was a big iron ring embedded in the wall and at night when the prisoners went to bed, the bosses would run a chain through all their leg irons and attached them to the ring in the wall, so they couldn't get out of bed at night and escape."

That recollection is a good example of how the passage of time can morph a physical feature into something it never was. The "cave" actually was man-made and had nothing to do with accommodating prisoners at night. (They slept in tents.) Two large pieces of cut flat rock had been propped up to cover a limestone overhang, with a gap in the middle for a strong door. A thick layer of dirt had then been piled outside the rocks. Inside the roughly eight-by ten-foot structure, quarry operators kept blasting powder and related explosive equipment.

"I used to play there when I was young," Josephine McCullough said. "People used to say convicts were kept there at night but it was just a powder shed." When the highway that developed into US 290 was put through Oak Hill in the early 1930s, the highway department bulldozed the "cave."

More accurate than the cave story is Wier's passed-along recollection that the prisoners used a water trough fifteen feet long, four feet wide and six feet deep both for bathing and washing their black-striped cotton prison clothes once a week. "The prisoners would go in on one end and they would be handed a bar of lye soap and they would take a bath and wash their clothes at the same time, before coming out on the other end," he said. "At the end, they would put their clothes back on."

While their guards apparently figured the prisoners could get by with only one bath a week whether they wanted it or not, the convicts did get three meals a day. But they did not have to waste time trying to decide what they would like to eat. Their menu of salt pork, cornbread and coffee did not vary. McCullough said that due to an economic recession at the time, those convicts ate better than some local families did.

Wier, friends with one of the landowners, got to spend some time poking around atop Convict Hill as work began on the residential development that covers the hill today. "Digging around through the rocks, rubble

What remains of Convict Hill as seen from an abandoned roadside park on US 290 in Oak Hill. *Photo by the author.*

and all," he recalled, "we found [various] things." Among artifacts likely associated with the capitol project were several old oil-burning lanterns or parts, empty twenty-five-pound black powder cans and part of a metal wheelbarrow wheel.

But by then, most evidence of the large-scale operation was long gone. As the *Oak Hill Gazette* put it, "Nature and looters reclaimed whatever was left after operations finally shut down....All that remains now is a sinkhole and two iron bars driven into the ground, where prisoners were tied up at night." (The bars served some industrial purpose, not to restrain convicts.)

In 1971, when Oak Hill still lay outside the city limits, longtime Austin businessman Ralph Moreland opened a restaurant on the north side of

US 290 he named Convict Hill. The eatery was built around an ancient oak tree, beneath which was a section of railroad tracks and an old cart, presumably dating from the days of the capitol construction. Framed blowups of old photographs showing the quarry in operation, along with assorted rusty artifacts found on the hill, decorated the interior walls. A popular venue offering steaks and seafood, Convict Hill Restaurant stayed in business until 1992, when it was torn down to make way for future highway expansion.

LAST ROUNDUP AT THE XIT

The story of the legendary XIT Ranch, its long-abandoned first headquarters at Buffalo Springs some six hundred miles northwest of Austin, is entirely different from that of the capitol except for one thing: neither the ranch nor the capitol would have been possible without the other, at least not in the period that each came into being.

In 1885, when the newly organized Capitol Freehold Land and Investment Company (created by the Capitol Syndicate to allow for a much-needed infusion of cash from British investors) began its effort to make money off the three million acres the state had agreed to exchange for building Texas a new statehouse, the ranching industry and the far-from-finished capitol had yet to acquire their romanticized images. The new ranch in the Panhandle, though notable for its size, simply amounted to a business operation. Downstate, the capitol was just a large government building still under construction.

Cowboys employed by the largely offshore-funded Chicago businessmen building the capitol took more interest in their wages, the availability of good grub and the ranch's relative proximity to the saloons, gambling dens and easy women in the wide-open little town of Tascosa than in the fact they were working on land the state had leveraged to pay for its new statehouse. All the complicated legislative and contractual legalese (not to mention the wheeling and dealing that scholars are still struggling to untangle) that made the ranch and the capitol possible was beyond the easy understanding of most of the ranch's boots-in-the-saddle workforce—assuming they even cared. In fact, from the time the first cattle went to pasture on the ranch, a

half century would pass before any sense of connection to the capitol began to develop on the part of the XIT's aging former hands.[12] The occasion was what amounted to the XIT's last roundup, an annual reunion of former hands first held in 1936.

When the Dallham and Hartley County town of Dalhart hosted the third annual XIT reunion in the summer of 1938, scores of men who had worked on the ranch before its owners broke it up and started selling it off in 1912 came by train and automobile to talk about the good old days. Only then, treated as VIPs and eagerly sought out by reporters for stories about the by then fabled ranch, did it begin to sink in for most of the old-timers that they had been a part of something much bigger than the world's largest ranch. Now they realized that they had worked on the ranch that essentially paid for that giant red granite building that Texans liked to brag about so much. The old cowboys didn't always agree with the laws that came out of that capitol, but by golly, they could tell their grandkids that they'd had a hand, however indirectly, in putting it up.

Of all the old cowboys who came to Dalhart for the reunion every year they could, none better personified the tie between Austin and the XIT than Ab Blocker. As a youngster, he had seen the old limestone capitol many times. He knew it had burned in 1881, and when family or business necessitated that he come to town, he noted the slow progress on the new capitol. Now, decades later, he had come to understand the effect Austin had on the sprawling Panhandle ranch and vice versa.[13] In at least a symbolic way, he had been the one who brought the two together.

Abner Pickens Blocker was born "of cultured parents" (as talespinner J. Frank Dobie later described them) on his family's ranch three miles south of Austin on January 30, 1856. He later related to an all-ears young reporter the family story that a herd of cattle had been milling around their ranch house the day he came into the world and his older brother John Rufus had been "toddling around the place playing cowboy" as the family grew by one.

Blocker worked on his family's place until he was twenty, when he joined elder brothers John and William on a ranch they had started in Blanco County. A year later, in 1877, he made his first trail drive, herding three thousand steers from Central Texas to a ranch in Wyoming. Soon the Blockers moved farther west, with the 1880 federal census showing Blocker and his four brothers living in Runnels County. As for their occupation, the enumerator wrote by each name, "works with cattle."

Sticking with that occupation for most of the rest of his life, Blocker got pretty good at it. He later claimed, and no one questioned it, that he had

"looked down the backs of more cows" and "drunk water out of more cow tracks" than any other fellow who "ever pointed a herd towards the North Star."

Reporters in Dalhart corralled the eighty-two-year-old Blocker when he hit town for that year's reunion on August 5, 1938. "Straight and sturdy with his twinkling eyes undimmed by the years," the *Dalhart Texan* said, "Blocker chuckled as he recalled his first entrance into this territory 53 years ago."

In the early summer of 1885, only three months after the laying of the capitol's cornerstone in Austin, the new ranching operation—so far only known as the Capitol Reservation—began buying livestock to be herded from South and West Texas to the vast Panhandle holdings. Among the sellers was John Blocker. Little brother Ab gathered 2,500 head of cows and calves from his brother's ranch in Tom Green County and drove them north toward the grass-covered high plains. By July, Blocker and his hands had the cattle up on the Caprock and moving toward the ranch's new headquarters at Buffalo Springs, thirty-five miles north of what would later become Dalhart.

Less than a day away, Blocker and his men bedded the cattle down for their last night on the trail. At some point, Blocker learned that another herd headed for the new ranch was ahead of him. He knew who the trail boss was.

"Boys," he said, "Joe Collins is ahead of us with his herd. We're going to drive tonight."

Intent on being the drover to deliver the first herd to the new ranch, Blocker waited until the moon came up and started moving his cattle. By losing some sleep, he gained the distinction he wanted. They arrived shortly after sunup. B.H. "Barbecue" Campbell, a Kansas cattleman imported by the Syndicate to manage the new ranch, rode out to meet the herd.

"I'm Ab Blocker," the trail boss said. "Here's your cows."

Blocker's arrival caught Campbell by surprise. He had been expecting Collins's herd, coming up from George West in South Texas, to arrive before the cattle the company had ordered from Tom Green County. No matter the order in which the herds got there, the next piece of business was getting the cattle branded. But the ranch did not yet have a brand.

Years later, Blocker told a reporter with the *Pampa News* what happened next:

"Barbecue wanted to use three letters and he wanted a brand a rustler couldn't blot. He had drawn a lot of designs with his boot in the dust. I started drawing in the dust with my boot heel. For some reason I happened to draw XIT.

THE CAPITOL FREEHOLD LAND & IN-
VESTMENT CO.

O. C. CATO, Foreman.
Principal office 148 Market St. Chicago, Ill.
P. O. address
Miles City, Mont.
Range: Head of
Red Water, Cedar,
Cherry, and Custer
creeks, Dawson
and Custer Cos.
Horse brand X I T
on right thigh.

The XIT brand designed by Ab Blocker became a Texas icon. *Author's collection.*

"'How's that, Barbecue?' I asked, and he said, 'Get to branding them cows.'"
Which is what Blocker did.

"I had one of the hands to open the corral gate and let a cow loose," he recalled. "I roped her and dragged [her] to the fire we had built. Then I socked on the brand. After I branded about twenty head Barbecue stopped me and told me he didn't like my work, that I couldn't brand cows for him. That suited me. We left."

As for the soon-to-be-famous brand, Blocker continued: "There was absolutely no reason for my drawing an XIT.…It was just a brand that could be put on with an iron that had only one bar. The brand could be blotted out, of course. So could any brand that was ever created."

Since the ranch, which extended more than two hundred miles north to south and roughly thirty miles wide, covered parts of ten Panhandle counties, the legend arose that XIT stood for "Ten in Texas." But Blocker scoffed at that. "It didn't mean ten counties in Texas or anything else," he told the reporter for the Pampa newspaper.

While working on the XIT was just a job for its cowboys, anytime the ranch's general manager or any of his division foremen got a letter from the Capitol Freehold Land and Investment Company's Chicago or London offices—which was not infrequently given the firm's hands-on management style—they got a visual reminder of the enterprise's unique purpose: the firm's imposing letterhead prominently featured an engraving of what the

capitol would look like when completed. To the lower left beneath the image was the short declaration: "Owners of X.I.T. RANCH, Panhandle, Texas."

At its peak, enclosed by six thousand miles of fence, the giant ranch had 150,000 head of cattle, 1,500 horses and 150 cowboys. But the XIT was never financially successful, and the Chicagoans only began to profit from their investment when they sold off the ranch in parcels. Still, the XIT had a tremendous effect on the Texas Panhandle.

In January 1888, the new statehouse nearly complete, a reporter for the *Waco Examiner* interviewed a "Mr. Calhoun, a traveling representative of the *Fort Worth Gazette*" shortly after he returned from a trip to the High Plains. He declared: "I consider the exchange of that 3,000,000 million acres of land for the magnificent capitol building now going up in Austin the best piece of legislation ever enacted in Texas, in that it has advanced the development of that country [the Panhandle] at least a quarter of a century."

As for Blocker, he would push multiple thousands of Texas longhorns to buyers in Wyoming, Montana, Colorado, Kansas and Oklahoma before making his last trail drive in 1893 to Deadwood, South Dakota. While trains

The sprawling XIT never made its owners any significant money until they broke it up and sold it off. *Library of Congress.*

and trucks eventually changed the way cattlemen moved livestock to market, Blocker continued to work cattle on his family's South Texas ranch until he could no longer sit a horse. Never interested in owning land or livestock, his life revolved around cattle and horses. He never drove a car or went up in an airplane and had no desire to. He did enjoy regaling people with stories of the old days, especially when sipping a little good bourbon.

The old trail driver died at a relative's house in San Antonio on August 9, 1943, at the age of eighty-seven. Honoring his wishes, his family buried him with his old high-topped boots on, his favorite silver spurs still strapped on the heels.

THE CAPITOL THEY NEVER BUILT

The capitol, magnificent as it turned out, stands as a literally rock-solid example of the often vast difference between what we envision and what we eventually end up with.

One notable for-instance is that the original plan for the capitol called for the building to be topped by a square Baroque tower with a mansard roof. Fortunately for aesthetics, on the recommendation of the consultant who reviewed all the proposed plans, Detroit architect Elijah E. Myers agreed to alter his design and crown the building with a round dome more like the one atop the U.S. Capitol. It would be slightly taller, of course.

When the state advertised for design proposals in 1880, Myers had been one of eight architects (including one woman) submitting eleven architectural drawings. (Some of the architects presented more than one drawing.) Of the contenders, Myers had the most experience and landed the $12,000 contract to draw the plans for the Texas Capitol. He had designed a roughly similar, if somewhat smaller, capitol for Michigan and would later draw plans for a domed capitol for Colorado.[14]

Wisely, as it turned out, the state hired New York architect Napoleon LeBrun to travel to Austin, select the best plan from those submitted and suggest any needed changes. After recommending Myers's proposal, in addition to urging that the envisioned square tower be nixed, LeBrun suggested changes to the rotunda, thickening interior walls and tweaking the building's proportions. He also proposed adding two water-powered hydraulic elevators. Myers agreed to the changes, though only one elevator ended up being installed.

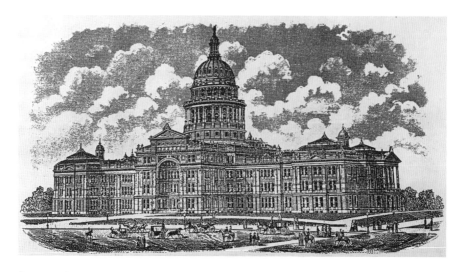

An engraving of original architectural rendering of the capitol by Detroit architect Elijah E. Myers. *Author's collection.*

"Architecture is an index of the civilization of all ages," the capitol board declared in its January 1, 1883 report. "The design which has been secured for the Texas State Capitol, combining as it does, all the essential elements of proportion, dignity, size, adaptability, and modern improvement, is believed to be a fair reflex of the enlightenment of our age."

As it developed, the biggest difference between the capitol as planned by Myers versus the one Texas ended up with had to do with its exterior. Original specifications called for the building to be constructed with limestone, not granite. Following a statewide search, the capitol board and the contractor had decided to quarry limestone near Oatmanville in Travis County since it was close, plentiful and seemed of good quality.

But when the first load of stone arrived at the construction site, newly hired capitol board building superintendent R.K. Walker (the third person to hold the job) rejected it for use on the building's exterior. It would be fine for the basement and interior walls, but the huge white blocks of stone contained pyrite, which over time rusts and causes unsightly stains. Virtually indestructible granite seemed the obvious better choice. That marked the beginning of a complicated period of option-weighing, negotiation and behind-the-scenes maneuvering on the part of state officials and contractor Abner Taylor.

For a time, however, it looked like a better grade of limestone from Bedford, Indiana, would be selected. When word of that got out, Texans

didn't like it. "We ought to have the very best of material in the capitol," the *Fort Worth Gazette* opined, "but it looks strange that out of an area of 374,000 square miles we cannot find stone enough without going to Indiana for it."

Burnet County rancher George Washington Lacy proposed another remedy: he would gladly donate as much granite off his land as the contractor needed. While few would disagree that granite looked better than limestone, Taylor estimated that using the stronger igneous rock would cost an additional $613,865, primarily in transportation and labor. Of course, he had also said that limestone from Indiana would end up costing more than his syndicate had planned to spend.

Lacy's offer, however, was not as out of the blue as some tellers of the capitol story have suggested. Subcontractor Gus Wilke had already received granite from Lacy and his partners for use in laying the structure's water table. The term "water table" looks strange to the modern eye, but it's how the builders referred to the granite base Wilke's workers had set down to prevent water seepage into the limestone foundation that would rise on top of it.

Meanwhile, as the *Chicago Inter Ocean* noted on June 26, 1885: "Indiana feels as independent as a boy with his pocket full of rocks during the blackbird season. She proposes to furnish the stone for the State Capitol of Texas. The job in itself is not a small one, but the big feather in the Hoosier cap is that her stone quarries are pronounced equal to the best in the land."

While the capitol board, eager to see the construction project get off high center, favored the out-of-state limestone, newly sworn governor John Ireland did not. Besides, the existing contract stipulated the use of Texas stone. On top of that, the granite had been offered to the state for free. The governor, the public and the press did not seem at all bothered by the fact that Nimrod L. Norton of Salado, one of the capitol commissioners, had an interest in the Marble Falls property that had the granite on it. While the granite would not cost the state anything, Norton and Lacy realized that the area would benefit enormously from the construction of a rail line from the county seat of Burnet to the quarry. Also, a stonework shop would be set up at Burnet if the deal went through.

"If the press of Texas is a mirror of popular sentiment," the *Galveston News* observed as the debate continued, "Indiana stone will not receive a generous welcome for use in the state capitol. There is a good deal of sentiment in Texas, and sentiment, by the way, even when mistaken, is a bad thing to buck against."

Indeed, pressure from the governor and the general public finally swayed the capitol commissioners. That said, University of North Texas history

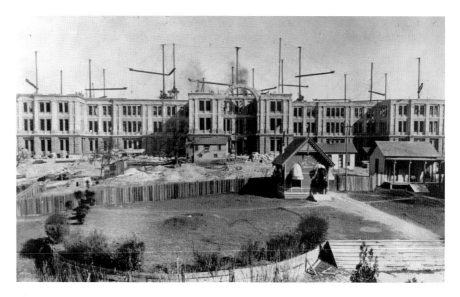

The capitol under construction sans dome. *Author's collection.*

faculty member Mick Miller suggested in his 2010 master's thesis on the capitol that Taylor might have been using the limestone versus granite issue as leverage in his effort to get the state to release a major portion of the promised Panhandle lands. The syndicate needed to start making money off that distant real estate.

"It has at last been decided to build the capitol of Burnet granite," the *San Marcos Free Press* reported on July 23, 1885. "All the [capitol] board voted for it except [Treasurer Francis] Lubbock. Col. Taylor is allowed an extension of two years, which will make the capitol contract expire in 1890."

Taylor had finally agreed to use granite provided that "the state furnish me…such a number of convicts as I may require not to exceed 1,000, I to board, clothe and guard them." Using prisoners instead of hired laborers would cause additional problems, but Texas ended up with a far more attractive and lasting capitol.

Given the higher costs involved, even with the convict labor, changing the exterior specifications from limestone to granite led to yet another alteration: to lower costs, planned elaborate porticos on the east and west wings of the building would have to be eliminated. The Corinthian capitals topping the column Myers had envisioned would be replaced with the less ornate Doric style. Other changes, including a switch to a copper roof instead of one made of slate, were approved.

The capitol not only looks different from what had been planned, but in one sense, it's also not even the building Texans thought they had. During the extensive renovation set into motion by the February 6, 1983 capitol fire, architects discovered something about the building that didn't add up, namely its measurements. Not to say that anything inside the capitol is crooked, but nothing in the eighteen-acre building is totally plumb. In fact, some of the column spacing is off as much as six inches. The reason, of course, is that the building went up when craftsmen built things by hand, doing their own measuring.

Still, minor variances in measurement are not noticeable to the naked eye, the difference in no way as jarring as exterior limestone would be compared with red granite. As the *Austin Daily Statesman* editorialized during the construction: "The man who can look at the beautiful granite walls of the new capitol, now going up and regret that the change was made to that stone, should be kicked out of Texas."

When the capitol opened to the public in April 1888, a publication called the *Texas Review* put the limestone versus granite issue into perspective:

"The 'Indiana Limestone Question' threatened at one time to array the Press and the People against the members [of the capitol board] who voted to accept the foreign rock for the Texas Capitol. It is hoped that the Board has secured the erection of a stable and grand building, that will last until a new race will muse over ruins, and ponder at the little world of land that, under a former administration, was bartered for its fabled splendor."

FORTUNATELY, W.C. WALSH PAID ATTENTION IN MATH CLASS

From his office in the 1857-vintage general land office building, land commissioner W.C. Walsh had been watching the construction of the new capitol since the low-key tossing of the ceremonial first shovel of dirt on February 1, 1882. Not only did he have a front-row seat to the biggest construction job to that point in Texas history, but Walsh also had an official reason to follow the building's progress: he sat on the capitol board, the state entity overseeing the project.

By the spring of 1887, the red granite, Greek cross–shaped functional portion of the future statehouse had been completed. Soon, work would begin on the towering dome that would give the giant four-story government building (the east and west wings are only three stories) its distinctive silhouette. When finished, the Texas Capitol would—except for its color—resemble the U.S. Capitol. Naturally, members of the capitol board and other prideful Texans believed it would look even nicer.

Born in Dayton, Ohio, on the eve of the Texas Revolution in 1836, Walsh came to Texas with his family when only four. They settled in Austin on New Year's Day 1840, when all the capital amounted to was an assortment of log cabins lining a broad thoroughfare called Congress Avenue. Following his graduation from Georgetown University in Washington, he returned to Texas and went to work as a clerk in the land office. Walsh stayed there until the beginning of the Civil War, when he signed up to fight for the Confederacy. Wounded three times, he survived the conflict even though he carried a Yankee Minié ball in his hip and had to use a crutch for the

rest of his life. Back in Austin, he farmed and ran a rock quarry near Barton Springs until 1873, when he became chief clerk of the House of Representatives. Five years later, Governor R.B. Hubbard appointed him to fill the unexpired term of land commissioner J.J. Gross, who had died in office. Elected to a full term in November 1878, Walsh would serve until 1887.

With the new capitol slowly taking shape, as a member of the body charged with making all the spot decisions that come up during such a large-scale venture, so grew Walsh's layman's knowledge of architecture. Now, with construction about to begin on the dome, Walsh became increasingly uneasy.

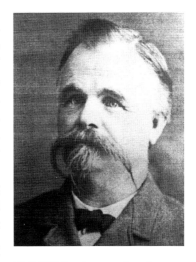

W.C. Walsh, who served on the capitol board, worried that the originally planned dome support would not work. He was right, and the plans got changed. *Courtesy of Texas General Land Office.*

"The plans," Walsh later wrote, "called for a dome of brick, the lower thickness of the walls to be five feet and diminishing gradually to the foot of the lantern."

Rereading the specifications, the land commissioner figured the weight of the brick, added the weight of the substructure and went to bed not liking the number he got: 2.25 million pounds. Assuming he had made a mistake, the next night he went over his calculations and got the same result.

"The weight shown not only wiped out the 'factor of safety' but exceeded the theoretical resistance of the foundation," he wrote. Simply put, the capitol as planned would not support a brick dome. At some point, either during construction or over the course of time, the building's distinctive top likely would come crashing down and possibly take much of the rest of the building with it, not to mention those who happened to be inside when it happened.

Walsh tore up his calculations and burned the scraps. "As far as I could, [I] dismissed the question from my mind for ten days," he continued. But then, still troubled, he ran the numbers again, coming to the same catastrophe-portending figure. This time he submitted the numbers to someone else, who reached the same conclusion.

"I then hunted up [Gus] Wilke, the building contractor, and broached the subject," Walsh wrote. "He told me the question had been worrying him for months, and he wished I could get some action by the Board."

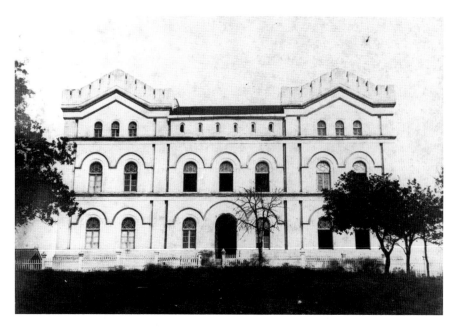

Walsh watched the new capitol go up from his office in the 1857 Land Office Building. The building now houses the capitol visitors' center. *Author's collection.*

Walsh did just that, but the timing was bad. All the state officials who sat on the board, including Walsh, were about to leave office. Only the state treasurer would be retaining his seat.

"The general thought was that the outgoing Board had brought the building through troubles and discouragement to its practical completion, and it was now too late for the retiring board to take up the question—besides the new Board ought to have something to worry over," Walsh wrote.

Soon a private citizen, Walsh remained concerned. When the new board took no action on the dome issue after its second meeting, Walsh broached the matter with the new governor, former Texas Ranger Sul Ross. The governor asked Walsh to submit his concerns in writing and shrewdly asked if he minded the document being made public. The former land commissioner said he had no problem with that, and soon his belief that the blueprints for the new capitol contained a potentially disastrous design flaw hit the state's major newspapers.

When that happened, Ross appointed a panel of Texas and Louisiana architects to study the dome issue and prepare a report on the matter. "After thorough study [the architects] reported to the Governor that my contention

The capitol's dome under construction. *Author's collection.*

was correct, that the existing plan was dangerous, and recommended the substitution of steel plates for the brick, above the walls."

A new plan for the dome in place, the state again turned to convict labor to save money. The East Texas State Penitentiary (now the Rusk State Hospital) had a foundry where inmates produced cast- and wrought-iron products from iron ore relatively plentiful in that part of the state. Iron produced by prisoners went into the dome and elsewhere throughout the building.[15]

Disaster likely averted, Walsh still did not feel totally satisfied. He sent capitol architect Elijah E. Myers a copy of the report on the dome, asking for "at least a personal explanation." Myers's secretary replied that his boss was in ill health and unable to answer Walsh. (For his general unresponsiveness and other reasons, the capitol board eventually forced the architect's resignation.)

"The only theory I could ever work out was that the upper dome was planned on the theory that the walls supporting it were treated in the estimate as solid, while in fact from basement to top story they were opened on four sides by immense arches," Walsh wrote. "The mystery will never be solved."[16]

A principled man, at some point after Walsh left his post at the general land office and on the capitol board, the Capitol Syndicate tried to hire him.

"He was offered two and one-half times…his salary as Land Commissioner to manage the holdings of the company that built the Capitol and received 3,000,000 acres in payment but he declined," reads an undated typewritten sketch of Walsh's life in the files of the general land office. His reasoning, the four-page document holds, was that someone might conclude "on account of offers made to him by the contractors, he might have neglected his duty to the State in requiring them to fulfill their every obligation in the erection of the Capitol."

By the time Walsh died on August 30, 1924, the ironclad capitol dome had stood for more than a quarter century, and it remains structurally sound well into the twenty-first century.

"A FIGHT ON WILKE IS A FIGHT ON ME"

It's logical to assume Gus Wilke subscribed to the *Chicago Tribune* to keep up with the news back home while working on the capitol, but if he did not get the paper, surely one of his friends or associates mailed him a clipping from its February 9, 1888 edition.

"The New Texas Capitol…One of the Finest State-House Buildings in the World," began the one-column, three-layer headline topping a long article labeled as "Special" from Austin. The final deck of bold type preceding the article concluded: "Constructed by a Chicago Syndicate, the Compensation Being a Tract of Land in the Lone Star State as Large as Connecticut and Comprising 3,000,000 Acres of Land—The Edifice Has Cost $4,000,000—It Will Be Dedicated in May with Imposing Ceremonies."

All that was correct except for the price, which had been rounded up a bit, but the story had one glaring omission, at least to any reader who knew anything about what had been going on in downtown Austin for the last six-plus years. Nowhere did the dispatch from Texas mention the name of the man who had overseen its construction. Nor did the name "Wilke" appear in any of the stories published in the Chicago newspapers following the dedication of the capitol.

While nineteenth-century newspapers competed vigorously, their daily or weekly products ranging from staid to sensational, the sheets of the day—though definitely not devoid of opinion—tended to focus on the classic "who, what, when, where, why, and how." Personality profiles of newsmakers were not common. In fact, while a search of a large online database of digitized

newspapers reveals numerous references to Wilke during the capitol construction project, none of the stories deals with Wilke the man.

So, later-day historians, barring discovery of an introspective diary that would be out of character given what is known about him, are left to speculate how he must have felt about receiving virtually no credit for the giant granite statehouse he steered to completion. He might have felt slighted, or maybe he got all the self-satisfaction he wanted by merely looking up at the monumental building that had gone up under his direction.

Having spent the first fifteen years of his life in his native village of Ludershaden near the coastal city of Stralsund in what is now Mecklenburg-Vorpommern, Germany, Wilke may well have possessed a stereotypical Germanic no-nonsense, industrious nature. That would fit with the fact that he does not seem to have sought publicity for his accomplishments. Born Gustav Wilke on October 1, 1853, he arrived in New York with his parents on July 21, 1868. Within a year, the family had moved to Chicago. While still in Germany, the young Wilke had been schooled in the building trade, and once in the United States, he quickly learned to speak and write English. As a young man, he worked for his father's construction company, which saw brisk business following the devastating 1871 Chicago fire. Nine years later, in what might have been their last project together, father and son oversaw construction of the museum building at the University of Michigan at Ann Arbor.

Wilke's connection with the Texas Capitol project began in the summer of 1882, when fellow Chicagoan Abner Taylor selected him as subcontractor for the massive building's foundation and basement. Soon, the swarthy, mustachioed Wilke arrived in Austin for a construction project he assumed would only last a couple years. The job took more than expected, in more ways than one. On July 9, 1884, while supervising the unloading of a huge piece of limestone, a link of chain slipped and, as the *Austin Statesman* reported, smashed a portion of Wilke's forefinger, middle finger and right hand into "a perfect jelly." A doctor had to amputate the subcontractor's forefinger.

Clearly, thirty-one-year-old Wilke did not spend his work hours sitting around the construction office. He did, however, find time to patronize Brown's Saloon, at least until he got a letter from Taylor instructing him to stay out of it. In his defense, the German immigrant grew up in a culture where most saw beer as a necessity equal to water. Another clue to Wilke's character is the way he handled the laying of the cornerstone. The event, which would include a parade, prayer, speeches and a Masonic leveling

Capitol construction office. Contractor Gus Wilke stands second from right. *Author's collection.*

ritual, was set for March 2, 1885—the forty-ninth anniversary of Texas's independence from Mexico. Confident the final decision would be made to use granite instead of limestone for the building's exterior, Wilke ordered an eighteen-thousand-pound hunk of granite from Marble Falls. When the state declined to pay for the stone's quarrying and transportation by wagon and train to Austin, not to mention its cutting, dressing, polishing and engraving, Wilke covered the cost out of his own pocket. The bill came to $1,545.

Taylor and the capitol board liked the work that Wilke had done on the foundation and basement. When Taylor returned to Chicago to take care of some personal issues, he awarded Wilke the subcontract for the rest of the job, a $2.3 million deal. (Wilke's total compensation came to $362,000.) Clearly, Taylor had the upmost regard for his builder. "I shall stand by [Wilke] and a fight on him is a fight on me," he said in a letter to the capitol architect. Once the limestone-granite issue was resolved in July 1885, Wilke resumed work on the capitol in earnest early the following year. To make faster progress, he had electric lights strung up around the job site so work could continue at night.

Wilke seems to have had a good sense for public relations. With the rail line completed to the granite quarry, the contractor put together an excursion to the site in the summer of 1886. The capitol board and other state and local dignitaries enjoyed what the *Austin Statesman* termed "a splendid dinner" and noted, "Mr. Wilke is a prince of an entertainer."

One person not so sold on Wilke was the mostly absentee capitol architect. In 1885, Myers had written the capitol board to suggest that it "should place itself upon record as determining whether Mr. Wilke or the writer is the architect of the capitol." Wilke was not an architect, and

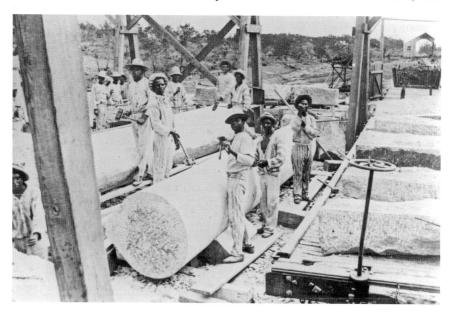

It took four thousand rail cars of granite quarried in Burnet County to build the capitol. *Author's collection.*

by early 1886, neither was Myers the capitol architect. Fed up with his reluctance to come to Austin and slow response to requested tasks, the board effectively fired him.

As the man ramrodding the capitol job, Wilke took most of the heat when controversy arose. His use of convict labor to remove the granite from the quarry in Burnet County led to a costly dispute with the International Association of Granite Cutters. When the union (referring to the contractor as "Great-I-Am-Gus" Wilke) voted to boycott the capitol job, Wilke responded by hiring nonunion stonecutters from Scotland. That violated a recently passed federal law prohibiting importation of alien labor, and charges were filed in federal district court in Austin against Wilke and Taylor. But that didn't stop the work.

By early 1888, the building stood mostly complete. In mid-April, the capitol commissioners reported to the governor that the "solid, substantial, magnificent and imposing State House was now ready for a thorough inspection." In early May, state officials gave the building a walk-through and noted certain interior elements still needing completion. Wilke said he would take care of them in time for the May 16 dedication ceremonies, and he got it done.

Referring to complaints about the copper roof (he had opposed using copper but got overruled), he offered to cover the costs of the repairs. In a letter to the capitol board, he wrote: "[N]o matter how it [the roof] got there, it will not be a credit to have built this magnificent building, spending six of the best years of my life in the undertaking. I cannot afford to have anything seriously wrong with this building."

Meanwhile, with the dedication only a few weeks away, an Austin newspaper editor plotted an extortion scheme targeting Wilke. M.C. Harris of the *Austin Evening Dispatch* threatened to run a long article detailing alleged deficiencies in the new capitol. He had already published several of what Wilke termed "scurrilous attacks against the construction of the new state capitol." Either Harris or a surrogate made it known to Wilke that the whole issue could go away with a large payment to Harris, a combination of cash and real estate.

When Wilke refused to be shaken down by Harris, the *Dispatch* came out with a lengthy screed on April 30, even reporting that Wilke had tried to bribe the editor. Instead of going after Harris with fists or gun, as many a lesser man might have done, Wilke confronted him publicly in print with a long letter published in the city's mainstream paper, the *Austin Statesman*. In the letter, the subcontractor exposed what Harris had been trying to do.

Elsewhere in the same issue the *Statesman* declared the accusations against Wilke baseless, and the contractor survived the experience with his reputation intact. However, as the *Galveston News* reported, the *Dispatch* piece and Wilke's rebuttal created "a great sensation." Even so, the matter disappeared from the public prints after May 3. One article did refer to Harris as the "late editor" of the *Dispatch*, so he might have been fired. Whether authorities pursued a criminal case against Harris has not been determined.

After the dedication celebration, Wilke completed his punch-list work, and the state formally accepted the structure in December 1888. By that time, the contractor already had another job underway, building a new depot in Austin for the International and Great Northern Railroad. That project finished, he and the syndicate's other key players landed a contract to build the granite jetties extending into the Gulf of Mexico from the mouth of the Brazos River. Wilke moved to the old town of Quintana in Brazoria County to oversee the project.

The Brazos job complete, Wilke and his wife returned to Chicago in 1890. Having become wealthy in Texas, he built them a two-story mansion on Wrightwood Avenue in the city's Lake View district, so named because many of the elegant houses in that neighborhood looked out on Lake Michigan. Wilke built the house with granite that legend holds came from Texas.

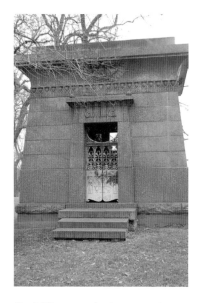

Gus Wilke supervised construction of his mausoleum on Chicago's north side nineteen years before his death. According to legend, it is built of the same red granite used in the Texas statehouse he built. *Author's collection.*

The federal case against Wilke stemming from the hiring of the Scottish stonecutters dragged on until 1893, when Wilke ended up paying an $8,000 fine and court costs. It could have been a costlier matter. Initially, Taylor had also been charged, but the counts against him were dismissed. At the same hearing in Austin, Wilke, having waived jury trial, was assessed a $1,000 fine for each foreign stonecutter he had hired. Though most reports say sixty-two Scots came to Texas, Wilke had been found guilty on sixty-four counts.

By 1896, the forty-three-year-old Wilke had accomplished much since leaving Texas a rich man, and he would be

putting up more notable structures, but in an era when the average male life expectancy in the United States was only forty-seven, he must have begun to ponder his mortality. That year, he did what future generations, thanks to twentieth-century funeral industry marketing efforts, would label "pre-planning." He bought property in Chicago's 119-acre Graceland Cemetery on the city's north side and oversaw construction of a mausoleum that when the time came would be the final resting place for him and his family. Again, the story is that he had sunset red granite from Marble Falls shipped to Chicago to build what some day would be his last address.

Ten years later, Wilke took care of another piece of unfinished business and became a naturalized U.S. citizen on March 24, 1906.

All the while, his contracting business continued to flourish. Though none of his later projects matched the scale of the Texas statehouse, he put up significant buildings in New York State (the Cullom Memorial Building at West Point, 1898), Indianapolis (the Traction Terminal Building, 1904), Memphis (the Memphis Trust Company, 1905), Denver (the Denver Public Library, 1907), Houston (the Scanlan Building, 1910), Davenport, Iowa (the Putnam Building, 1910) and Cincinnati (the Union Trust Building, 1915).

Wilke lived nearly another twenty years, dying in Chicago on April 24, 1915, at sixty-two. With Masonic rites, his fellow lodge members laid him to rest inside a Texas granite structure he had known would stand for centuries, just like the capitol he had built in Austin.

THE LOST SWORD

Somewhere there is a sword with quite a history.

The long steel blade could be rusting in an old trash dump, it could be hanging on someone's wall or it could be for sale at a gun show. No one knows, and most likely, no one ever will. What is known is that the sword's first owner lost it twice. And each occasion made him justifiably angry.

The sword, probably Civil War surplus, was issued in the mid-1880s to Captain Charles Vernon Terrell, second-in-command of Decatur's volunteer militia company, the Decatur Rifles.[17] In the spring of 1888, Terrell's company, along with other guard units from across the state, converged on Austin to participate in what were then known as "sham battles" and march in the parade following the May 16 dedication of the new capitol. That's when the twenty-seven-year-old officer got an unusual request, albeit one he couldn't very well turn down. State senator Temple Houston, son of the first president of the Republic of Texas, wanted to wear a sword as he led the parade. Not having one himself, he asked Terrell's commanding officer if he could borrow Terrell's sword.

Though not particularly keen on being the only sword-less captain in the Congress Avenue procession, as a junior officer and a gentleman, Terrell unbuckled the belt and scabbard that held his sword and handed it over to his company commander, Major Tully A. Fuller. The major outranked Terrell when they had uniforms on, but in civilian life, Tully was Terrell's friend and law partner. Fuller, in turn, took the sword to Senator Houston.

The Panhandle lawmaker, first elected to the legislature in 1884, had not chosen the Decatur militia company at random. Houston had met Fuller when the Decatur lawyer served in the House of Representatives. The two had worked closely together in defeating an effort to impeach a district judge from the High Plains. In the process, they became friends, so it was natural enough that Houston approached Fuller for the loan of a sword.

But the grand parade down Congress Avenue would come later in the day. The first order of business was the dedication, an event that began about 11:30 a.m. following a military review. Governor Sul Ross served as master of ceremonies, recognizing all the VIPs sitting at the capitol's south entrance. Following a prayer, the governor introduced Judge A.W. Terrell (of no direct relation

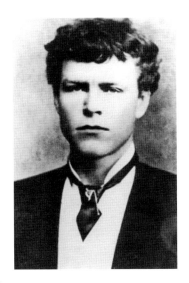

Temple Houston, Sam Houston's son, gave the keynote speech at the dedication of the new capitol on May 16, 1888. *Author's collection.*

to young C.V. Terrell). As a member of the Senate from 1876 to 1884, Terrell had been a key, if mostly behind-the-scenes, player in stewarding important legislation regarding the capitol. The judge, as the *Austin Statesman* reported, gave a "rather lengthy" talk covering "a great extent of history." The governor then introduced the man who gave the shortest—yet most impressive—speech of the day: capitol contractor Abner Taylor.

Modestly, Taylor revealed that he had been told he could choose someone else to speak if he did not care to address the crowd himself. That, he said, he had done.

"I have listened to the gifted speaker who has welcomed you here and shall listen to my distinguished friend [Temple Houston] from North Texas, but when all that has been said…on this occasion may have been forgotten and we have all passed away, the friend who speaks for me will still be here. When the ages have gone by, century upon century…the one who speaks for me will still be remembered."

Taylor then raised a hand to point at the capitol. "There stands my orator," he continued, as the gathered thousands applauded and cheered. "That magnificent building speaks for me, and nothing that I can say, or that any tongue can say, will add one word."

After Taylor formally handed the building over to the state, the governor introduced Sam Houston's sole surviving son. The senator, born across the street in the governor's mansion only twenty-four years before, may have been armed with a ceremonial sword, but he sure didn't use it to cut short his keynote speech.

"The greatest of states commissions me to say that she accepts this building, and henceforth it shall be the habitation of her government," Houston began. "When the title to the noblest edifice upon this hemisphere thus passes from the builder to Texas, reason ordains a brief reference to the deeds and times that eventuate in this occasion."

With proper modesty, Houston did not once mention his famous father in summarizing Texas's history to that point. But the solon's "brief reference" to "the deeds and times" ran to 3,200 words delivered with appropriate solemnity and at a measured pace respectful of the momentous occasion. In other words, his talk—which lasted thirty-five minutes—seemed to drone on forever. Not that Houston didn't get off a few prophetic lines:

The survivors of early struggles who view this building realize that all which they did was not in vain. The architecture of a civilization is its most endearing feature, and by this structure shall Texas transmit herself

The capitol, its walkway still barren of trees, not long after it opened. *Courtesy of Ken Wukasch.*

to posterity, for here science has done her utmost. All that enlightenment and art could do has been done.....Here glitters a structure that shall stand as a sentinel of eternity, to gaze upon passing ages, and, surviving, shall mourn as each separate star expires.

The invention of microphones, amplifiers and speakers still well into the future, many of those gathered in front of the statehouse that day could not hear what was being said. "Took in the capitol, and saw Terrell make his speech," one woman wrote in her diary of that day's events. She continued: "Though we were within 15 feet of the speaker we did not hear much on account of the vast multitude of people.... [I]t sounded something like about fifteen calliopes all at once, or a large herd of Texas steers or cowboys on a stampede. The speaker said something good every once and a while for those around him clapped their hands."[18]

Meanwhile, it had started to rain. The cliché about getting one's parade rained on had not yet been invented, but that's what happened that day. Not only did a heavy spring shower fall during the dedication ceremonies, but it also quickly became evident to the gathered dignitaries and honored guests that the roof of the brand-new capitol leaked. The event proceeded, despite the splat of falling water on the floor, but it left attorney general (and future governor) James Stephen Hogg quietly boiling with anger. Of course, the fact that last-minute construction changes to his new capitol office had done away with the heating radiators and a private urinal called for in the blueprints did not improve his mood.

After all the speechmaking and the long parade that followed, Captain Terrell and the other militiamen attended the final dedicatory event of the day: a grand ball in the mopped-up capitol rotunda. At some point, presumably later on the following day, he set out to retrieve his sword. To his chagrin and Houston's embarrassment, Terrell learned the honorable gentleman from North Texas no longer had the sword he had been loaned. He had lost it, Houston admitted.

Whether Terrell questioned the senator enough to learn that he had gone on a toot the night before or whether the young lawyer figured it out on his own based on Houston's obvious signs of a hangover, Terrell walked down Congress Avenue to check all the saloons. Sure enough, the militia officer found his military gear at a popular capital city watering hole to which Houston had retired following the formal festivities.

Meanwhile, as soon as he could, Attorney General Hogg exercised his authority to prevent final acceptance of the new capitol from the

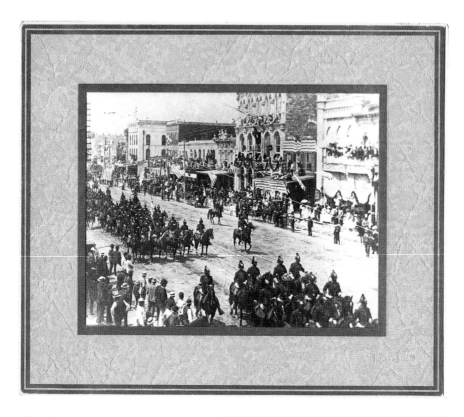

Above: Austin celebrated for a week following completion of the new capitol. This is the dedication parade on Congress Avenue. *Author's collection.*

Right: C.V. Terrell loaned his sword to Senator Temple Houston and almost didn't get it back. Later, he lost it again, and it's still missing. *Author's collection.*

contractors until the roof had been fixed and certain other punch-list items completed, including installation in his office of heating radiators and what back then was euphemistically referred to as a "water closet." The capitol's extensive cooper roof received the solder it needed to become watertight, and following completion of other construction fix-ups, the state formally took possession of the new capitol on December 8, 1888, six months after the gala dedication.

Back in North Texas, Terrell stayed in the Decatur militia company through the Spanish-American War, but he did not see service in Cuba. Though no longer a citizen-soldier, he kept the belt, scabbard and sword. After all, it had once been worn by the son of the man who assured Texas's independence from Mexico.

Terrell moved to Austin in 1921 during the administration of Governor Pat Neff to be sworn in as state treasurer. Now Terrell would be officing in the still grand building he had helped to dedicate thirty-three years earlier. In preparing for the move to the capital city, his wife, Etta May, came across the old sword. Having no idea of its historical value, she disposed of the saber without consulting her husband.

The judge had intended the long-obsolete sword to go on display in a museum someday, but this time, he had no luck in finding it. Just how his wife got rid of it was not reported when the ninety-two-year-old Terrell (he would live on for another six years) relayed the story to a young newspaper reporter in Austin in 1953. While that interview saved the tale for posterity, the sword worn by Sam Houston's son on the day of the capitol dedication remains missing.

14
WHAT ABOUT THE GROUNDS?

The day before the dedication of the state's new capitol, members of the Twentieth Legislature, then sitting in special session, realized they had forgotten something.

Sure, Texas had a glorious, red granite statehouse that stood as one of the largest public buildings in the world. In fact, someone had done some research and declared that only six government buildings anywhere on the globe were bigger. (No one seems to have kept the list naming the six larger buildings.) But the grounds around the new capitol looked drab in comparison, offering no reason for pride. It was too late to do anything before the dedication, but the lawmakers voted to hire a civil engineer to see to it that the area around the new building would soon look as attractive as the building itself.

As any capitol visitor picking up a brochure offering a self-guided tour of those grounds today can read, the grounds in the late 1880s "needed considerable attention." Trash and scraps left over from the construction project still littered the property. Wooden retaining walls dating from the construction period and the original limestone steps from the previous capitol added to the lack of aesthetics.

The state hired Dallas civil engineer William Munro Johnson to pretty up the grounds, and he did, designing a stately, symmetrical Renaissance Revival landscape. That included a black-and-white diamond-patterned Great Walk from Congress Avenue to the building's south doors. He put a similar walk around the building and laid out carriage drives with limestone

This postcard from the early 1900s shows the black-and-white checkerboard grand walkway leading from Eleventh Street to the capitol's south entrance. *Courtesy of Ken Wukasch.*

curbing. The main walkway leading to the capitol he flanked on either side with elm trees, a feature formally known as an allée. Finally, Johnson surrounded the new capitol with an ornate iron fence set in a granite base. Each of the four carriage entrances to the capitol grounds had large gates mounted on sturdy granite posts, and for a time after they went up, they had to be kept closed. As the *Austin Statesman* explained on February 9, 1890, "The drive gates can only be opened to the public convenience as soon as the town cow is prevented from running at large and destroying property."

In the early 1890s, workers planted an apple tree, ornamental evergreens and two live oaks on the grounds. Still, visitors and locals did not find the acreage around the capitol particularly impressive. The grounds looked better than they had before Johnson entered the picture, but in no way were they comparable to the building itself. Three years into the new twentieth century, the *Austin Statesman* observed that the capitol grounds looked like "a widow woman's calf pasture."

With the nationwide City Beautiful movement underway at that time, the capitol grounds began to acquire park-like features, including flower beds and, southeast of the building, a grotto with a goldfish-stocked lagoon traversed by a small bridge. A small pond on the west side of the capitol, a feature once

said to be home to numerous frogs and snakes, had been there before the new building but got prettied up. (It would remain until the 1920s, when the state drained it and grassed over the area; the grotto lasted into the 1970s.)

By 1910, the grounds looked much better. "There are a number of artificial lakes, pools and fountains where aquatic plants are grown in tropical luxuriance and where innumerable goldfish disport themselves," a promotional brochure touting the capital city said. "A great number and variety of flowers both annual and perennial are grown upon the grounds as well as shrubs and trees of almost every known variety."

Two ornate spraying fountains had been added in 1904 along with a pair of drinking fountains, one on the east side of the Great Walk, the other on the west side. (Water from the west fountain supposedly came out cold, while water from the east fountain came out hot.) The water for the east drinking fountain flowed up from a 1,554-foot-deep artesian well completed in 1889. "It is quite the fad now to take morning rides and walks to the well in the Capitol yard," the *Austin Evening News* noted on November 11, 1893. "Each morning we see crowds of two, threes and fours winding their way to and from the grounds."

For years, two ponds graced the capitol grounds, but they have long since been filled in and grassed over. *Courtesy of Ken Wukasch.*

The liquid that came from the well was wet, but that was about all that could be said for it. It smelled like rotten eggs and tasted even worse. A state health department analysis in the 1970s found the water contained 1,759 parts per million of dissolved solids. Nearly one-third of those solids were sulfate, a mineral that has a laxative effect. The state study concluded the well water was "not very good chemically" and should not be considered suitable for drinking. Long-standing legend held that it was good for your health to down a hearty dose of capitol fountain water, but in truth, it was beneficial only to those with constipation issues. Still, as late as the early 1960s, people regularly drove up in front of the capitol and got out of their vehicles with gallon jugs to fill with the stinky water. (The well was restored as part of the redo of the grounds in the 1990s and is now connected to city water.)

In 1908, the state built an elaborate greenhouse to the southeast of the capitol that lasted until 1925, when fire destroyed it. Another greenhouse replaced it, but that structure was eventually moved to the Texas State Cemetery in East Austin.

A thick carpet of Saint Augustine grass, amply watered thanks to the larger of the artesian wells on the grounds, surrounded the statehouse and of course had to be regularly mowed. Until 1926, mules pulled the mowers, but that year, the state retired the four-legged workers and bought gasoline-powered lawn mowers.

As the years passed, the grounds grew increasingly garden-like, much of the greenery being nonnative ornamentals. The proliferation of exotic plants, including some that in the twenty-first century would be considered noxious invasive species, bothered those who cherished Texas's rich botanical diversity.

One man who saw red in beholding the capitol's greenery was noted Texas writer and University of Texas faculty member J. Frank Dobie. Invited to speak to a joint session of the legislature on July 28, 1931, the folklorist did a little lecturing with his storytelling.

"It's a shame for Texas to import arbor vitae to shade its capitol grounds and ignore the historic huisache, the native mesquite, the noble oaks and stately elm," he told the lawmakers gathered in the packed House chamber. While stressing that he had not come to advise the legislature, he went on to do just that, recommending more monuments and a state museum. Over the years, more oaks and Texas pecans did get planted around the capitol, but governmental inertia had more to do with the look of the grounds than planning.

The state built this greenhouse on the capitol grounds in 1908. It made it until 1925, when fire destroyed it. *Courtesy of Ken Wukasch.*

Mother Nature did some landscaping herself. A severe thunderstorm in 1972 toppled several of the elms Johnson had planted along the Great Walk decades earlier. The state did not replace the trees, and the rest were removed in the 1990s after they had considerably exceeded their life expectancy. By that time, the capitol's landscaping, as least when it came to trees, had become a matter of public safety as well as aesthetics.

"The Capitol grounds have been deteriorating steadily for many years," read a portion of the ninety-two-page capitol restoration master plan, "a victim of diminishing maintenance budgets and neglect."

With the addition of the capitol's underground extension in 1993, the northern part of the grounds took on its modern appearance, followed by a major redo of the rest of the grounds that came during the 1995–96 capitol renovation. By 1997, nearly $6 million had been spent on the capitol grounds. Today, with the exception of the various monuments erected over the years, the grounds look much as they did prior to 1915, minus the long-removed fountains and ponds.

One thing the capitol grounds brochure does not talk about is what happened to a big chunk of the ornate fence placed around the capitol shortly after its completion. During the winter of 1956, contract workers tore down the northwest corner of it to make room for the Supreme Court Building, then referred to as the State Courts Building. A minor problem arose: what could be done with the approximately one hundred tons of granite blocks left over from the removal of the fence?

"After considerable head-scratching," the *Austin American* reported on January 11, 1957, "a decision was reached....A large hole was dug at the site and the granite blocks...were buried."

With 200,000 pounds of granite beneath its highest court, it's hard to argue that Texas justice does not rest on a solid foundation.

REMEMBERING THE ALAMO AT THE CAPITOL

In the late 1950s or early 1960s, a worker bulldozing a trench during construction of a new building at the Granite Mountain Quarry near Marble Falls made a discovery that created a mystery still unsolved. The puzzle involves two of Texas's most-recognized icons: the Alamo and the capitol.

Four feet down, the machine's heavy metal blade struck something hard. Climbing from his seat to see what he had hit, the operator saw a chunk of concrete or plaster. Soon he found several other pieces. Brushing the dirt from the larger of the objects, he could make out one word indented on its smooth side: "Thermopylae."

Someone took the jagged fragment stamped with that unusual word to Marie Houy, librarian and keeper of a small museum in Marble Falls.[19] About ten inches long, it looked like part of some kind of monument or marker. But what did the artifact commemorate, and what was it doing at the Burnet County granite quarry? Neither the librarian, a longtime area resident then in her early seventies, nor anyone else she contacted had any idea.

The only clue was that one word: "Thermopylae."

Checking the library's not-so-up-to-date encyclopedia set, Mrs. Houy read that Thermopylae had been in ancient times the only northern entrance to Greece. It had been defended bravely if unsuccessfully against invading Persians. While Houy had not heard of that Grecian city until she looked it up, in the nineteenth century, educators stressed the classics much more

than they would in the following century. In the 1800s, many well-schooled individuals knew the story of the 480 BC Battle of Thermopylae.

Given the general similarity between the Grecian fight and the Alamo siege, the figurative ruins of Thermopylae lay ripe for use as metaphor. The *Telegraph and Texas Register*, in an editorial published on March 24, 1836—only two weeks after the massacre in San Antonio—called the battle "the Thermopylae of Texas." That comparison having been made, others picked up on it. Republic of Texas vice president Edward Burleson later used the analogy in a speech said to have been ghost-written by General Thomas J. Green. In this talk, Burleson famously recited, "Thermopylae had her messenger of defeat; the Alamo had none."

In 1841, some stones from the ruins of the crumbling Spanish mission in San Antonio were removed and transformed into a monument honoring the dead Alamo defenders. Englishman William B. Nangle, a sculptor, fashioned the piece in partnership with one Joseph Cox, a stonecutter. A tapered shaft resting on an ornately carved base, the commemorative work rose ten feet. Most pertinent in regard to the mystery object found just west of Marble Falls, the Alamo monument bore Burleson/Green's ten words comparing Thermopylae to the Alamo. The other three sides of the stone shaft read:

> *"To the God of the fearless and the free is dedicated this altar, made from the stones of the Alamo"*
>
> *"Blood of heroes hath stained me. Let the stones of the Alamo speak that their immolation be not forgotten"*
>
> *"Be they enrolled with Leonidas in the host of the mighty dead."*
> [Leonidas was the warrior-king of the Greek city-state of Sparta. He died in the last stand at Thermopylae.]

After displaying the piece for a time in San Antonio, Cox (Nangle having died soon after the monument's completion) took the monument to Houston and then Galveston, where he collected twenty-five cents a head from folks wishing to have a look at it. Next he took the monument to New Orleans, hoping to make more money in a larger city, but residents there did not find it particularly captivating. Cox ended up selling it. Somehow after the change in ownership, the ornate piece, which one writer who viewed it called "a credit on any artist of ancient or modern times," ended up in a discard pile at a Crescent City marble yard. Following its rediscovery in the early 1850s, the monument was returned to Texas and placed in the vestibule of the new capitol in 1855. Three years later, the legislature appropriated $2,500 to

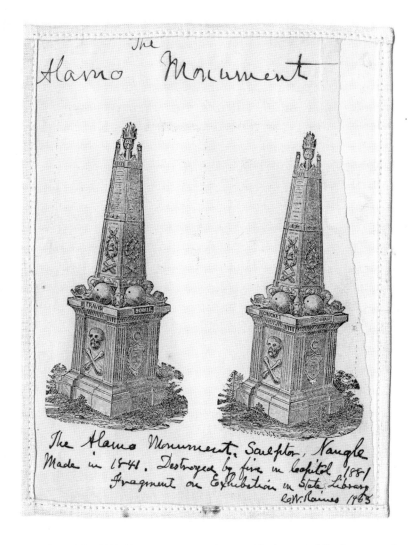

An engraving of the 1841 Alamo monument destroyed in the capitol fire forty years later. *Courtesy of Ken Wukasch.*

buy the monument. The monument remained in place for the next twenty-four years. But in 1881, as Mrs. M.E.M. Davis explained in her 1897 book *The Story of Texas Under Six Flags*, the "old capitol…was burned, and with it many priceless relics of the earlier days of Texas. Among those was the old monument dedicated…to the heroes of the Alamo." Collapsing interior beams and walls, not to mention the intense heat, destroyed the monument.

The day after the fire, the *Austin Statesman* reported that some "thoughtful persons tore away the iron railings around the monument, made from the ruins of the Alamo, and carried off the upper portion. The pedestal was permitted to remain, in its position, as it was thought it could withstand the weight of anything which might fall upon it."

Another version is that after the fire, Judge John P. White, picking through the ashes and debris hoping to salvage what he could, found the portion of the shaft containing the verbiage on each side. Even though the Alamo memorial was only forty years old at the time, White appreciated its historical significance and kept it for seven years. Then, with the opening of the new capitol in 1888, he conveyed it to L.L. Foster, state commissioner of insurance, statistics, history and agriculture.

If White assumed the damaged monument would go back on display in the new building, he was wrong. The state kept the remnant in storage until passing it on to the Daughters of the Republic of Texas for display in the museum the organization then maintained in the old general land office building across from the capitol. Exactly when that transfer occurred has not been determined, but the Handbook of Texas online says it was at the museum by 1950. It stayed there until September 1989, when the DRT returned the remnant to the state when that organization moved its museum from the old state building to a new location on the north side of Austin.

"How the pieces landed here we do not know, unless they hauled it off, after the fire, to get it out of the way at the time they were bringing granite blocks from here to Austin for the new Capitol," Mrs. Houy wrote of the Marble Falls artifacts in 1963.

The remnant held by the state includes the Thermopylae wording, which rules out any possibility that the piece found near Marble Falls came from the original Alamo monument. What seems likely, though no documentation has been found, is that during construction of the new red granite capitol, the state commissioned one of the Scottish stonecutters to make a granite replica of the monument. For whatever reason, that did not happen, and what may have been a concrete prototype or casting from the original ended up getting broken up and buried at the quarry.

One more mystery: the Marble Falls fragment with the word "Thermopylae" has again gone missing. Mrs. Houy died in 1989, just shy of her 100th birthday. The library she once ran in an old downtown building got a more spacious new home in the mid-1990s, and the much-expanded Marble Falls museum, now known as the Falls of the Colorado Museum, is located in the old Marble Falls schoolhouse. While the artifacts Mrs. Houy

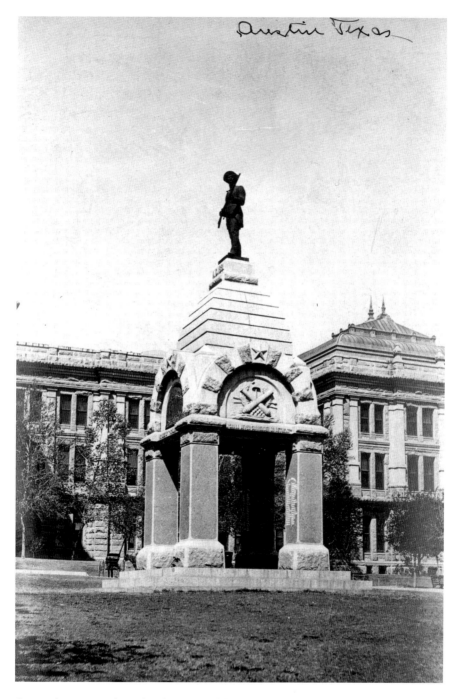

A second monument honoring the Alamo defenders went up on the capitol grounds in 1891. *Author's collection.*

curated presumably ended up in the Falls of the Colorado collection, no one knows anything about a piece of concrete or plaster bearing the simple legend "Thermopylae."

The next time the legislature met after the 1881 fire, lawmakers appropriated money for a new Alamo monument. But another decade passed before such a monument finally stood on the grounds of the new capitol. Made of red Texas granite, the piece was produced by the James S. Clark and Company of Louisville, Kentucky, and placed at the right of the main entrance. Sculptor Chrohl Smith shaped the bronze figure of a young Texian soldier armed with a muzzle-loader that stands atop the piece.

The statue is considerably larger than its predecessor, rising thirty-six and a half feet. It sits on a two-foot gray granite foundation that is nineteen feet square. On each corner is a three-foot-square base topped by a polished seven-foot pillar. Each of those pillars bear arches that come together in a dome. The soldier stands sentinel-like on top of that. The names of the Alamo defenders as known in 1891 are engraved on each of the pillars.

A long-extinct nineteenth-century publication called *Texas Topics* did not view the Alamo monument as particularly memorable. "Already two most unsightly monuments occupy conspicuous positions on the front terrace," the magazine noted. "One of these monstrosities [the Alamo monument] resembles nothing so much as an old-fashioned well-house, and notwithstanding it cost the State several thousand dollars, every judicious and self-respecting citizen who visits the capitol would be willing to stand a reasonable tax for the purpose of removing such a piece of burlesque on art and architecture."

While not commenting on the monument's appearance, the State Preservation Board's website definitely has an opinion on the work's historical accuracy. The board notes:

> [A]*s a product of the 1890s, the Heroes of the Alamo include historical omissions and errors. The Alamo historical site recognizes 189 defenders. The monument includes only 90 from the official list with the correct spelling, 46 misspelled names and 47 other individuals listed but not recognized by the Alamo as having fought at the battle. After consulting with museum and historical professionals, the* [board] *determined not to alter the monument and leave it as a historic artifact of the period.*

The 1891-vintage second Alamo monument may not be perfect, but at least Texans know where to find it.

SMOKEY HENDERSON HANGS IN THE CAPITOL, TOO

Calculated solely on the basis of square footage, the capitol amounts to the largest art museum in Texas.

The 365,000-square foot original statehouse, augmented by the 667,000-square-foot underground extension opened in 1993, holds a rich inventory of paintings, sculptures and other art objects or historic artifacts. Of course, Texas's many sizable art museums have much larger collections than the capitol contains, but the list of works in the big granite building on Congress Avenue is not inconsiderable.

With an initial appropriation of $10,000, acquisition of art began as soon as the state started moving in. In 1887, the legislature created a board to purchase pictures. The board started by commissioning portraits of each of the Republic of Texas's presidents and then oversaw the painting of gubernatorial portraits to that point in the state's history.

The capitol holds some 275 paintings, 175 artworks on paper and 25 sculpture pieces, both inside and outside. By the broadest definition, the building itself is a work of architectural art, from the five-point star hanging on the inside of its dome to its Art Deco terrazzo flooring installed in 1935. The list of paintings hanging in the capitol includes three portraits of colonizer Stephen F. Austin, one of Sam Houston (well, two including the monumental painting of General Antonio Lopez de Santa Anna surrendering to Houston after the Battle of San Jacinto), Davy Crockett, Lyndon B. Johnson, Barbara Jordan and many more paintings of people and places.

The portrait collection of former chief executives begins on the fourth floor around the rotunda and continues to the first floor, where paintings of the more recent governors are on display. Each time a new portrait is hung, all the other portraits are moved one space to the left. The addition of a new portrait is always a media event welcome on a slow news day, with a ceremony featuring remarks by the former governor being honored. Former governor Ann Richards quipped that it is "not every day you get to come to a hanging," but former governor and president George W. Bush improved on that by noting when his portrait went up, in effect, that it's not every day that you get to go to your own hanging.

Among the portraits of well- or relatively well-known governors hangs the likeness of the Lone Star State's most anonymous chief executive since statehood, though determining just who deserves this singular honor is not easy and open to challenge. Even figuring how many governors Texas has had is something of a mind-twister. Part of the problem is determining the rules. Should only the number of governors since Texas joined the Union be counted? That's relatively easy, but what about during the days of the Confederacy? Do Rebel governors count? And what about governors appointed during the military occupation following the Civil War?

No matter the calculus, Texas has had far more governors than the United States has had presidents. As of 2016, the number had reached one hundred. But considering there's even some confusion over how one of these men spelled his name, the count may not be perfectly accurate. (Was it Governor Tomas Felipe Winthuisen or Winthuysen? Whichever, he served from 1741 to 1743 during the Spanish colonial period.)

The list of honor begins with one Domingo Teran de los Rios, who served from 1691 to 1692 as governor of the Spanish province that included what we now know as Texas, as would Winthuisen/Winthuysen. In all, thirty-eight men governed Texas until Mexico wrested itself from the Spanish Crown in 1821. Fourteen other men held the title of governor when Texas was under the Mexican flag.

Henry Smith served as Texas's provisional governor when Texas pulled away from Mexico in 1835, only to become the first of two governors who have been impeached. Another man served as acting governor during Smith's impeachment proceedings.

Since statehood in 1846, forty-seven persons (including two women and one governor who served two nonconsecutive terms) have been governor. But even this list depends to some extent on how you count. One person was only an acting governor when James Pinckney Henderson—the state's first

governor after Texas's admission to the Union—left Austin to fight in the Mexican War.

Some people count Lieutenant Governor Fletcher S. Stockdale as deserving of gubernatorial status since he served for a while after his boss, Governor Pendleton Murrah, headed for Mexico in the summer of 1865 following the South's defeat in the Civil War. Others maintain Stockdale wasn't really a governor, though he did get a town in Wilson County named in his honor.[20]

But among those whose service as governor is not in doubt, only one man stands out as the least known: James Wilson Henderson. Better known as Smokey Henderson, he held office as governor of the great state of Texas for twenty-eight days, from November 23, 1853, to December 21, 1853. That's the shortest term of office any Texas governor has enjoyed, by the way. His definitive biography is yet to be written and probably won't be, but one source says Henderson came off as "earthy" and not well educated. Even so, he progressed from being a surveyor to practicing law, served as Speaker of the House and, after one defeat, got elected as lieutenant governor, the presiding officer of the Senate.

He served under Governor Peter Hansborough Bell, a former Texas Ranger who handled his own gubernatorial security, often strolling Congress Avenue wearing a double rig of six-shooters. When Bell resigned to take a seat in the U.S. Congress, Henderson took over the reins of state. He also had ridden as a ranger, though another source says he turned down a commission offered by then governor Sam Houston.

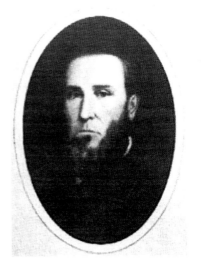

Smokey Henderson's administration is marked by, well, not much. He did not raise taxes or slash budgets, that's for sure. As one book put it, "Little of note occurred during Henderson's brief term as governor."

When Elisha M. Pease took the oath of office as Henderson's successor, Smokey returned to his law practice, then gained reelection to the legislature in 1855. He

Governor James "Smokey" Henderson didn't stay in office long, but his portrait hangs in the capitol with all other former governors as well as presidents of the Republic of Texas. *Author's collection.*

was a member of the convention that steered Texas toward secession in 1861 and served in the state's home guard during the Civil War that followed.

After the war, Henderson went back to the law, dying in Houston on August 30, 1880, at sixty-six. No matter the brevity of his service as Texas's chief executive, Smokey Henderson's portrait graces the rotunda of the capitol with all the other post-statehood governors.

A PICTURE'S WORTH A THOUSAND...LOBBYISTS

Hanging near the entrance on the first floor of the 1855-vintage Neill-Cochran House in Austin, an elegant piece of architecture designed by the noted Abner Cook, is an oil painting credited with doing what even high-priced lobbyists can't always accomplish—swaying the Texas legislature.

The significance of the piece of art goes back to the turn of the last century, when Texas lawmakers departed from their usual weighty deliberations to ponder what native plant should be designated the official state flower. It quickly became a thorny issue, literally in a way.

Representative John Nance Garner of Uvalde thought the prickly pear cactus deserved the honor. As tough as Texas, the needle-protected plant produced a flower the future vice president considered as beautiful as any orchid. Cactus Jack's notion of having a cactus as the state flower earned him a colorful nickname but no cigar. Garner's proposal definitely got under Representative Phillip H. Clements's skin. To the Goldthwaite legislator's mind, nothing would do but to name the cotton boll—he called it the "white rose of commerce"—as the official state flower.

However, though with all due respect, the ladies of the National Society of the Colonial Dames of America (NSCDA) took Garner and Clements both for blooming fools, as least when it came to Texas flora. The Dames argued that any real Texan realized that only one flower truly represented the beauty of the Lone Star State: *Lupinus subcarnosus*.

To underscore their opinion, members of the Austin NSCDA chapter rode in their buggies to the capitol and displayed for the members of the

This bluebonnet painting by Mode Walker helped sway the legislature to designate the bluebonnet as the official state flower. *Courtesy of Neill Cochran Museum, Austin, Texas.*

House an oil painting by a local artist, Mode Walker. The piece features a reddish-brown pitcher full of bluebonnets and primroses. The blue and pink brushstrokes still catch the eye, an artful rendering in a genre often cluttered with amateurish work. Walker's painting clearly got the attention of the House. Oh, and the sweet-smelling bouquets of bluebonnets the Dames placed on each lawmaker's desk also helped make their case. As one woman who was in the capitol that day recalled, when one of the Dames walked into the House with Walker's painting, "deep silence reigned for an instant. Then deafening applause fairly shook the old walls."

Representative John Green of DeWitt County carried the bill making the bluebonnet the Texas state flower, and it passed. Governor Joseph D. Sayers signed the measure into law on March 7, 1901.

So who was this artist whose work influenced the legislature as effectively as a high-powered lobbyist armed with campaign contributions, a hospitality suite and fifty-yard-line University of Texas football tickets?

Mozelle (Mode) H. Walker, born in Dayton, Ohio, on October 11, 1868, came to Austin with her family when she was three. Her father, a lawyer named Moses Walker, fought for the North during the Civil War and following the conflict served in a unit sent to Texas on occupation duty. With Texas still under military control, General Joseph J. Reynolds named Walker as a district judge in 1869. Later, new governor Edmund Davis appointed him as an associate Supreme Court justice. When Richard Coke took over as governor in 1874, Walker got kicked off the court for political reasons and returned to Ohio with his family.

At some point, daughter Mode returned to Austin. By the early 1900s, she was a well-known Austin artist and art teacher. Around 1905, she went

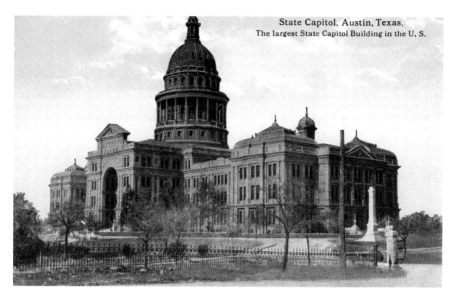

A postcard image of the capitol not long after lawmakers gathered inside chose the bluebonnet as the state flower instead of the prickly pear cactus. *Author's collection.*

back to Ohio and married Eugene Rogers in Canton. "I haven't been able to learn anything about her Ohio years," said Neill-Cochran Museum director Rowena Dasch, who began trying to learn more about Walker when she started at the museum in 2013. "She surely did other work, but I have not been able to locate any other of her paintings. She does not show up in any of the compendia of American artists." The artist died in Canton on September 24, 1950, and is buried there.

While little information on Walker seems to have survived the intervening century-plus since she completed her influential bluebonnet still life, the painting has endured. Mr. and Mrs. Pierre Bremond donated the oil to the Neill-Cochran House Museum in 1985. (Located at 2310 San Gabriel Street, the house is open for tours.)

While Walker's painting has been credited with convincing the legislature that bluebonnets deserved official status, another oil painting is also connected to the issue. It's a bluebonnet landscape by Julian Onderdonk once owned by Mrs. Sawnie Robertson, one of the Dames who took part in the campaign to gain recognition for the wildflower. In commemoration of Robertson's role in achieving official standing for the bluebonnet, her granddaughter presented the painting to the governor's mansion in 1980.

Even though the Dames succeeded in transforming the bluebonnet into an official Texas icon, the early twentieth-century law had a loophole big enough to walk a cow through: the statute specified *Lupinus subcarnosus* as the state flower even though Texas has other varieties of *Lupinus*. Not until March 8, 1971, did the legislature return to the bluebonnet issue, finally amending the law to add *Lupinus texensis* and "any other variety of bluebonnet not heretofore recorded."

"TEX" O'REILLY STORMS THE SENATE

On August 3, 1909, a tall cowboy rode his horse Aransas into Austin on his way to Washington to present an invitation from the people of San Antonio to President William Howard Taft, asking him to visit the Alamo City.

Nineteen-year-old Edmunds Travis, a Tennessean whose family had moved to Central Texas in 1904, covered the story for the afternoon *Austin Tribune* and, in doing so, met and went on to become good friends with a man who would become world-famous as a soldier of fortune and one of Texas's most colorful hell-raisers: Edward S. "Tex" O'Reilly. Then managing editor of the *San Antonio Light and Gazette*, O'Reilly planned to continue his horseback journey from the capital city via his adopted hometown of Chicago to Washington, though he only got as far as Chicago. As intended, the ride made headlines all across the nation and generated ample free publicity for San Antonio and the *Light*, not to mention O'Reilly.

"I had a wonderful time on that 1,700 mile ride," O'Reilly later recalled. "When I reached Chicago I learned President Taft was at a baseball game. So I rode my horse onto the diamond and dashed up to him. The amazing thing was he recognized me, remembering me from the days when I commanded his bodyguard in the Philippines." (It's actually only 1,240 miles from San Antonio to the Windy City, but he may have wandered some.)

Born in San Saba in 1880, O'Reilly would fight in ten wars under numerous flags, a consummate soldier of fortune. In addition to his Spanish-American War service with the U.S. Army in Cuba and action in

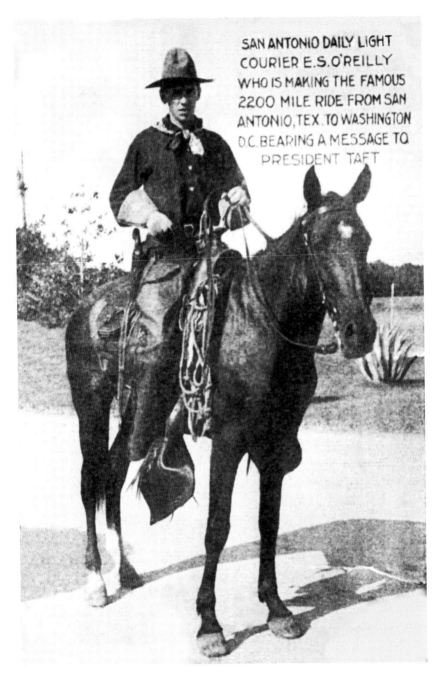

SAN ANTONIO DAILY LIGHT
COURIER E.S.O'REILLY
WHO IS MAKING THE FAMOUS
2200 MILE RIDE FROM SAN
ANTONIO,TEX.TO WASHINGTON
D.C.BEARING A MESSAGE TO
PRESIDENT TAFT

"Tex" O'Reilly rode on horseback from San Antonio to Chicago to invite President Taft to the Alamo City. On the way, he passed through Austin and became friends with young newspaper reporter Edmunds Travis. *Author's collection.*

the Philippines and Shanghai during the Boxer Rebellion, he would later fight in Venezuela, Honduras and Nicaragua. He rode with Pancho Villa in Mexico during the Mexican Revolution and fought with the Spanish Foreign Legion in North Africa.

Travis and O'Reilly—less than a year after the San Antonio journalist rode through Austin with the message for the president—would take part in an episode on the floor of the Texas Senate that, while it nearly erupted in bloodshed, amounts to one of the strongest stands for freedom of the press in the state's history.

By 1910, Travis had already helped to cover two regular sessions of the legislature and several special sessions. That summer, Governor Tom Campbell called a fourth special session of the Thirty-First Legislature.

"The Legislature was a lot more important in those days than it is now," Travis recalled years later. "I suppose we didn't have so many news services as we've got now, but it was quite an honor to record its proceedings."

Back then, literally everything the legislature did got news coverage, and the lawmakers were not always pleased with the way things came out in the papers. That year, a cloud of scandal hung over the capitol dome. Speaker of the House Austin M. Kennedy, a former newspaper publisher from Mexia who first gained election to the lower chamber in 1898, was suspected of misdeeds in office. On the Senate side, members expelled one of their own for accusing some of his colleagues of playing poker with lobbyists and assorted other ethical issues. Travis had written about all that, but it was the Speaker who reacted to Travis's coverage with enmity.

"Kennedy just hated my guts," Travis said, laughing. "There were a lot of rumors around about him getting rake-offs on furniture for the Speaker's quarters. He had a secretary that would buy this furniture at a discount and he'd split it with her. [Then called a stenographer, the woman had been on the House payroll at $120 a month (around $2,500 in today's dollars) even though she had not moved to Texas until the sixth week of the special session.] Anyhow, he decided to meet those rumors head-on. So he demanded an investigation."

Being Speaker (albeit having been elected to the post by only a six-vote majority), Kennedy appointed a three-member committee—two of them close friends—to conduct the probe.

"So I began writing up that investigation as a whitewash," Travis said. "That made old Kennedy hate me worse than ever."

A report that would clear the lawmaker was imminent, but Kennedy made a mistake when he addressed the committee. He gave out advance

copies of his speech to all the statehouse reporters but Travis, which turned out to be the worst political blunder he ever made.

"He made it very pointed that I was not to have any copies of his speech because I hadn't treated him right," Travis said. "Well, the result of that was that I attended this session and the other newspapermen didn't. I sat there and took notes on it. And he launched into a tirade in the course of which he mentioned rumors that they hadn't gotten into at all and accused the governor of instigating all these charges against him."

At the end of the speech, one of the committee members, John T. Briscoe (uncle of future governor Dolph Briscoe), stood up and said, "Gentlemen, we've heard things here today that we don't know a thing in the world about. I move we reopen the investigation."

Travis's report of this speech—though Kennedy literally begged him not to publish it—created the final movement to oust the Speaker. That came by a vote of seventy to forty-eight on March 13, 1909. Even so, while no longer its presiding officer, Kennedy remained a member of the House until he died in office in 1914. Despite Kennedy's grudge against Travis, worse trouble soon developed in the upper chamber.

Young Travis, besides working for the *Tribune*, also "strung" for some of the state papers, including the *San Antonio Light*, where O'Reilly entered the picture again. The *Light* had dispatched a man to Austin to "muckrake" the Senate, a Philadelphian named R.M. Johnson. Rather than prowl the halls of the capitol in search of legislative malfeasance, the *Light* journalist spent most of his time ensconced in his room at the Driskill Hotel, emerging only to wire scandalous tales about the antics of the Texas solons to his editor at the *Light*.

The *Light* being well read if not well liked, it didn't take Johnson long to offend a sizable cross-section of the Senate, many of its members known to pack guns. Evidently unaware of the firepower in the upper chamber, on August 25, 1910, the reporter actually walked the six blocks from his hotel to the capitol. As Travis put it, "One day he made the mistake of coming up on the Senate floor and they mobbed him....It was a terrific scene for a while."

A mounted Austin policeman galloped up Congress Avenue to quell the battle. While no shooting broke out, Senate members voted to bar the *Light* from the floor. Seeing that as a clear violation of the First Amendment, the *Light* denounced the move in page-one editorials, declaring that the *Light* would be restored to its rightful seat at the Senate press table.

The war-toughened O'Reilly would personally be overseeing his newspaper's restoration. The tall Texan came to Austin—this time by train—and proceeded

to give his bruised statehouse reporter shooting lessons. Man had flown in airplanes, was beginning to give up horses for automobiles, could communicate by telephone and benefit from rudimentary X-ray technology, but with many Texas senators discreetly concealing handguns under their coats, an element of the old Wild West still remained.

Travis sat on the other side of the rotunda covering proceedings in the House when he heard a commotion coming from the east wing of the capitol. O'Reilly and Johnson had shown up at the statehouse, ascended the steps to the second floor and were about to barge their way into the Senate, no matter that august body's resolution prohibiting them from the floor. When O'Reilly saw Travis, he gave his Austin correspondent his marching orders.

"O'Reilly's instructions were that he and I and Johnson were to make a grand entrance into the Senate," Travis said. "And I said if we try to do that we'll probably all get killed. Those senators were mad as the dickens at the *Light* and Johnson."

"'Well,' O'Reilly said, 'you don't have to go if you don't want to, but I'm going to take Johnson in.' Old Johnson was quivering all over. I never saw as good an imitation of a bowl of jelly," Travis laughed.

O'Reilly packed four guns, one on his hip, one under his shirt, one in an armpit holster and one in his left pocket. Assuming all were six-shooters, O'Reilly carried twenty-four votes in support of the *Light*. So O'Reilly, a legislative friend named (Ralph Ray) "Railroad" Smith and Johnson prepared for their entrance.

The tall Irishman appointed to restore the *Light* thrust one of his guns into Travis's hand. Travis handed it right back to him. "He said, 'If you don't

The senate chamber as it looked about the time a heavily armed "Tex" O'Reilly burst in to assure the *San Antonio Light*'s access to that body's proceedings. *Courtesy of Ken Wukasch.*

take this gun, you can't go in with us,'" Travis recalled more than a half century later.

To O'Reilly, Travis countered, "Oh no, I wouldn't miss it. But I'm not going in there carrying a gun. I've got more respect for the Senate than that, and, besides, it would just give somebody an excuse to shoot me."

The ad hoc freedom of the press delegation then opened and walked through the heavy wood and opaque glass doors into the Senate. A tense standoff developed that could have gone either way. But O'Reilly's six-gun diplomacy and the cool nerve of the unarmed Travis paid off. The Senate agreed to let Johnson and other representatives of the *Light* stay in the chamber, under the condition that Johnson would leave Austin "in a day or so." Showing his good faith, the next day, Johnson disappeared. Just to make sure the Senate abided by the agreement, O'Reilly "stood guard" for the *Light* and Travis for the remainder of the twenty-four-day special session.

As Travis put it years later, "We restored the *Light.*" And without a shot being fired.

THE CRACK IN THE FLOOR

For decades, most people who knew the fate of Ed Wheeler avoided stepping on or across the long crack in the terrazzo floor of the rotunda. Not that they did not stare at the thin fissure in morbid curiosity, grimly imagining what it must have been like when the young painter plunged to his death from high in the capitol dome and hit that very spot, but somehow it seemed disrespectful to stand on it.

The December 13, 1922 accident made big news at the time, but while it gave life to one of the capitol's better-known legends, the details of the incident itself had been largely forgotten by the late 1960s. However, in the early fall of 1968, a San Antonio painting company got the contract to repaint the robin egg–blue interior of the capitol dome. A few old-timers in the capitol press corps remembered the tragedy connected to a previous dome repainting, and a young reporter for the *Austin American-Statesman* got the assignment to resurrect the tale while a colleague focused on interviewing the latest workmen.

Checking the newspaper's "morgue," a room crowded with battleship-gray file cabinets containing yellowed clippings of past news events, the reporter assigned to the back-when piece read up on the accident. One of the things he found folded up in the envelope of material on the incident was a two-page typewritten statement made in 1955 by Vernal Ray Ramsey, one of the painters who witnessed his co-worker's fall more than three decades earlier.

That noon hour, he remembered, they had eaten their lunch and told jokes. During that time, Ramsey noticed that Wheeler seemed unusually quiet. Finally, he admitted to a bothersome leg injury. Ramsey suggested that

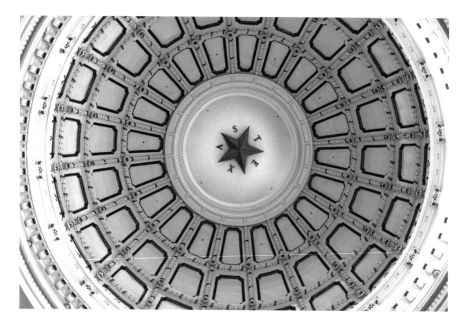

A painter touching up the interior of the dome fell to his death in 1922. *Author's collection.*

he loosen the bandage covering the wound (he didn't say in his statement how Wheeler had been hurt), and Wheeler said that made it feel much better.

Back on the job at one o'clock, they climbed back out on their painter's platform—they called it a stage—that hung from ropes up in the dome. Having started at the top, they would paint a "stretch," as Ramsey called it, and then lower their platform to start working on a new area.

Ramsey continued, "We heard a most peculiar noise and I said, 'Ed, what's that?' We looked at our falls and they were alright. We looked at our ties, and they were alright. So I said, 'It must be the hook.' He said, 'It must be my hook. It seemed like it hung on something when I put it in.'"

Since that hook is what held up half of the swaying platform, Ramsey told his colleague that he'd better move over and make sure it was secure.

"He set his pot and brush down...and started back to see what was the matter," Ramsey went on. "As he took his weight onto his hand, the hook straightened out....Mr. Wheeler slipped off the stage onto the top ledge [of the fourth floor]. But he gradually went to sliding off. I hugged my rope and closed my eyes."

If Wheeler screamed on the way down, Ramsey had blocked it out of his memory, recalling only that he did not hear him or his paint pot when it crashed to the floor nearly three hundred feet below.

"When I looked again," he said, "I saw the hole where he went through." At the time, the floor of the rotunda consisted of thick opaque glass bricks. Wheeler had smashed through the glass and landed on the concrete basement floor. The terrazzo floor, which eventually developed a crack to which was attached a gruesome and unfounded story, was not laid until the Texas centennial in 1936. The state repaired the infamous crack during the extensive renovation of the capitol in the late 1980s.

Another of the five painters working that day was twenty-six-year-old O.L. Stiefer, president of the painter's union, Local 221 in Austin. He and the other painters met after the accident and voted not to go back on the job until safety precautions were taken. Once waist-high fencing had been installed around the platforms—a measure that would have kept Wheeler from sliding off to his death—the union men went back to work and finished the job without further incident.

When the dome needed repainting after more than forty years, a new generation of painters wore safety harnesses. And stretched beneath them at the fourth-floor level was a strong, well-secured nylon net, just in case.

For years, capitol visitors stared at this crack in the rotunda floor, thinking a hapless painter's fall in the early 1920s caused it. But this floor was not put in place until the mid-1930s. *Author's collection.*

LOVE ON KISSING HILL

The capitol stands on high ground known to early day Austin residents as Kissing Hill.

The modest eminence at the head of Congress Avenue had its romantic name even before the state's first stone capitol went up on the site in 1853 and kept it for some time afterward. First earmarked for governmental use when the Austin town site was laid out in 1839, the hill afforded an awe-inspiring vista. Here's how one nineteenth-century writer described it:

> *It commands a magnificent view of the scenery up and down the Colorado River for fifteen miles. Patches of prairie appear to the southwest, low mountains and cedar-crowned hills rise in the blue distance in the west. In the foreground the...Colorado runs like a thread of silver. At the feet of the observer lies the city, with its palatial residences and numerous public buildings.*

Couples seeking a private place where they could enjoy both the scenery and some together time came to the hill hand-in-hand on foot or snuggled up in a buggy. In daytime, the undeveloped hilltop made a nice place for a picnic. At night, gentlemen might casually suggest the hill as a good vantage point from which to enjoy the stars or a full moon, hoping to work in a little smooching while they were at it.

Austin and Texas having a much smaller population back then, even after the first capitol rose on the hill, it was still pretty quiet up there in the evening, especially if the legislature happened not to be in session. Nor did the hill's appeal to lovers end when the present capitol opened in 1888. The grounds around the new statehouse remained a popular trysting place, while the building became the city's social center. Beginning with the grand ball in the capitol the night of its dedication and continuing into modern times, couples have danced there, met and fallen in love there, became engaged there and exchanged vows there. Doubtless, over the decades many couples, from high schoolers and University of Texas students to elected state officials and staffers, bypassed those steps while still relishing each other's company, if only for a few ecstatic moments or perhaps as their schedules allowed until it was time to go home to their families after the session ended.

One of the most notable weddings took place there a few months after the end of World War II. With Governor Coke R. Stevenson sitting on the front row before the makeshift altar, on December 20, 1945, Waylon

The high ground where the capitol stands had been a sparking place long before the present statehouse went up. *Author's collection.*

H. Galloway and Rose Mary Copeland became united in marriage on the rostrum of the Senate.

Theirs was not the first wedding in the capitol or on its grounds and definitely not the last, but the ceremony made news. For one thing, so far as is known, it was the only time a couple has been bound in holy matrimony in the Senate chamber. But something else made the event unique. As the Associated Press reported, at only forty-five inches, the twenty-year-old groom was "the state's tiniest employee." His twenty-one-year-old bride, who played one of the Munchkins in the 1939 *Wizard of Oz* movie, stood a diminutive forty-four inches. Though their heights were not reported, the attendants also were little people. Six-foot Dr. W.R. White, pastor of Austin's First Baptist Church, performed the ceremony.

Galloway, originally from near Wills Point in East Texas, worked at the time for Secretary of State Claude Isbell. He had started as a Senate messenger in the spring of 1943. The couple had met three years before at Vinita, Oklahoma, and after Galloway moved to Austin to take the state job, they carried on a courtship by correspondence. Long-distance telephone calls being fairly expensive back then, Galloway proposed by mail. And Copeland said yes by return post. However, they did use the telephone to wrap up details of their wedding.

The governor presented the couple a set of dishes, and Galloway's boss covered the cost of their honeymoon in East Texas. They got so many other gifts from state officials that they had not even had time to open all the boxes before they left on their wedding trip, the AP reported.

Later a state board of control printing, mail and supply department supervisor, Galloway remained with the state until his retirement on November 13, 1971, with twenty-nine years' service. The couple moved from Austin to Canton, where they raised dogs, gardened and worked with ceramics.

Unlike some deals struck in the Senate, the Galloways' marriage lasted. By the time Mary died on May 6, 2000, they had been man and wife for fifty-five years. Her widower, who had become an ordained Baptist minister in 1965, lived until March 6, 2009, dying in a Terrell hospital at eighty-four.

While they did not get married there, another Texas couple had a story to tell about the capitol. It started in Washington, when a girlfriend of a University of Texas student named Claudia Alta Taylor from a little town in East Texas called Karnack gave her a piece of paper with the name, address and telephone number of a friend she thought Taylor ought to meet while she was in town. "You'll just love him," the friend said. "He'll show

you around." Taylor politely took the information but had no intention of following up on it.

That fall, back in Austin, Taylor went from campus to the capitol one day to visit Eugenia "Gene" Boehringer, a friend who worked at the Texas Railroad Commission. When she walked in the first-floor office, she saw a tall, thin young man with wavy black hair. After her friend introduced them, she recognized his name. He was the fellow from Washington she'd been told about. Gene had arranged a blind date for him with one of her co-workers, and he had come to the capitol to meet her. Before leaving on the date, the fellow asked Claudia in a low whisper if she'd like to meet for breakfast the following morning at the Driskill Hotel.

Taylor demurred, but the next morning she had an appointment with an architect whose office was next to the Driskill. As she walked past the hotel, she saw the guy who had proposed breakfast. Spotting her, he began waving frantically until she stopped. Reluctantly, she took him up on the meal, and afterward, somewhat charmed, she accepted his offer to go for a ride. That constituted their first date. And by mid-November, they were married. From then on, except when people used her longtime nickname and called her Lady Bird, she was Mrs. Lyndon B. Johnson, wife of the future thirty-sixth president of the United States.

The Johnsons were not the only couple who met in the capitol and went on to get hitched. In 1905, Emily May Carter, a schoolteacher from Uvalde, happened to be in the north corridor of the capitol when she ran into handsome Wallace Ellis, a young railroad commission employee.

They soon fell in love, married and went on to have four children: a son and three daughters. In 1923, while they were out for a Sunday drive, a drunk driver crashed into their car and killed Wallace. May survived but never remarried. Often, as the years passed, May returned to the capitol just to stand on the spot where she and Wallace had first seen each other so many years before. With pleasure, not bitterness at her loss, she remembered what had been. "She was so sentimental about that spot," her daughter Virginia Ellis Adcock later recalled. "She just loved the capitol."

May Ellis died in 1967. Twenty years later, private funds to aid in the capitol restoration were being raised through the sale of commemorative granite pavers to go on the esplanade extending from the north entrance of the capitol over the planned underground extension. In 1993, Virginia and her husband, Howard, bought one of the pavers to honor her parents. All the twelve- by twelve-inch stone says is "In Memory of Wallace & May

Lady Bird and future president Lyndon B. Johnson in Washington shortly after their wedding in 1934. They met at the Texas Capitol. *Courtesy of Lyndon B. Johnson Presidential Library.*

Ellis," but for their grandchildren and other surviving family members, those six words tell a touching love story.

Not only have romances started in the capitol, but it has also been the scene of more than a few marriage proposals. When then representative Kyle Janek (later a senator and later still executive director of the state health and human services commission) decided to pop the question, he got help from Speaker Pete Laney in arranging a romantic event in a place only members of the legislature and maintenance workers are allowed to go: the top of the dome. The Speaker's wife, Nelda Laney, had a small table, flowers and a bottle of bubbly placed on the outside walkway, the highest anyone can go in the capitol without rappelling gear. When Janek took his intended up there, she saw the setup as they approached and whispered with alarm that they had to get out of there. "Somebody is having a party," she said. That's about the time she noticed Janek holding an engagement ring.

The couple went back to the dome on their second anniversary. This time, Shannon Janek carried their new baby, who one day will have his own story to tell about the capitol.

CAPITOL PROTEST HAD O. HENRY TWIST

William Sydney Porter did not start out his life in Texas, but the famous short-story writer—far better known as O. Henry—spent enough time in the Lone Star State to pick up some good material.

Sixty years after his death, in a way, O. Henry had a hand in one more yarn, this one involving the late governor Preston Smith. Call it "The Ransom of the Red-Faced Chief."[21]

To set the scene, in the spring of 1970, President Richard M. Nixon ordered U.S. troops into Cambodia during the Vietnam War. This apparent escalation of an already unpopular conflict triggered an immediate uproar among those opposed to America's continuing presence in Southeast Asia.

On Monday, May 4, an antiwar protest at Kent State University in Ohio turned violent when National Guardsmen opened fire on unarmed students, killing four. Outrage quickly swept through the nation's college campuses. In Austin, protestors began gathering at the University of Texas the following morning. That afternoon, thousands of angry students and others against the war spilled off campus and marched toward the capitol.

The Department of Public Safety quickly called in Highway Patrol troopers and Texas Rangers to protect the statehouse. "If any of those long-haired hippies get inside the capitol," senior Texas Ranger captain Clint Peoples told his men, "it better be over dead men." Despite the Ranger chief's unrealistic admonition and the best efforts of rangers, troopers and Austin police, the protestors poured into the building, breaking some of the original ornate glass in the doors and generally wreaking havoc.

Governor Preston Smith went to East Fifth Street for barbecue and ended up getting his state vehicle briefly impounded. *Author's collection.*

Only twice before had UT students descended en masse on the capitol. The first time came in 1917 during World War I, when Governor James Ferguson vetoed the university's appropriation. Led by a band, some two thousand students marched from the campus to the capitol. Entering the building on the south, they paraded through the main corridor waving banners reading, "We are fighting autocracy abroad, we cannot tolerate it here," as the band played "The Eyes of Texas." Ferguson ended up getting impeached. The second UT onslaught came in 1947 when popular UT president Homer Raney got fired.

However, neither of those incidents had been violent. In the 1970 protest, tear gas finally repulsed the students, though they soon began planning an even larger march for Friday, May 8. The Austin City Council denied the organizers a parade permit, saying they would have to walk on the sidewalks. But at the last minute, U.S. district judge Jack Roberts granted a temporary restraining order allowing the students to walk in the street. Many Austinites

Short story writer O. Henry's restored house in Austin. In 1970, during heated antiwar protests in Austin, then governor Preston Smith got in a bit of trouble there. *Courtesy of City of Austin Parks and Recreation Department.*

bordered on hysteria at the prospect of a second unruly protest and perhaps another assault on the capitol.

Even so, the potentially volatile situation that day did not spoil the appetite of Governor Smith when the noon hour rolled around. With more than twenty thousand chanting antiwar protestors headed downtown from UT, the governor decided he could sure use some barbecue. Smith and his DPS security detail left his capitol office and drove in a state vehicle to a popular BBQ place on East Fifth Street. That eatery—long since torn down to make room for a high-rise hotel—sat across the street from the O. Henry Museum at 409 East Fifth Street, which is how Texas's favorite North Carolinian gets into this story.[22]

The governor's driver could not find a parking place, so he whipped the unmarked DPS car into the O. Henry Museum's small parking lot. Neither Governor Smith nor his plainclothes bodyguards paid attention to a sign clearly reserving parking for museum patrons only.

When Smith and the DPS officers returned to their car after their lunch, they found a locked chain stretched across the entrance to the lot. As the governor and his party pondered why someone would in effect impound the vehicle used by the chief executive of Texas, Maree Larson appeared. The museum curator asked the governor if he had seen the sign, and he said he had. Her point made, Larson unlocked the chain so Smith could return to the duties of high office. Before he left, however, the embarrassed but good-humored governor promised Larson he wouldn't park in the O. Henry Museum lot again.[23]

In true O. Henry style, the tale even had a surprise ending: despite the violence earlier that week, the protest march on the capitol that day proceeded peacefully.

A MASSIVE MYSTERY–LITERALLY

Back in the 1950s, Austin's Airport Boulevard carried light traffic to and from the city's small air terminal, a one-story frame structure built in the 1930s. Railroad tracks paralleled the roadway from Airport's intersection with North Lamar Boulevard to East Avenue, a thoroughfare that later became Interstate 35. And along the railroad right-of-way adjacent to the boulevard lay several large blocks of red granite.

For those not familiar with Austin's landscape, red granite is not indigenous to the area. The closest point it occurs naturally is the wrongly named Burnet County town of Marble Falls, which more correctly should be Granite Falls. The granite blocks in Austin, and others strewn at various points along the railroad right-of-way from Burnet to the capital city, fell from rail cars carrying them to the capitol construction site in the mid-1880s. Since the state got the granite at no cost, no one had any incentive to spend the time, effort and money it would have taken to retrieve the stones.

After the decision had been made to build the capitol of Texas granite rather than Indiana limestone, subcontractor Gus Wilke needed a way to get fifty thousand tons of donated stone from the soon-to-be-opened quarry at Marble Falls to Austin.[24] Necessity being the mother of capitalism as well as invention, a sixteen-mile rail spur (locals called it the Wilkeville & Rosewood) was laid from Granite Mountain to Burnet, which had existing rail service to Austin. That was provided by the Austin and Northwestern Railroad, which had been in operation since the spring of 1882. Under Wilke's supervision, workers completed the spur on December 1, 1885, and the quarrying

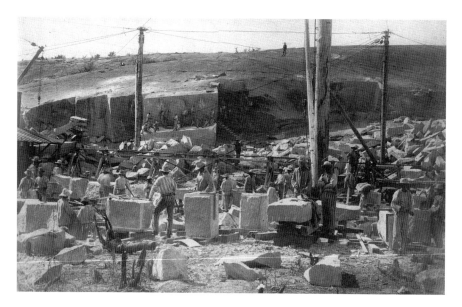

Prison inmates quarried granite from near Marble Falls, Texas, but stonecutters brought in from Scotland dressed the stone. *Author's collection.*

process soon began in earnest. By July 25, 1886, 300 convicts were working at Granite Mountain.[25] An additional 148 non-inmate laborers, nearly half of them Scottish stonemasons, dressed the granite at a facility Wilke had constructed in Burnet. As had been the case in Oatmanville, the project noticeably perked up the local economy.

Harry Landa, whose father had come to San Antonio from Germany via New York in 1844, ran a flour and feed supply house in Burnet at the time. His place of business being adjacent to the tracks, Landa got hired by Wilke to supervise the loading of the granite onto the rail cars at one dollar a car. "Wilke would come to town every Saturday," Landa later recalled, "pay me for my services, and then pay off the workmen. The main street of Burnet became a lurid Broadway, with the saloons, gambling houses and everything going full swing."

The capitol project not only stimulated a boom in Burnet County, as capitol board construction superintendent R.L. Walker presciently told the *Austin Statesman*, but the benefit would likely also continue for a long time. "[The quarrying] opens up the way for future developments that are grand in their possibilities," he said. "There will be no need to cease working these inexhaustible quarries even on the completion of the capitol. The time will come when it will be in demand for...the erection of other costly

edifices all over the state." (Walker was right. The Marble Falls quarry, which has sent Texas granite all over the nation, remains in business, albeit under different ownership.)

From Burnet, the granite blocks intended for the capitol were shipped to the Austin and Northwestern depot between Fourth and Fifth Streets, just east of the present interstate highway. The granite was then transferred to a short line that extended up East Avenue and west on Twelfth Street to a point near the capitol construction site. The line took that route because Austin city fathers had rejected the original plan to run the tracks right up Congress Avenue.

The syndicate's steam engine *Lone Star* pulled four thousand carloads of granite to Austin during the construction of the capitol, often at a rate of ten to fifteen cars a day. One flatcar could only carry two blocks of granite, the load being placed over each set of wheels. The tremendous weight put intense pressure on the forty-pound narrow-gauge rails, often causing them to spread. When that happened, the cars jumped the tracks and the granite spilled from the train.

The long-lost stones remained visible along Airport Boulevard through the 1960s. But they are gone today and have been absent for decades. So where did they go?

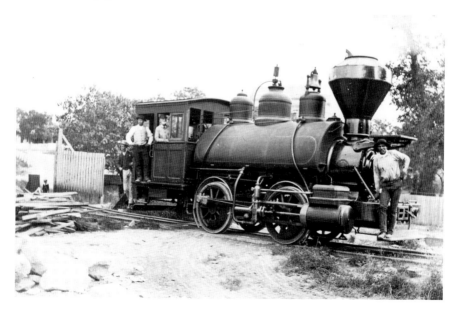

The Capitol Syndicate had this locomotive custom built to haul granite to the capitol job site. They named it the *Lone Star*. *Courtesy of Texas State Library and Archives.*

Left: A hunk of spilled granite remains where it fell in the mid-1880s along the railroad right-of-way in the Burnet County community of Bertram, Texas. *Photo by the author.*

Right: Three Scottish stonecutters never saw their native land again. Their co-workers placed this granite monument over their graves in what is now the Old Burnet Cemetery. *Photo by the author.*

That some souvenir hunter took the granite is easily ruled out. Granite weighs 168 pounds per cubic foot, compared to a mere 62 pounds for a cubic foot of water. Obviously, it would take heavy equipment to remove rocks of that size. At some point in the early 1970s, someone using some stout hydraulic equipment must have removed the granite along Airport Boulevard, but the files of the public library's Austin History Center make no mention of it. Why the stones were removed is also a good question, though it probably had to do with the value of the granite finally exceeding the cost of moving it. Or maybe the corporate successor several times removed of the long-defunct rail line that initially owned the right-of-way had the stones removed.

Fortunately for those interested in history, not all the fallen granite in Austin has disappeared. There's still a medium-sized chunk on the railroad right-of-way where 38½ Street crosses the tracks, just east of I-35, and more in the vicinity of the old Watters Park community. Other single pieces of granite can still be seen between Burnet and Austin along the rail right-of-way adjacent to State Highway 29.

The largest scattering of long-abandoned cut granite lies in Brushy Creek in Williamson County near a railroad trestle that still crosses the creek bed at that point. Eighteen flatcars derailed there in 1886, leaving thirty-six giant blocks lying in the creek. Since half the rail line's rolling stock also ended up in the creek bed, the flatcars were put back into service as rapidly as possible. No one cared about the spilled granite, which was left where it lay.

Another piece of granite connected to the capitol stands in the Old Burnet Cemetery. The tallest tombstone amid nearly two thousand, it marks the spot where three Scottish stonecutters who died while working on rock for the capitol lie buried. The piece, a large square base supporting a smoothed granite column with its top symbolically broken off, was placed "By Their Fellow Workmen" in memory of the three young men who came to the United States seeking a better living and never made it home. In the lower left corner is noted, "Cut of Burnet Granite."[26]

Closer to Austin, starting at 5:30 a.m. Monday through Friday, a Capital Metro commuter train makes ten trips a day across Brushy Creek and the scattered granite blocks left over from that long ago freight train wreck. Traveling from Leander via Cedar Park to downtown Austin along modern, standard-gauge tracks built on the old Austin and Northwestern right-of-way, most passengers—lost in their smartphones, tablets and laptops—have no idea they're zipping past history.

THE DAY THEY ATE THE CAPITOL

It should be remembered that on February 1, 1982, the government of Texas sanctioned an event at which its citizens were cordially invited to eat cake—a giant replica of their historic capitol.

Queen Marie Antoinette is famously credited with derisively dismissing the fate of her starving subjects during the French Revolution by uttering four hard-to-swallow (at least for them) words: "Let them eat cake." Turns out the expression had been around a lot longer than that, and no documentation exists that the young queen actually said it. Still, she continues to get the blame for the arrogant remark. Convicted of treason, she went to the guillotine on October 16, 1793, in the wake of the bloody uprising that transformed France from a monarchy to a republic.

State officials probably didn't have the late French queen in mind when they decided to provide free cake for all comers at the celebration they were planning to mark the capitol's first century, but it proved a nice touch at an otherwise fairly low-key event. As a matter of fact, the festivities that February 1 amounted to a mere cupcake in comparison to the five-day dedication celebration in May 1888. Still, more than 2,700 Texans (and two members of royalty from Scotland in remembrance of the Scottish stonecutters who came to Texas) showed up for the observance and ingested a 250-pound cake shaped and iced to look like the capitol. They ate it, naturally, in the rotunda of the building they had come to honor.

In yet another superlative associated with a long list of capitol-related superlatives, the Texas Restaurant Association—with considerable help

In 1982, to celebrate the centennial of the capitol's construction start, the state served a giant capitol cake to all comers. *Author's collection.*

from numerous other organizations—presented the people of Texas with the massive cake. The edible replica of the capitol included more than seventy-five pounds of flour, one hundred pounds of sugar and forty-five dozen (540) eggs. It stood two and a half feet high, six feet across and three and a half feet wide. Granite not being digestible, the cake was covered with pink pastillage and buttercream icing. The well-manicured grounds around the capitol were represented by landscaping covered with light-green icing.

Just as the state government eventually outgrew the 1888 capitol and began putting up other office buildings to accommodate Texas's expanding bureaucracy, the giant capitol cake was not large enough to afford a slice to everyone who wanted a piece. So an additional fourteen sheet cakes made it possible for all comers to enjoy a little sweet taste marking the occasion.

The cake went on display in the rotunda at 8:00 a.m. that day. Three hours later, workers moved the giant pastry to the front steps of the capitol for the program. Sugar junkies in the crowd could only look on with watering mouths until all the speechifying ended. Volunteers then moved the cake back into the rotunda.

Finally, Governor William P. Clements, Texas's first Republican governor since Reconstruction, and his wife, Rita, cut the initial piece of cake with a sterling silver cake cutter donated by an Austin jeweler. By then, it was lunchtime, but most of those on hand for the event decided, given the significance of the observance, that they would eat dessert first. After that, volunteers fed the masses until the capitol cake had been reduced to crumbs.

Of far more substance than cake, an essay written for the occasion by noted Texas historian T.R. Fehrenbach put the capitol in perspective:

Buildings are erected by people for shelter, but more than that, as symbols and monuments. Legislators in 1879 wanted a new structure to house state government, but they also wanted a symbol of the state's inherent greatness. They did not dwell on the past, and they did not think small. This was to be the best state capitol…a statement for the ages.

Clearly, all those involved in the process had succeeded in making that statement true. But Fehrenbach also noted that the statehouse had not been built "without political feuds, rhetoric, controversy and wheeling-dealing on a Texas scale.…There was fine-lining and maneuvering, and trade-offs.… There were cost overruns." Yet, he declared, "the capitol emerged in its full magnificence…and so [has]…the state it symbolizes today."

Reducing that symbol to a king-size cake must have proven quite popular, because a second capitol cake was prepared six years later for the centennial of the capitol's completion. This time, however, the cake was the tasty highlight of the children's party. First Lady Rita Clements (her husband had lost a bid for a second term in 1982 to Democrat Mark White but regained office in 1987) made the ceremonial first slice.

The kids loved the cake, but the centennial celebration turned out to be a washout. On May 7, a steady drizzle began falling about twenty minutes before the centennial parade's start time and lasted throughout the Congress Avenue procession. Whereas an estimated twenty thousand people had attended the capitol dedication a century before, only 10 percent of that number showed up for the 1988 festivities. When the precipitation continued, officials decided to scrap plans for an outdoor celebration and moved the centennial ceremony to the House of Representatives. At least this time, one hundred years after the 1888 dedication, the capitol's roof did not leak.

CAPITOL KITSCH

Back when most American adults smoked, many a cigarette butt got ground out and left to stink up ashtrays bearing an image of the Texas Capitol. And no telling how much whiskey got knocked down by folks drinking from a genuine Texas Capitol shot glass.

Visitors to the capitol or Austin in general have been buying statehouse souvenirs since there's been a capitol. Actually, even before the new capitol opened, entrepreneurs realized money could be made by producing capitol commemorative items. "The News has received a copy of the Capitol Souvenir, a handsome advertising card, published by Mr. W.M. Edwardy," the *Galveston News* noted on March 1, 1885, the day before the laying of the capitol cornerstone. "It contains a lithograph picture of the state capitol." The newspaper applauded it as "a model of lithographic work...gotten up with that taste and care which are characteristic of Mr. Edwardy in his advertising enterprises. The Souvenir will be circulated throughout the State and distributed at Austin on the occasion of laying the corner-stone."

With the building's dedication approaching in the spring of 1888, vendors hoped to make money off the thousands of people expected for the event. "The carver and wood-workman who finished up the governor's room at the capitol has purchased all the remnants, and is working them up into beautiful souvenirs, as mementoes of the state capitol," the *Austin Daily Statesman* noted on May 6, 1888, ten days before the capitol dedication.

The State Preservation Board, which curates some 3,500 original or reproduction items of historical significance in the capitol, has in its

This souvenir coin was distributed the week of the capitol's dedication. *Author's collection.*

collection two small goblets made of pressed wood that were sold as souvenirs during the capitol dedication. Each bears a pasted paper label reading, "Capitol Building, Austin, Texas, May, 1888. This is to Certify that this SOUVENIR is Manufactured from the Remnants of the Lumber used for Finishing the Interior of the TEXAS STATE CAPITOL...Gus Wilke, Contractor." Another early capitol souvenir was identified when it surfaced for sale on the Internet auction site eBay. That item, purchased by a private collector, was a small piece of cut granite bearing a label asserting that it was left over from the construction of the capitol. It, too, noted the name of the capitol contractor.

The preservation board and a few private collectors also had a white metal commemorative coin struck as a dedication souvenir. One side features a raised image of the capitol with the wording, "Capitol of Texas" rounded on the top and "Dedicated May, 1888" rounded on the bottom. The other side of the coin has an image of an array of flags behind a cannon and a pyramid of stacked cannon balls. The top says "Camp Ross" and the bottom says "Austin Interstate Drill." Camp Ross was a large, if temporary, state militia bivouac on the south side of the Colorado River within a short march of the Congress Avenue bridge. The line about the drill referred to the maneuvers and "sham battles" the state troops held during the week of the dedication. Also sold were photographic prints of the new statehouse, suitably labeled "Souvenir...May 1888."

Another vendor sold copies of "The Texas State Capitol Grand Waltz," a special composition written by Lenora Rives-Diaz for the dedication. At sixty cents each, five thousand copies quickly sold out, according to *Austin Statesman* coverage of the dedication. Even the newspaper got into the act, selling within hours ten thousand copies of a special capitol dedication edition.

The most common of the older capitol souvenirs are postcards, the earliest dating to the first decade of the twentieth century when it cost just

a penny to send a card with a lithograph image on one side and space for a message and address on the other side. Postcard collectors have found dozens of Texas capitol cards. Far less common are vintage capitol postcards on which the sender actually wrote something about the statehouse itself. The preservation board has two such cards. One, mailed in 1906, was from a woman who had ascended the spiral staircase to the dome. "I climbed to the top of the dome on Sat. but I haven't gotten over the effects of the trip yet," she jotted on the card. Another woman, sending a card in 1916, wrote: "I climbed to the top of the Capitol dome…and was treated to a fine view of a small and not very nice city." While e-mail and texting have practically killed off the sending of printed "Wish you were here" images, postcards of the capitol are still sold.

A wave of Texas-related souvenirs hit the market in 1936 to capitalize on the Texas centennial celebration. A few, including a sterling silver ring, had images of the capitol, but most featured other Texas icons, particularly the Alamo. The majority of the items manufactured for sale bore the official seal of the Texas Centennial Exposition (which was held at the State Fair of Texas grounds in Dallas) and the dates 1836–1936. When the U.S. Post Office Department issued a three-cent Texas centennial stamp, at least one of numerous first-day-of-issue covers produced for philatelists featured an image of the state capitol.

Hundreds of prints of this photograph of the capitol got sold as souvenirs during the building's dedication in 1888. *Author's collection.*

Not everyone wanted to go to the trouble of paying for a remembrance of their capitol visit. In the 1930s, and perhaps earlier, the state kept watchmen in the building to guard against vandalism and theft on the part of souvenir hunters.

"Guards maintain constant watch to prevent souvenir hunters or others from despoiling the capitol of its historical treasures, but occasionally their vigilance is eluded," the Associated Press reported on May 31, 1938. "An example of vandal's work is seen in the iron grill which ornaments the niches near the rotunda where originals of the Texas Declaration of Independence from Mexico and ordinance of secession from the Union are displayed. A number of leaves and acorns have been broken off the decorative tree and vines."

More brazen souvenir hunters (sometimes including legislators) also were known to remove pieces of wood, finials and ornate brass door hinges and door knobs stamped "Texas Capitol." It got so bad, the state finally reinstalled the surviving original hinges, along with needed reproductions, with screws only a special tool can remove.

Over the years, visitors wishing to take home a reminder of their capitol could buy assorted statehouse trinkets in some of the stores and shops along Congress Avenue, including Woolworth's, when it was still in business. Items ranged from china plates bearing transfer images of the capitol to salt shakers. In the 1990s, the preservation board opened two gift shops, one in the new underground extension and one in the restored land office building. Both still sell plenty of capitol souvenirs seven days a week.

Most state capitols, and certainly the U.S. Capitol, have been commemorated with ornate silver spoons over the years. In fact, the gift shops at the capitol visitors' center and in the extension still offer a silver-plated capitol spoon. Older sterling silver spoons featuring the Texas Capitol occasionally turn up on the market.

Other capitol collectibles include coffee mugs, replicas of capitol architectural hardware, snow globes containing a small model of the capitol (which gets snowed on way more than the real capitol), miniature metal or plaster capitols and other traditional kitsch. The capitol also shows up in advertising pieces, from Grand Prize Beer coasters to mirrors to framed prints.

During the renovation and expansion of the capitol in the late 1990s, stone carver Philip Hoggatt of Dripping Springs, a community half an hour's drive west of Austin, heard that a quantity of granite and limestone from the statehouse had been removed and would likely be hauled off by

Right: A collage of capitol souvenirs from author's collection. *Photo by the author.*

Below: This display in the capitol visitors' center gives the history of the hugely successful Christmas ornament program. Proceeds from the sale of each year's ornament, which features some aspect of the capitol's architecture, go to help with capitol restoration projects. *Photo by the author.*

the contractor. Hoggatt drove to the job site and left with several pieces of stone laid more than a century before. At his shop outside Drippin', as locals call it, Hoggatt cut the stones into souvenirs, including Texas-shaped paperweights and other items. Each of the granite objects bears a small glued-on metal label: "Granite from the front steps of the capitol, once part of the Historic South Grounds Texas State Capitol, Philip Hoggatt, Artisan 2015."

The most successful capitol souvenir has been the annual capitol Christmas ornament introduced in 1996. Started by Nelda Laney, wife of Speaker Pete Laney, by 2016, the program had raised more than $8 million for Texas statehouse preservation projects. Each year's ornament features a different element of the capitol's architecture, from its dome to fence finials. Since the state stocks only the last ten years' previous ornaments, the earlier ones have become pricey collector's items.

"The capitol ornament is a wonderful way for Texans, and those who love Texas, to support the care of our magnificent capitol...and tell the incredible history that it represents," Julie Straus, wife of Speaker of the House Joe Straus, said in 2013. "The ornament is also a great way to put a bit of Texas on your Christmas tree."

LADY WITH A PAST

A lady with a past, she stood cloaked in mystery and a long robe.
For years, no one—including the press—gave the feminine figure atop the capitol much thought, although tens of thousands looked up at her daily. In fact, holding an upraised five-point star in her left hand and a downward-pointing sword in the other, she towered over the statehouse for thirty-eight years before finally capturing the eye of an Austin newspaper reporter who thought there might be a story about her to tell.

"Did you ever hear the legend that the giant cast iron lady in white on top of the capitol dome was once blown off the foundation by a wind storm, hanging only by a twisted girder, and that a bunch of valiant men and boys, including several University of Texas students, climbed to the top of the dome in the dark, as the storm whirled and lightning flashed, and after heroic efforts, finally put her back in place again?" the *Austin American-Statesman* asked in a breathlessly long sentence on February 25, 1925.

The newspaper reporter checked with the inspector of buildings for the state board of control (the agency then responsible for maintenance of the statehouse) and got this reply: "Impossible. For one thing the heroic maiden in white weighs several tons. It is firmly bolted in place, and the highest wind on record would not be sufficient pressure on it to move it. In the second place, if it were to topple over, it would go right through the dome and down to the basement."

What little newspaper attention the statue had received prior to 1925 had not been particularly positive. Shortly after she began her reign atop the

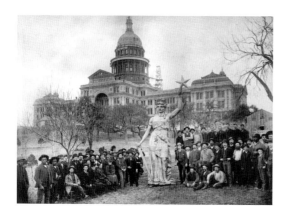

Austinites and construction workers posed for this photograph before the *Goddess of Liberty* statue went to capitol dome. *Author's collection.*

statehouse in February 1888, the *Austin Weekly Statesman* called her the "Old Lady Goddess" and observed that "her face resembles an old woman of 80." In 1903, another local sheet termed the statue "ludicrous," saying she stood out of proportion to the capitol. "One wishes as he gazes on it that it were lower that he might pelt it with mudballs," the writer concluded.

By the early 1950s, *Austin American-Statesman* reporter Frank Davis wasn't even able to confirm her name. Most people, he wrote, knew her as the *Goddess of Liberty*, but the chief justice of the state supreme court insisted she was the *Goddess of Victory*. Though Davis didn't mention it in his article, still others thought the statue was the *Goddess of Liberty Enlightening the World* or even a copy of the Statue of Liberty.

While some old-timers who had been around for the capitol's dedication in May 1888 still lived when Davis did research for his story in 1952, no one could even tell him what the statue was made of. Guesses included bronze, copper and marble. Neither did Davis find anyone sure of where she came from. Some said Belgium, France or Spain, while another story had her hailing from the Keystone State.

J. Steve Kennerly, then assistant curator of the Daughters of the Republic of Texas Museum (in the old Texas General Land Office building at the time), said that the statue had been cast in France and that the first statue intended for the capitol had been lost at sea on the way to the United States. On the other hand, a master's thesis on the capitol completed by J.L. Greer in 1932 said the statue had been cast of bronze at a temporary foundry in the basement of the building.

While no one seemed to know much about her, the robed lady finally had begun to cause talk. Gladys Greenwood, then an information clerk at the capitol, said the statue's sword pointed downward because "Texas gained her

independence from Mexico in 1836 and there was no more reason to fight." Less delicately, some said that Confederate veterans had pressured the state into having the statue looking south so that her backside faced forever north.

When completed during the last week of February 1888, she stood fourteen feet tall and weighed in at about a ton. Finally, workers laid on three coats of lead-based white paint mixed with sand to make her look like solid stone instead of hollow zinc.

After taking her place atop the capitol, the statue stood aloof literally and figuratively. The only time anyone got up close and personal with her was when she got a new coat of paint. The first time was in 1891, when painters found a hive of bees in her head. To keep from being stung, they supposedly poked two beer corks up her nose.

Fittingly enough, workers painting the capitol's dome in 1983 were the first to notice the iron lady had become a damsel in distress. At ninety-five, she had very much begun to show her age, with cracks visible on her arms, hand and sword. In 1985, the State Preservation Board (a successor to the old state board of control) contracted with the Sculpture Conservation Laboratory at Washington University in St. Louis to evaluate the statue. The lab concluded the lady needed help, her problems ranging from corrosion to missing pieces. Rather than repair the existing statue and keep it in place, the board decided to replace it with a reproduction and put the original on display in a stable interior setting.

Once the statue had been shored up with supports and straps, a Texas National Guard helicopter plucked her from her longtime pedestal on November 24, 1985, and sat her down on the capitol's south lawn. She hadn't been on the ground since the late winter of 1888, when someone took a photograph of her surrounded by folks prior to her placement on top of the new statehouse. (Contrary to legend, one of those who posed with the robed lady was not mustachioed former outlaw and Austin city marshal Ben Thompson, who was already dead by then, having been gunned down in San Antonio in March 1884.)

On June 14, 1986, a replica cast from a mold made of the original statue was hoisted to the top of the capitol by a large "Sky Crane" helicopter from the Mississippi National Guard, and two years later, the restored original went on display at the Texas Memorial Museum. When the Bob Bullock Texas State History Museum opened, she was moved there.

Meanwhile, as work proceeded on the original statue's rehabilitation, researchers delving into her story began to replace legend with fact—or, lacking absolute proof, more-informed guesses. The State Preservation

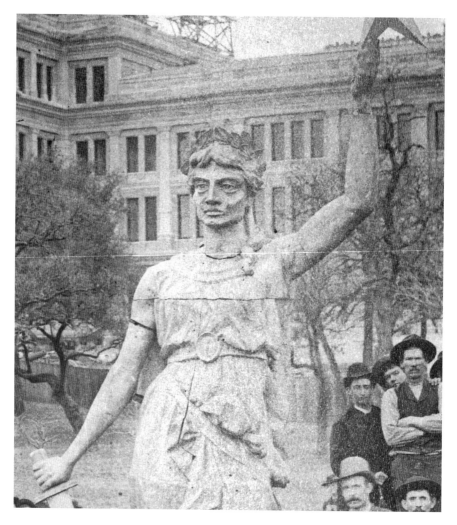

Features of the goddess's face had to be exaggerated so she would look good at a distance. *Author's collection.*

Board concluded that John C. McFarland of Chicago, the subcontractor who handled the capitol's galvanized iron and zinc work, furnished the statue as part of his contract. Two of his foremen—Albert Friedley and Herman F. Voshardt—oversaw the transformation of plaster molds made by an unidentified sculptor into a metal statue. The work involved welding eighty different zinc parts into four major sections: her torso, head and each arm. The sections were then hoisted to the top of the dome and put together with large iron screws.

Born in Manitowoc County, Wisconsin, to Norwegian immigrant parents during the Civil War, Herman Voshardt's surname somehow got attached to the most outlandish tale told about the statue. Supposedly, just before the statue assumed her perch above the capitol, Voshardt's nephew Tom rode up on a horse, grabbed a rope wrapped around the lady's not-so-delicate neck, kicked his mount in the flanks and attempted to drag her off. But given the lady's two-thousand-pound weight, the abduction went for only as long as the rope did. Accordingly, the next thing Voshardt knew, one of the Scottish stonecutters was helping him up off the ground.

Pressed for an explanation, Tom Voshardt is said to have claimed that his wife had posed for the sculptor who fashioned the statue and he simply could not bear the thought of her likeness being consigned to such a lonely spot. To support his case, he produced a small photograph of Mrs. Voshardt and showed it to the Scotsman.

"No offense laddie," the rock worker said after studying the image, "but I think the Goddess is a wee bit prettier."

"She's not only prettier," Voshardt said of the goddess, "she's far less demanding and considerably more cordial."

LOST AND FOUND

Jack Patterson fought panic.

The state worker had crawled beneath the floor of the House chamber, wedging himself between a sandy-colored brick subfloor and the old oak planks above. At most, he had two and a half feet of space in which to operate.

"It was easy at first," he said. "But the closer I crawled toward the front of the House, the narrower it got. I finally got stuck, and had to use a saw to cut a beam so I could get back out. I was about to get sick at my stomach, but I knew if I had gotten in, I could get out."

Patterson, who then worked for the state as a technical services employee, had been working on the installation of a new electronic voting board. To string new wiring, he had to get under the floor.

As the project continued, Patterson began mixing a little lay archaeology with his electrical work. He went on to discover a treasure-trove of yesterday's garbage under the House floor, some of it dating to the days when the granite statehouse was still under construction.

Each time Patterson entered the dark, sub-political world in the capitol, he found another piece of history. The material was casually displayed in a room in the Speaker's office. "We're getting a little museum here," said George Work, Speaker Bill Clayton's press aide.

Work said the oldest items discovered were two plaster pots, one bearing an 1885 patent date. Also dating from the mid-1880s were the remnants of a tobacco package discarded by some long-ago workman, a handmade scoop

Workers upgrading the House's electronic voting system in the late 1970s found numerous artifacts beneath the flooring. *Author's collection.*

fashioned with tin, wood and square-headed nails and a patent medicine tract guaranteeing a sure cure for everything from piles to headaches.

"We know this material was left by the men who helped build the capitol," Patterson said. "It's fascinating."

It seemed to him that just about every carpenter or repairman who crawled under the floor over the years had in some way left his mark. Patterson found a Prince Albert tobacco can with a 1910 revenue stamp on it, a 1914 *St. Louis Post-Dispatch* and an *Austin American* of the same date, an old Eastman film package that cautioned, "Develop before December 1920" and an empty five-cent box of Lemon Snaps.

Lawmakers have been known to blow their top on the floor, and apparently so did at least one unknown tradesman—Patterson found the lid only to an old-style white straw Panama hat. "Some carpenter probably cut the top out of his hat to keep cooler," Patterson said.

Things must have been a little rough for another long-ago maintenance man. Patterson found a pair of old black shoes, holes worn in both soles. Whoever owned the shoes had neatly folded a 1914 newspaper to use as liners. Why he took off his shoes and left them beneath the floor of the House can only be a matter of speculation.

Journalists, lobbyists and anyone else who knows anything about government understand that sometimes proposed legislation falls through the figurative cracks and disappears into oblivion—at least until the next session when its sponsor might give it another try. Patterson found evidence that might have actually happened, at least in one case: an undated proposal for limiting the money spent on high school textbooks to $285 for "1st class schools." Also discovered in the dust was a handbill, again undated, urging, "Listen for the Bombs! When you hear them go to the traveling Public Health Exhibit Car of the Texas State Department of Health and the Texas Public Health Association." Another handbill he discovered under the floor touted the West Texas city of Abilene, population 13,500, where farm and ranch land in tracts from 320 to 100,000 acres could be had for $2.50 to $5.00 an acre. (Based on U.S. census records, Abilene's population was 10,274 in 1920 and 23,175 by 1930.)

The state worker even discovered some early graffiti of the "Kilroy Was Here" genre. "Somebody named E.J. or F.J. Schock wrote his name all over down there," Patterson said. "He spelled his name in neat, German-style letters. He must have been a carpenter who was proud of his work."

Patterson was neither the first nor the last worker to find interesting things in the capitol. In the summer of 1963, state board of control plaster foreman Glendon Doss, while replacing some of the original ceiling in the capitol, found two vintage hand tools left on ledges of interior walls later covered. One of the tools was a stone drill, the other a rivet hammer. Both were hand forged. The river hammer (used to shape or turn hot rivets) had a hickory handle about sixteen inches long. The stone drill, about ten inches long, was used to drill dowel holes in granite, no easy job done by hand.

"Texas' Capitol may contain other 'lost' items of the 1883–1888 period," the article offered. Of course, the cornerstone is definitely known to contain historic artifacts, since newspapers of the day recorded the items that got sealed inside. The nineteenth-century time capsule included, among other things, a stone from the old capitol; a book of Texas statistics by Colonel A.W. Spaight; a copy of a speech given by then governor John Ireland; an olive leaf plucked from a tree on Mount Zion by F.S. Roberts; copies of the *Austin Daily Statesman* and the *Boston Gazette* of March 7, 1785, as well as other newspapers of the day; two twelve-inch ears of corn grown by one Henry Ray; "an ode to Texas by a young lady"; a twenty-five-cent meal ticket dated August 9, 1862; some Confederate money; and a "silk winder made and presented by Gen. Sam Houston to Miss Annie E. Kyle."

When the *Goddess of Liberty* statue was taken down in 1985, preservationists found a time capsule of sorts they didn't even know about. Discovered in the five-point star the lady holds was a German-language newspaper published shortly before the statue had been set in place, two newspapers from Wisconsin, an assortment of calling cards and a printed broadside.

Another round of surprise discoveries came during the restoration of the capitol in the early 1990s following the destructive 1983 fire that started in the lieutenant governor's apartment. In 1992, a cache of six old postcards dating from the early 1900s was found by workmen stuffed inside a wall near a window in a third-floor room likely once occupied by an appeals court judge or clerk. "Practice makes perfect but be careful what you practice" read one of the cards. Another said, "Here's champagne to our real friends, and real pain to our sham friends." One of the cards, showing a stately Victorian house on Dallas's Maple Avenue, had been mailed to Austin from Dallas on August 1, 1910.

Other finds during the 1990s capitol redo were a pair of black women's dress gloves and a fan discovered by a worker crawling under the House floor—items apparently missed by Patterson fifteen years earlier. Clearly dating from the initial construction was a portion of a plaster barrel lid

A fire in February 1983 heavily damaged the capitol and brought about a major renovation that revealed long-lost items. *Author's collection.*

labeled "Windsor Plaster Mills, Staten Island, N.Y." Its still-intact red-and-yellow label added, "The celebrated Diamond Brand Plastic. Pure white gypsum plaster was quarried from mines in Nova Scotia."

Not all unexpected capitol finds have been made by maintenance workers. Shortly after the beginning of what would later be called World War I, a clerk organizing and re-filing records stored in the capitol basement found an age-yellowed envelope containing $200 in cash, bills issued by the U.S. Treasury during the Civil War on March 10, 1862. Before the cleanup was completed, around $1,000 had been found. "It is not known how the money came to be lost among the records," the Associated Press reported on July 29, 1915. "The old records have been buried under odds and ends for years."

By far the most significant discovery made at the capitol came not long after noted Texas suffragette Jane Y. McCallum took her oath in January 1927 as secretary of state under Governor Dan Moody. In getting familiar with the records of her office, which ranged from corporate filings to extradition proceedings, she found the original copy of Texas's Declaration of Independence from Mexico stashed away in the department's vault.

The document, signed at Washington-on-the-Brazos on March 2, 1836, had originally been sent to the U.S. State Department in Washington. There it remained for at least the next sixty years before the federal government returned it to Texas. Presumably, one of McCallum's predecessors in office locked up the document. As the years passed and secretaries of state came and went, it had apparently been forgotten.

McCallum transferred the document to the state board of control in 1929. That agency placed the declaration into a revolving, custom-made iron and glass enclosure for display in the main corridor of the capitol. Governor Moody gave the keynote speech at the dedication of the new display on March 2, 1930.

When Moody concluded his remarks, seven-year-old Sterling Robertson Fulmore Jr. and young Mary Elizabeth Miller, descendants of declaration signatories Sterling Robertson and Samuel A. Maverick, pulled a Texas flag away to unveil the exhibit.

ALL TEXANS OWN THE CAPITOL, BUT...

Anyone who has ever bought a house knows that nothing gets signed until all parties to the transaction—seller, buyer, lien holder—are satisfied that a clear title exists for the land on which the property stands.

But while possession is proverbially "nine-tenths of the law," the state has never had a perfectly clear title to the land beneath the capitol even though it has paid for that land three times. In fact, an argument can still be made that the statehouse and most of the state office buildings surrounding it technically occupy land belonging to someone else, not the state.

The land saga started with Thomas Jefferson Chambers, who, in 1834 when Texas was still a Mexican province, gained appointment as superior judge of the Circuit of Texas. His court never convened, but in lieu of salary, Mexico awarded him an eight-league tract of land "on the eastern margin of the Colorado [River] near the foot of the mountains" that covered much of what is now the capital city. Unfortunately for Chambers and his heirs, he did not file a claim for this land in a timely manner.

Meanwhile, Texas declared its independence from Mexico in 1836, and Chambers served with distinction as a general in the revolution. After Texas won the fight, Chambers settled in Liberty County. Knowing the new Republic of Texas's constitution confirmed all Spanish and Mexican land titles, he apparently felt no rush to perfect his claim to the remote acreage in Central Texas.

When a five-member commission appointed by President Mirabeau B. Lamar recommended the village of Waterloo as the site for the young

nation's capital city, its Congress condemned 5,004 acres for government use and set aside $15,000 to pay the landowners. But for some reason, Chambers's land was not included, even though it contained the hilltop that one day would become the capitol site.

Since Chambers had never filed his claim, the republic's land office began doling out tracts from his grant to others as payment for their service to the republic. One of those grantees was Samuel Goucher, who in 1838 received roughly 1,500 acres. Unfortunately for Goucher, he never got a chance to enjoy his bounty. Not long after he obtained the grant, Indians attacked his cabin near Bastrop and supposedly massacred Goucher and his entire family. Edward Burleson (one-time Republic vice president) and Joseph Porter Brown had Goucher's land surveyed and filed a claim on it. Once they had title,

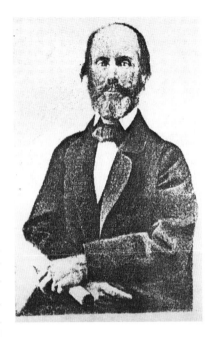

A participant in Texas's revolution against Mexico, Thomas Jefferson Chambers was the first owner of the land on which the capitol would later stand. *Author's collection.*

they conveyed it to the republic and got some of the money Congress had earmarked for buying the condemned land.

In 1840, Chambers finally decided to file on his land, only to discover that more than 150 patents had already been granted on his tract. One of those patents, the land that had gone to Goucher, is the tract on which the capitol would eventually stand. Chambers sued to recover his land, including the future capitol tract. His lawsuits dragged on for years, but Chambers never prevailed either with the Republic or the State of Texas following its admission to the Union in 1845.

While the late Samuel Goucher no longer figured in the capitol land dispute, at some point, it became apparent that his three children had not been killed by Indians, only captured. And they had since been ransomed and released. Since they were Goucher's legal heirs, the Burleson-Brown conveyance of the tract legally became moot. One of Goucher's sons had died in 1849, and a daughter named Jane had died around 1850, but not before bearing some children. That left another son, William

Goucher, who signed a quitclaim deed to one E.M. Smith in 1853 in consideration of $500.

In 1858, a year after the limestone state capitol had been completed on the still-contested property, the state supreme court handed down an opinion affirming Chambers's grant, ruling that Chambers had "as perfect a title as the law is capable of bestowing" to the 35,427 acres in question, including the 25-acre capitol grounds. For whatever reason, Chambers took no immediate action on the favorable high court ruling. Despite Chambers's legal victory in the supreme court, under the venerable doctrine of sovereign immunity—common law that goes back to the early monarchies—the "king" must grant permission before his subjects can bring suit. And the state legislature would not give Chambers leave to sue for payment.

Chambers may have believed that sooner or later he would prevail in his case, but for him that possibility and everything else ended on March 18, 1865. His family had just finished supper, and Chambers sat on the second floor of his home in Anahuac holding his six-month-old daughter Stella in front of an open window. Across from him, thirteen-year-old daughter Kate sat on a sofa while Mrs. Chambers occupied another chair nearby. Suddenly, a shotgun blast shattered the domestic tranquility. Still holding baby Stella, Chambers slumped over dead. The killer was never identified.

The matter of the capitol land seemingly died with Chambers. In fact, his family believed his murder had something to do with his claim.

Meanwhile, Smith had acquired legislative approval to sue the state for compensation for the capitol tract he had obtained from Goucher's son. But he did not actually file the suit until 1867, a decade later. Finally, in 1874, the state ponied up for the land—the second time Texas had paid for the capitol tract.

Following the death of their mother, Chambers's two (by then married) daughters, Stella MacGregor and Kate Sturgis, both of Galveston, believed they were the rightful heirs to the property and, in 1884, resurrected the dispute as the current capitol was under construction. They did that by filing a legal notice that improvements were going up on land they owned and those improvements would therefore automatically become their property.

Once again, however, the legislature refused to give its consent for the Chambers daughters to sue the state. That attitude on the part of Texas lawmakers so exercised former governor James Hogg that he offered to represent the two women for free. "Build a log cabin on the capitol grounds," he said, "move in and Jim Hogg will defend you in any legal actions brought by the state."

Proper gentlewomen, the two Galveston ladies declined to stoop to such an outlandish maneuver. Instead, they opted to go on with their lives, though frustrated by the fact that the state ought to settle with them.

In 1925, two elderly women walked into the Austin office of attorney R.E. Cofer and said they owned the capitol and its grounds. At first, Cofer later recalled, he thought the "sweet old ladies" were simply eccentrics with no valid case. But he agreed to look over the documentation they offered him, a large packet of vintage legal papers he called "General Chambers' Portfolio."

"I had not read thirty minutes until I realized that these women just as certainly owned the Capitol grounds as I owned my home," he wrote in an article published in the *Texas Law Review* in 1931. Agreeing to take the case, Cofer succeeded in getting the matter presented to the Thirty-Ninth Legislature.

"At first the Chambers case caused much banter and merriment among the legislators," he wrote. "The claimants' lawyers [he and a colleague] were greeted with the jocular inquiry: 'When are you and your clients going to move into the Capitol?'" But then the lawmakers got a chance to study the 1858 supreme court ruling. Dallas senator John Davis took the matter particularly seriously.

The state did not get a clear title to the capitol site until 1925, and even today, it's possible someone could make a claim of ownership. *Author's collection.*

"Mrs. MacGregor and Mrs. Sturgis can come marching up here with the sheriff in front, armed with a writ of possession, to take over the Capitol and its grounds," he told his fellow lawmakers. "In my judgment as a lawyer the state has a chance to settle a dangerous claim for a small sum."

Senator Davis thought that "small sum" ought to be $100,000, but the legislature ended up offering only a fifth of that: $20,000. That still being a lot of money in 1925, the sisters opted to take the money and signed a deed relinquishing their interest in the capitol tracts. Even though the two women no longer had a claim on the building or grounds, their father had left his mark on the building. Two stubby-barreled howitzers that General Chambers acquired for the Republic of Texas still flank the doors at the south entrance of the capitol.

Despite all the paperwork connected to the ownership of the land the capitol stands on, if anyone can prove that he or she is a descendant of Jane Goucher, yet another lawyer might be able to make some money on the land that first belonged to Thomas Jefferson Chambers.

CAPITOL GHOSTS

Slate employees put in their eight hours a day (usually more during legislative sessions) and then go home, but true believers in the supernatural say the capitol's ghosts roam the building around the clock.

"The Capitol is haunted day and night," ghost hunter and author Fiona Broome told the Associated Press in 2008. "If you've got a nice, misty day... people see ghosts walking up the path to the Capitol building all the time."

On foggy mornings, she said, mysterious handprints appear in the condensation of one of the windows in the Senate reception room. That's where a twenty-three-year-old man died in the fire that gutted the lieutenant's governor's apartment in 1983. Others, Broome said, have seen a ghostly lady in red, the supposed spirit of a woman who had been the secret lover of some long-ago lawmaker. Still others, she continued, have seen a dark-suited, derby-wearing man gliding along the corridors of the capitol.

One purported capitol apparition, a man who in life never set foot in the building he is said to haunt, is former governor Edmund J. Davis. No matter that he died in 1883 during the early building phase of the current capitol, his lingering ethereal self is supposedly occasionally seen peering from one of its large first-floor windows. Some claim the gray-bearded Davis will fix a chilling stare on a person and not look away until that person takes his or her leave. That the spirit of the governor, one of the least regarded of any of Texas's former chief executives, would like to hang around the capitol is understandable enough. (Assuming a person suspends rationality to the extent of believing in ghosts.) The Reconstruction figure, as close as

Texas has ever gotten to having a despot in the governor's mansion, was so reluctant to leave office in January 1874 that it took armed militiamen—and a refusal of federal military intervention by the president of the United States—to oust him from the old limestone capitol.

A ghost story's prime ingredient is someone's too-soon or violent demise, and the capitol has seen its share of both. At least three workers died in or near the capitol during its construction.[27] (Contrary to legend, they were not convicts. All the convict labor took place during quarrying operations either at Marble Falls or Oak Hill.) A fourth worker died accidently in the building early in the second decade of the twentieth century, and in 1977, a twenty-four-year-old man committed suicide by jumping from the third floor inside the rotunda.

The most notable violent death—the only assassination of a state official in Texas history—occurred in the capitol on June 30, 1903.

Fifty-six-year-old comptroller of public accounts Robert Marshall Love, a Confederate veteran and former lawman who had served both as Limestone County sheriff and U.S. marshal for the Northern District of Texas (August 28–December 11, 1894), sat behind his desk in his office on the first floor of the capitol's east wing when a man he recognized as W.G. Hill walked in about 10:00 a.m. as the comptroller talked with a local minister. Colonel Love, as he was known, and the clergyman greeted Hill and then continued to talk while Hill waited patiently. When the minister finally left, Hill handed Love a letter:

> *Dear Sir:*
>
> *Public office is a public trust. Public offices are created for the service of the people and not for the aggrandizement of a few individuals. The practice of bartering department clerkships for private gain is a disgrace to the public service, and in this nefarious traffic you are a record breaker. You have robbed the state employees and your incompetent administration has prompted others to rob the state. The greatest mind that ever gave its wisdom to the world, the mind of all others capable of "umpiring the mutiny between right and wrong" said, "You take my life when you do take from me the means by which I live." If that be true, you are a murderer of the deepest crime. Although I cannot help myself before laying life's burden down, I shall strike a blow—feeble though it be—for the good of my deserving fellow man. For the right against the wrong, in the weak the strong.*

As the comptroller sat reading the letter, Hill pulled a borrowed .38-caliber Smith & Wesson revolver from his coat and shot Love in the chest. Hearing the shot, chief bookkeeper J.W. Stephens rushed into the office in time to see Hill put a second bullet into Love. Hill then pointed the weapon at Stephens, who rushed him and began trying to take away the pistol. Scuffling, both men fell to the floor. As they continued to struggle, a third shot echoed through the capitol.

By this time, Love's secretary had come into the office along with the minister who had just left. After the third shot, Stephens and Hill lay still for a moment before Stephens slowly stood up while blood began to spread from under Hill. Stephens later said the revolver went off accidentally as he tried to pull it from Hill's hand.

At that point, though also shot in the chest and gravely wounded, Hill reached into his coat pocket and pulled out a vial of laudanum, an opiate that in a large enough dose could be fatal.

"Let me take this and die easy," he said, but Stephens slapped the drug out of his hand.

Love, made as comfortable as possible on a couch in his office, died at 11:05 a.m. with his wife, family and Governor Samuel W.T. Lanham at his side. His last words were, "I have no idea why he shot me. May the Lord bless him and forgive him. I cannot say more."

Hill, having been taken to the Austin Sanatorium, died at 2:30 p.m. The killer was a former employee of the comptroller's office "whom Colonel Love had refused to retain in his official family." He would not make a dying declaration, but the letter he had given Love and the life insurance policy he had taken out the day before made it clear enough that he had planned to kill his former boss and then commit suicide.

"Texas loses her first official at the hands of an assassin," the *Austin Statesman* noted the following day.

A postcard image of the capitol at night, when many believe the ghosts come out. *Author's collection.*

The Office of the Comptroller of Public Accounts, having grown over the years, left the capitol for its own office space in the 1960s. But legend has it that Colonel Love's ghost never got the memo and continues to occupy his old office in the east wing of the first floor.

In 1915, only a dozen years after Love's murder, people started hearing an unearthly howling in the statehouse at night. After a day or two, someone finally identified the source of the scary sounds: the state health department, then located on one of the upper floors, held a quarantined dog that apparently got lonesome in the evening after everyone had left the office for the day.

In 1962, an Austin man named C.D. Greer self-published a booklet containing a poem called "The Phantom Capitol." As Greer explained in a note at the end of the poem,

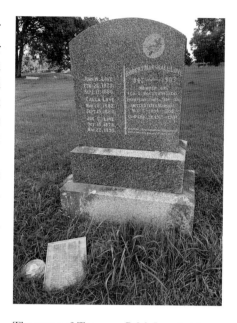

The grave of Treasurer R.M. Love in his native Limestone County. Ironically, he came from Tehuacana, which early on had been in the running as the seat of government instead of Austin. While serving as comptroller, Love was gunned down inside the capitol. *Photo by the author.*

> *The phenomenon alluded to…is accounted for in this manner: Mighty floodlights are turned on the capitol dome at night, and are left focused until twelve o'clock. When there are low-hanging banks of clouds above the capitol, these serve as a background upon which the shadow of the capitol dome is projected. Since floodlights are focused on the dome from all four sides, you may see the "phantom" from as many directions as you may choose to look.*

Some say another capitol ghost is that of a man buried in an unmarked grave on the capitol grounds. The only problem with that story is that there isn't anyone buried at the Texas Capitol Complex. But there is a lost-grave story connected to Austin's first statehouse, the one-story frame structure built for the government of the Republic of Texas and used from 1839 to 1853. The intersection of Colorado and Eighth Streets now covers the site.

According to the State Preservation Board, descendants of one John Ballantyne contacted the agency in June 2000 to say they had heard their forebear's unmarked grave lay somewhere on the capitol grounds. They said they had found that Ballantyne, who died in 1846, had been buried "near the river…on the capitol Grounds." Since the site of the present capitol was only an undeveloped hill top in 1846, the preservation board realized the burial must have occurred near the first capitol. Why officials of the day saw fit to allow Ballantyne's burial on state property remains a mystery.

MORE CAPITOL MYTHS

The statehouse has no shortage of tales best not taken for granted. Here's a rundown of some of them.

It's Not Pink

For years, practically everything written about the capitol would have readers believe the statehouse was built of pink Texas granite. Unfortunately for those who think pink, that's wrong. The correct color is red, sunset red to be exact.

Not that there isn't such a thing as pink granite. That's the type of stone that comes from a quarry near the Burnet County community of Granite Shoals, but the stone for the capitol was not quarried there. Starting in late 1885, all the rock hauled to the capitol construction site came from Granite Mountain west of Marble Falls, which affords sunset red granite.

Who first decided to gentle a bold, Texas-sounding color like red to wimpy pink is not known, but vintage capitol postcards from the first decade of the twentieth century correctly refer to the capitol granite as red. Red granite or pink, there's actually more limestone in the building than granite.

WHY THE CAPITOL FACES SOUTH

Myth has it that the main entrance of the capitol faces south as a snub to the North, a reflection of the degree of sectional animosity that still existed when construction of the new statehouse began nearly two decades after the Civil War. Of course, the 1853 capitol, built eight years before the Civil War, also faced south. So did many buildings in the days before air conditioning, since south-facing structures caught more cooling breeze.

The other part of the facing-south myth is that the placement honored the memory of the 342 men massacred at Goliad on March 27, 1836, during the Texas Revolution, but no documentation has been found to support that. The truth is that having the capitol's main entrance on the south side was an obvious choice. In addition to being able to take advantage of the prevailing winds, the Colorado River and Congress Avenue was the logical area the building should face.

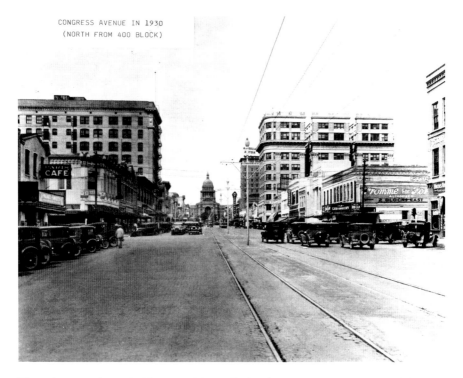

The only reason the capitol faces south is to afford a view of downtown Austin and the Colorado River (now Lady Bird Lake). *Author's collection.*

THE TWIN SISTERS ARE NOT THE TWIN SISTERS

Since 1910, two short-barreled cannons have flanked the main entrance of the capitol. Known as the Twin Sisters, the twenty-four-pounders were among six pieces ordered by Major General Thomas Jefferson Chambers during the revolution against Mexico in 1836. Unfortunately, they did not arrive until April 1837, a year after the fighting ended. (Contrary to legend, Chambers did not use his own money to buy the cannons and did not give them to Texas; he just picked them up when they reached New Orleans from the foundry in Pittsburgh.) Though popularly known as the Twin Sisters, they are not *the* Twin Sisters—two matching artillery pieces donated by the citizens of Cincinnati, Ohio—used to such devastating effect in the pivotal Battle of San Jacinto on April 21, 1836. Those historic guns disappeared after the Civil War and have never been located.

THE CAPITOL HAS CANNONBALLS IN ITS WALLS

The State Preservation Board shoots this myth down on its website, theorizing it is probably based on a misreading of the capitol's architectural plans. A notation in Exhibit F, Appendix to the Memorandum of Agreement (October 20, 1884), says that "five eight inch round iron shall be substituted for one inch by one quarter flat iron for the anchors in the exterior walls." That refers not to cannonballs, but metal anchors used to affix ornamental granite stone to the base wall. And no, the anchors are not old nautical anchors.

ALL THE BUILDING MATERIALS CAME FROM TEXAS

The limestone and granite in the building is native to the Lone Star State, as well as some of the iron and some of the interior wood, but not all of it. Some of the wood, not to mention everything from nails to the ornate brass door hinges labeled "Texas Capitol," was shipped to Austin by rail. Much of the construction material was procured in Chicago, since that's where the Capitol Syndicate had its office.

THE WASHINGTON MONUMENT COULD FIT INSIDE

Somehow, reflective of Texas braggadocio, the story got started that the Washington Monument could stand inside the rotunda and not touch the inside of the dome. But the monument in D.C. is 555 feet and 5⅛ inches tall—more than 200 feet higher than the Texas Capitol.

THE CAPITOL HAS SECRET TUNNELS

Legend has it that secret tunnels large enough to accommodate horses extend from the statehouse to what is now Lady Bird Lake. The capitol did have tunnels, but they were for utilities and neither secret nor intended as escape routes. One of those tunnels, though not nearly large enough for man or beast, was dug to carry sewage to the Colorado River. Fortunately for the environmental health of the river, the tunnel extending from the statehouse was later tied in to a city sewage line for proper treatment. Building plans also included a tunnel five feet high and three feet wide connecting the capitol to the powerhouse that once stood northeast of the building. That tunnel held steam lines for heating and electric lines.

THE CAPITOL BASEMENT
ONCE ACCOMMODATED HORSES

Horses were still the primary motive power when the capitol opened in 1888, but contrary to the myth that the basement had a stable, visitors and lawmakers kept their horses tied outside. For one thing, how would folks have gotten horses in and out? Surely nineteenth-century officials knew that such an extravagance as a below-ground horse parking would have led to way too many jokes about horse manure piling up in the statehouse.

THE CAPITOL HAD AUSTIN'S FIRST TELEPHONE

Even the capitol that the present capitol replaced had a telephone by the time it burned down in 1881. In fact, Austin's volunteer fire department got alerted to the blaze by telephone. The temporary capitol also had a telephone installed in 1887, the city's twenty-fourth.

FAMOUS FURNITURE THAT ISN'T

As anyone who grew up in the 1950s can attest, Davy Crockett, King of the Wild Frontier (and ill-fated Alamo defender), was "born on a mountaintop in Tennessee." The Governor's Public Reception Room in the capitol has a table that legend says is made of cherry wood from the old Crockett place back in the Volunteer State. Also, its marble top supposedly was smoothed by one of Crockett's relatives. In truth, the table is merely one of hundreds of pieces of Victorian-era furniture bought for the capitol in the 1880s from A.H. Andrews and Company of Chicago, the top maker of office furniture in the late nineteenth century.

Another unusual piece in the second-floor room is an S-shaped tête-a-tête chair supposedly made of Texas mesquite by prisoners in Huntsville. Again, not true. In the same room, the capitol's fanciest, hangs a fifteen-foot-tall mirror supposedly given to Texas by the people of France on the occasion of the new statehouse's dedication. Alas, it came from Chicago, another low-bid state purchase. Nor is it one of only three perfect mirrors in the world, as has been occasionally claimed. Finally, legend held that the velvet drapes in the room came from Persia. Actually, they also probably came from much less exotic Chicago.

For years, many believed a desk in the secretary of state's office once belonged to Texas colonizer Stephen F. Austin. Another story has it having been used by Sam Houston. Research has been unable to verify either claim, though the desk is believed to be older than the capitol.

On the other hand, an odd-looking colonial-style chair with a large, extended right arm (that part reminiscent of a school desk) that sits in the Legislative Reference Library does have a provenance connecting it to Mexican dictator General Antonio Lopez de Santa Anna. He used it while a prisoner for a time in the residence of Dr. James Phelps following the Battle of San Jacinto. Phelps's descendants later presented the piece of furniture to the state.

THE CAPITOL'S WATER COMES FROM AN ARTESIAN WELL

Two wells were drilled on the capitol grounds way back, and there was an artesian well that got covered when the building went up, but when state employees, legislators and visitors get thirsty and head for a water fountain, they drink city water.

Restored artesian water fountain near the south entrance of the capitol. *Photo by the author.*

SYMBOLIC STEPS TO THE SENATE

The first flight of the back stairs leading to the Senate between the first and second floors on the east wing of the capitol has thirty-one steps—one for each senator. The second flight contains eight steps. That used to be the number of Texas constitutional offices: governor, attorney general, land commissioner, comptroller, treasurer and three railroad commissioners. Those two coincidences led to speculation that the number of steps might have been intentionally symbolic, but the railroad commission was not created until after the capitol was built. (And in 1996, the duties of the treasurer were folded into the Comptroller's Office.)

THE *GODDESS OF LIBERTY* IS PREGNANT

Somehow, a story got started that the *Goddess of Liberty* is "with child," as they used to say in proper Victorian times. The figure does seem to have a bit of a tummy under that long robe, but no documentation exists to support that she was intended to look like a mom-to-be.

Detail of capitol architectural drawing showing the *Goddess of Liberty* statue on top of the dome. No, she wasn't intended to look pregnant. *Author's collection.*

No Ladies Restroom Until 1966?

While it's not true that women did not get a place in the capitol where they could powder their noses until three years into the LBJ administration, it is true that it is easier for a woman to find a restroom in the capitol than it used to be. But the original plans did provide for a "Ladies Retiring Room" on the third floor next to several other "water closets," which was a Victorian era euphemism for restroom.

The late Curtis Tunnell, when executive director of the Texas Historical Commission, put the matter of capitol folklore in perspective in 1995: "Texas has a unique heritage, a certain mystique, and people tend to fill in the blanks with their own stories—more so, I think, than other states. There are so many real, incredible stories about the capitol, it follows there would be a lot of good ones that were not true."

Indeed, truth has never been an essential element when it comes to a good story.

"Texas loves the capitol, and it loves the stories about it," said Dealey Herndon when she headed the State Preservation Board, "even if they aren't true."

MORE TRUE TALES

WHEN PIGS FLY

During its construction, as the granite building rose story by story, someone suggested, presumably somewhat tongue-in-jowl, that a pig should grace the top of the new capitol. This porcine proposition traced to an incident during the days of the Republic of Texas, when someone in Austin killed a hog belonging to the French charges d'affaires. That would have amounted to nothing more than an unpleasantness between the Frenchman and the hog shooter had it not been for the fact that the financially strapped republic had been trying to negotiate a much-needed $5 million loan from France. The pig incident proved to be the huff and the puff that blew the deal. But one historian later concluded the French loan would have been a pig in a poke, in that some of its provisions would have given the European power a toehold that might have ended in Texas becoming a French colony. In other words, a pig might have given its life for Texas and therefore deserved remembrance at the new capitol.

GOING UP?

If the elevator in the capitol when it opened in 1888 was not the first mechanical lift in the state, it was the fanciest by far—at least on paper.

That first capitol elevator was hydraulic, operated with water pumped from cisterns to an attic tank on the fifth level. The original architectural

drawings had specified two such elevators, but only one was built at first. Architect Myers had envisioned quite the elegant lift, more like a small private railway car than an elevator. As designed, it would feature fifteen mirrors set into panels of butternut and maple with some cherry wood thrown in for good measure. Leather seats stuffed with horsehair and springs would line the sides as well. Interior columns would be of mahogany. But practicality (and cost considerations) ended up trumping art, and what the state had built was a fairly plain wooden lift.

The *Austin Weekly Statesman* commented on the new elevator in June 1888. "A young man named Tollman is doing the escorting business [operating the lift], and yesterday the elevator made a great many trips up and down. This will prove a great improvement on the climbing-up-stairs business, especially during the hot weather."

A second elevator (on the north wing) was not installed until 1907. That was an electric elevator, and the first elevator, which was near the main entrance on the south wing, was converted to electric power at that time.

Roger Pinckney, a descendent of Governor James Pinckney Henderson, was a capitol elevator operator in 1961–62, working for the old state board of control after school and on weekends. Getting proficient at running the elevator, he recalled, was like learning to drive an automobile. The trick was in being able to stop the car so it was even with each floor. "You didn't want the governor to trip and fall," he laughed. If he stopped between floors and opened the door, he could read graffiti left on the limestone interior walls by construction workers in the early 1880s. By the late 1960s, the building's elevators had been automated.

TEXAS'S TALLEST BUILDING UNTIL 1929

Not only is the capitol taller than the nation's capitol, for forty-one years after its dedication, it stood as the highest building in Texas.

Given the generally accepted architectural standard that one floor equals 10 feet, to the tip of the *Goddess of Liberty*'s star, the capitol is slightly taller than a thirty-story skyscraper. Calculated solely on building height, not the number of floors with usable space, the capitol remained Texas's tallest structure until 1929 when Houston's 430-foot Gulf Building opened.

For years, the capitol also stood as the tallest of the state capitols. These days, five state capitols are taller than the one in Austin.

Before Austin became known for its music, barbecue and other modern attractions, the capitol was the city's prime tourist draw. A big bragging point was the building's size, mentioned in this early promotional piece. *Author's collection.*

HOME UNDER THE DOME

Since completion of the two-story governor's mansion across Eleventh Street from the capitol in 1856, the state has provided a residence for its chief executive. Not to be outdone, the lieutenant governor and Speaker of the House live in apartments behind their respective chambers, at least during legislative sessions.

Architectural drawings for the capitol included two rooms each for the lieutenant governor (the presiding officer of the Senate) and the Speaker of the House, but they were not intended as living quarters. While it is not clear how soon those officials began living in their respective rooms (the best guess is the early 1900s), judges of the state's two highest courts—the court of criminal appeals and the supreme court—lived in the capitol near their respective courtrooms from the time the building opened until the two high courts moved to a separate state building in 1959.

By the 1890s, chafing at their paltry per diem, to cut costs some senators and House members also took to living in the capitol during legislative sessions. Observing that the public often saw "red blankets and soiled sheets aired in the windows," in 1891, the *Austin Statesman* complained that the new statehouse had been converted into a "cheap John boarding house," with lawmakers sleeping "in different offices, corridors, garrets and in any corner they can find room for a cot."

Even though the lieutenant governor and speaker had been living in the statehouse for decades, it did not become legal until 1943. In fact, before then, a state statute prohibited using any portion of the capitol as a bedroom. Despite the eventual repeal of that law, a senator who argued that the free lodging was unconstitutional in that it amounted to extra compensation, tried in 1957 to evict Lieutenant Governor Ben Ramsey and Speaker Waggoner Carr from their capitol quarters. The effort failed.

A minor irony is that for decades, a state employee got paid to sleep in the capitol as a human burglar alarm outside the main vault in the first-floor treasury office. That continued until the department moved to a new building in 1971.

In modern times, if a lawmaker sleeps in his or her office, it's a nap between roll call votes.

THE MILLION-DOLLAR PARADE

Since the opening of the capitol, parades on Congress Avenue form on the thoroughfare's south end and proceed uphill to the statehouse. Starting with the 1888 dedication parade, the avenue and the capitol have seen hundreds of processions ranging from inaugural parades to marches celebrating the nation's victory in war to antiwar protests. But none was as strange as the one that proceeded up the avenue on April 24, 1909, the so-called Million Dollar Parade.

On that day, guarded by mounted Austin police officers, Texas Rangers, the Travis County sheriff and the chief of police, an entourage of county and state officials, numerous lawyers, several bankers and a district judge escorted $1,808,483 million (and thirty cents) in cash from two local banks to the state treasury. The money was a civil fine being paid by the Waters-Pierce Oil Company for antitrust violations in a case dating back to 1897, the largest corporate fine ever paid to that point in U.S. history. Had it not been for that infusion of cash, the state budget would have experienced a $347,144 deficit that year.

Capitol Once Had a White Dome

For whatever the reason, in the early 1920s, the state decided to paint the capitol dome white. The new coating had not even dried before the public started complaining about it, and capitol maintenance workers returned the dome to its original faux red granite look. For two weeks in 1969, during a repainting of the dome, visitors and locals were taken aback by the yellow-green primer coat. To make the dome better match the building, granite powder was added to the paint that went on next.

Thelma's Walk

Thelma Bills Anderson, who grew up a block from the capitol, became the Senate's first female page in 1931. That's reason enough to be remembered, but the potentially deadly stunt she pulled off on a dare is even more memorable. When her male teenage colleagues said she didn't have the intestinal fortitude to stand up on the eleven-inch-wide railing on the second floor of the rotunda and walk the full circle, thirteen-year-old Thelma took them up on it. To the boys' amazement, she climbed up on the railing and did it.

The Capitol Gets Cool

While hot air in the metaphorical sense is not unknown in the capitol, especially during legislative sessions, actual hot air used to be a real annoyance. The only means of air conditioning when the capitol opened were large windows and, not too long after, electric fans. Steam heat kept the massive building warm in the dead of winter, but during the dog days of summer, state workers, lawmakers and visitors were mostly on their own temperature-wise. During the legislative session of 1913, House and Senate members were kept semi-cooled by electric fans blowing over blocks of ice.

Forty-eight years after it opened, the capitol got its first air conditioner in 1936, when a window unit was installed in the governor's reception room. Finally, in 1955, the legislature appropriated $500,000 to have the capitol

air conditioned, an undertaking completed in 1957. In fairness to the state, central air in most schools, courthouses and other buildings did not become universal in Texas until the late 1960s or early 1970s.

RADIOACTIVE STONES

In the 1960s, with the specter of nuclear war with Russia on most thinking people's minds, state employees had something else to worry about: tests showed that people working in the capitol absorbed 5.0 to 10.0 millirems more radiation yearly than the average person. The source? The granite stonework that defines the statehouse. Even though the igneous rock

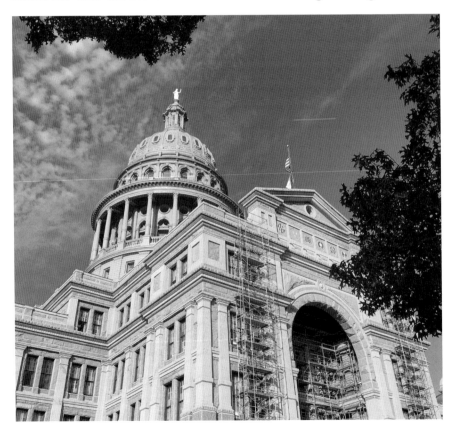

No one glows in the dark after visiting the capitol, but health officials have found that its granite walls emit low-level radiation. *Photo by the author.*

emits radiation in the form of radon, an odorless, colorless gas, the state health department said it was not high enough to worry about. The Texas Administrative Code sets the maximum radiation level per person at 0.1 rem per year for public buildings, or, overall, 2.0 millirem per hour. While radiation detected in the capitol sometimes reaches 10.0 micorem per hour, exposure under 5.0 rem produces no demonstrable health effects.

Red Light Under the Dome

As late as the early 1970s, the capitol stood open to the public around the clock. The huge statehouse had no video surveillance, no panic alarms for key officials, no metal detectors, no armed officers constantly patrolling its corridors and no mounted state troopers riding around the grounds. Consequently, late at night and in the wee morning hours, the big building made a convenient workplace for ladies of the evening. Police occasionally cracked down on freelance prostitution under the dome, but the problem did not go away until domestic terrorism necessitated much tighter security.

Unstately Statehouse

Members of the Texas House of Representatives and the Senate operate according to state and federal law, long-established parliamentary procedure and rules they adopt. Most of the time.

In its February 21, 1933 edition, the *Dallas Morning News* noted: "Senator Hits Lawyer with Heavy Pitcher after Lie Is Passed." The democratic process is not always stately. Thirty years after that Depression-era difference of opinion in the upper chamber, about the only thing that had changed was having a better sound system in both the House and Senate.

The late writer Willie Morris—a Mississippian who came to the University of Texas in 1953, worked on the student newspaper (the *Daily Texan*) and later edited the iconoclastic *Texas Observer* and still later *Harper's Magazine*— witnessed an incident in the House that demonstrates decorum is a fragile thing.

One night, as he described in his memoir, *North Toward Home*, several House members were in the midst of a vicious floor debate when suddenly one representative "pulled the cord out of the amplifier system…[and] another

hit him from the blindside with a tackle." That set off "mass pushing, hitting, clawing, and exchanges about one another's wives, mistress, and forebears." Guests of members, including girlfriends, wives, friends and secretaries, "cowered near their desks."

Morris continued: "In the middle of the brawl, a barbershop quartet of legislators quickly formed at the front of the chamber and, like a dance band during a saloon fight, sang 'I Had a Dream, Dear.'"[28]

A Capitol Sense of Humor

Beyond physical violence or the threat of it, over the years, numerous examples of less-than-decorous antics on the part of both legislative chambers have become part of the capitol's folklore.

In his memoir, former railroad commissioner C.V. Terrell, who had marched in the capitol dedication parade, recalled a session during which lawmakers were considering a bill involving "prohibition of whiskey and regulatory measures." When the House chaplain offered the daily prayer, he asked for divine assistance in passage of the "dry" bill. When the prayer appeared in the next morning's House journal, members opposed to the measure moved that the chaplain's remarks be expunged from the record. As members debated that motion, one representative stood and raised a point of order. When the Speaker recognized him, he said, "The motion to expunge the prayer from the record comes too late. The prayer has already reached the Throne."

The generally accepted low point in Texas legislative humor came on April Fools' Day 1971, when two representatives sponsored a resolution praising Albert DeSalvo, the notorious Boston strangler, for his efforts in population control. The resolution was subsequently withdrawn.

Truth in Fiction

The late Texas author Al Dewlen, who began his career as a newspaperman in Amarillo, practically had the capitol as a character in his 1981 political novel, *The Session*. The book's protagonist, a newly elected House member, comes to Austin in his old pickup truck with an honest enthusiasm to fairly

represent his district and perhaps, as so many politicians have said, "clean up" state government. Much of the action in the book happens in the capitol, a structure Dewlen captures in this evocative word picture:

> [T]*he Capitol floodlights came on, and by that magic he had chosen never to understand, all the stacked and sculpted Texas granite climaxing in the magnificent dome instantly changed color, from daytime's rich pink to a glistening night white. Day or night, pink or white, the great dome with its pillars and ribs, cornices and carvings, was a spectacle.*

Longtime House member Emmitt Curry, the same character making that observation, also took inspiration from the *Goddess of Liberty* standing atop the dome, "a sword pointing downward from her right hand while she raised the Lone Star of Texas aloft in her left. The pose prompted outsiders to say that she was proclaiming that in Texas, liberty was left-handed. But… the stone lady meant every decent thing he knew, and it could warm him just to look up at her."

Dewlen moved from Amarillo to Austin to write *The Session*. Later, he relocated to Waco and joined the journalism faculty at Baylor University. He died in 2011 at age eighty-nine.

Best Little Statehouse Movie Set in Texas

Hollywood has twice used the capitol for scenes in mainstream films, the most notable being the 1982 musical comedy *The Best Little Whorehouse in Texas.*

The movie was inspired by Larry King's popular 1978 Broadway musical, which in turn was roughly based on the story of a widely beloved brothel outside the Fayette County town of La Grange, between Austin and Houston. Known as the Chicken Ranch, its roots dated to the days of the Republic of Texas, and it had become an institution. Houston television reporter Marvin Zindler "exposed" what just about everyone in Texas (including law enforcement) already knew, which was that Texas had a whorehouse. Afterward, in 1973, Governor Dolph Briscoe ordered the Department of Public Safety to shut it down. Sheriff Jim Flournoy (played in the movie by Burt Reynolds) didn't like it, but the state prevailed.

The lovin'-for-pay place kept by madam Edna Milton (played in the movie by Dolly Parton) had, of course, never maintained a guest register, but over the decades, many a legislator (not to mention male-born state workers) took time from their busy capitol schedule for the hour's drive to La Grange. Thus it seemed quite fitting that Hollywood location scouts arranged for the filming of actor Charles Durning's notable gubernatorial song-and-dance routine in the rotunda of the statehouse.

In 1992, director Clint Eastwood filmed much of *A Perfect World* (he and Kevin Costner played the two main characters) in Central Texas. One scene, featuring actor Dennis Letts as Governor John Connally and John Hussey as the governor's aide, was shot in the governor's reception room at the capitol. A crime drama set in 1963, Eastwood portrayed Texas Ranger captain Red Garnett, who was after prison escapee Robert "Butch" Haynes (Costner). The wanted man had compounded his crime by kidnapping an eight-year-old boy.

The Texas capitol is the only statehouse in the United States used as a setting in a movie about another kind of house, one of ill repute. This is a playbill from the original Broadway production of *The Best Little Whorehouse in Texas*. *Author's collection.*

STATEHOUSE TIME TRAVEL

Legislators have perfected something mankind has fantasized about for centuries, the ability to travel in time.

But in the capitol, the only way lawmakers journey, if only for a few hours, is back in time. Both the upper and lower chambers each have large, still-functional clocks first installed in 1888. If faced with unfinished business as a session nears midnight on the final day of its constitutionally mandated 140-day session, House speakers and lieutenant governors (as presiding officer of the Senate) have often ordered their respective sergeants-at-arms to get a ladder and move the hands of the clock back from midnight until the body finally concludes its business.

ZOMBIE CAPITOL

Zombie-like, the old limestone capitol that burned in 1881 nearly rose from the dead in the late 1950s.

Though roundly disparaged by both those who used it and those who had to look at it, the three-story limestone statehouse built in 1853 and gutted by fire twenty-eight years later seemed on the verge of coming back to life in 1958. That February, the state library and historical commission (long since split into separate state agencies) proposed building a reproduction of the antebellum colonial-style capitol to house a state library and archives desperately in need of a new home.

While the library continued to maintain its presence in the 1888 capitol, most of its records, many dating to the days of the Republic of Texas, were stored in a Quonset hut at Camp Hubbard, a state highway department facility in West Austin. The raw materials of Texas history lay only an invasion of silverfish or a fire away from disaster.

Apparently with straight faces, the library and historical commission forwarded to the state building commission an architectural rendering showing the same old building except for the addition of two new wings. Along with the drawing came an estimate that building a replica of the old capitol would cost $2,500,000.

Fortunately, rather than cloning a building that had been poorly designed to start with, a different concept emerged: to relieve pressure on the 1888 capitol, the state would build a complex of modern, granite veneer state

Despite its nineteenth-century unpopularity, the 1853 capitol nearly made a comeback in the 1950s. *Author's collection.*

buildings that would not clash with the cherished but no longer modern capitol. One of those buildings, opened in 1961, became the new home for the state library and archives.

By 2017, the Texas Capitol Complex included twenty-nine state buildings plus the capitol they surround, covering 122 acres of downtown Austin.

SINE DIE

The Texas Constitution limits a regular legislative session to 140 days every two years. (An old joke has it that the Constitution got it backward... the legislature ought to meet for two days every 140 years.) However often it convenes, when the gavel cracks for the last time on the final day, the House Speaker and president of the Senate declare their respective bodies adjourned sine die.

Those two Latin words literally mean "without day," but they long ago developed their current meaning, which is that a governing body has concluded its proceedings without naming a day for further meeting or hearing. In all state legislatures or assemblies, as well as the U.S. Congress, sine die has further come to mean "the last day of the session."

Since this book is about the Texas Capitol, where both chambers have met since the Twenty-First Legislature gathered on January 8, 1889, saying "sine die" seems a proper way to end it. As with any legislative session, while a fair number of things have been accomplished (in this case, stories told), more stories could be told.

Even in modern times, standing on ground first designated for governmental use by the Republic of Texas, the capitol is a large, architecturally complicated building. Its ongoing story is large and complicated as well. The capitol has seen and will see statesmen and scoundrels at all levels of government, civilian and military leaders and followers, lawmakers, law enforcers and lawbreakers, supporters and opponents, celebrities and just folks—all, in some way or another, will

interact with this building raised at the height of the nineteenth-century's Gilded Age as the people's house.

The capitol is still every Texan's building, though the specter of terrorism and the growth of bureaucracy have made it less accessible. For instance, the men who planned for and built this building would have never dreamed that one day visitors would have to empty their pockets or hand over their pursues and then walk through a metal detector before they could enter the building. Neither would they have envisioned that a journalist or private citizen would sometimes have to file an open records request for information about their government's doings or even to get an answer to a simple question. Just getting a response to an e-mail or a telephone call returned from someone with an office in the capitol or some other state building is not guaranteed.

On the upside, the law giving the public the right to demand all but legally protected information from its state, county and local government came into being inside this capitol. So will all future state laws, good or bad. Still, the capitol is more than a place where legislation passes or fails. It holds the story of Texas, past and future.

Adjourned sine die.

CAPITOL NUMBERS

3	Acres the capitol covers
4	Months it took draftsmen to make triplicate linen drawings of original capitol plans, 117 drawings total
5	Pairs of iron carriage gates installed on the grounds in 1890, each set spanning 14 feet; all removed in 1907
7	Miles of wainscoting in the capitol. Wainscoting is made from oak, pine, cherry, cedar, walnut and mahogany; doors and window frames are oak and pine except those in the governor's reception room, which are cherry, mahogany and walnut
7.75	Weight (pounds) of each custom-made, eighteen-inch-long bronze door hinge stamped "Texas Capitol," including screws
8	Weight (tons) of capitol cornerstone before dressed
8	Diameter (feet) of star in dome
8.5	Floor space (acres) in capitol. Original flooring was hand-blocked clay tile, glass and wood; current halls and rotunda are terrazzo
10	Derricks at construction site used to offload limestone and granite
10–15	Number of flatcars of granite shipped from Burnet to Austin daily during capitol construction
18	Vaults in capitol
19	Elevators in the capitol (8 in the original structure, 11 in the underground extension)

21	Number of monuments standing on the capitol grounds
29.93	Tons per square-foot load imposed by dome at fourth-floor level
32	Legal-size pages in state's initial contract with capitol builders
39	Sheets of original architectural drawings by E.E. Myers
46	Unused rooms when capitol first opened
50	Number of restrooms in capitol as of 1934
55	Length of the booms on the derricks at the construction site
64	Diameter (feet) of rotunda
65	Depth (feet) of excavation for underground capitol extension; height of derricks used to lift granite and limestone blocks at the construction site
80	Pieces assembled to fashion the *Goddess of Liberty* statue; length (feet) of Senate chamber, which is 96 feet wide
96	Width (feet) of the two-story House chamber, which is 100 feet long
110	Columns inside capitol
200	Number of iron columns found throughout building cast by Rusk State Penitentiary inmates
266	Distance (feet) from star in Texas seal on first floor of rotunda to the star in dome
299	Width (feet) of capitol, including the steps (exact width is 299 feet and 10 inches)
309	Height (feet) of capitol from basement to top of *Goddess of Liberty* statue, which is 16 feet above the dome (exact height is 309 feet and 8 inches)
392	Rooms in capitol when opened
400	Average number of convicts who worked in the quarries
404	Doors in capitol listed in 1934
500	Stair steps from basement to dome; number of people who can sit in the gallery of the House of Representatives; number of trees on the capitol grounds by 1962—only 50 were native to Texas.
585	Length (feet) of capitol, including steps (exact length is 585 feet and 10 inches)
924	Windows in the capitol
2,000	Workers involved in construction
2,900	Weight (pounds) of restored *Goddess of Liberty* statue
3,200	Number of gas jets installed in the building, though most were never used

4,000	Railroad cars of granite shipped from Marble Falls
5,000	Number of etched 28-inch diamond-shaped pavers sold to state residents, schools, churches and businesses for placement on Oval and Great walkways
8,282	Five-point, gold-painted stars originally in capitol fence
11,000	Railroad cars of limestone and other materials
12,000	Weight (pounds) of capitol cornerstone after dressing
14,000	Austin's population when capitol opened in 1888
20,000	People attending capitol's 1888 dedication
85,000	Square footage of copper roofing
91,000	Cubic feet of concrete used in the building
181,518	Cubic feet of granite shipped from Marble Falls for use in the capitol
370,260	Square feet of floor space in 1888 capitol
667,000	Square footage of underground capitol extension
3,000,000	Acres traded for construction of capitol and which became XIT Ranch

Appendix B

BOTTOM LINES

Note: All values rounded to the nearest dollar

$98,000,000	Cost of capitol renovation completed in 1995
$75,000,000	Cost of 1993 underground extension
$6,000,000	Cost of 1990s capitol grounds restoration
$3,744,631	Cost of 1888 capitol construction
$500,000	Amount paid by state in addition to 3 million acres; cost of air conditioning the capitol in 1955
$115,000	Cost of woodworking
$114,341	Spent by contractor in excess of contract requirements
$90,000	Cost of all building hardware (doorknobs and hinges)
$64,000	Cost of plasterwork
$52,000	Cost of wood furniture for new capitol
$50,000	Monthly payroll in October 1886 at construction peak
$25,000	Cost of various storage cabinets
$22,787	Cost of ornate iron fence around capitol grounds
$20,000	Cost of floor coverings
$13,684	Cost of 114 cases of glass etched with the state seal
$12,000	Fee earned by capitol architect (1881)
$11,360	Cost of expanded electric system (1889)
$9,703	Cost of drilling artesian well (1889)
$7,444	Cost of surveying capitol land in the Panhandle (1879)

$5,150	Amount paid by vendor to purchase beer concession for capitol dedication
$3,000	Fee earned by New York architect who spent three weeks in Austin reviewing proposed capitol designs
$1,545	Cost of dressing, polishing and engraving 1882 cornerstone
$90	Monthly salary of draftsmen who made 117 copies of original sheets in capitol plan
$4	Wage paid per day to Scottish stonecutters
$3–$3.50	Daily pay for skilled laborers
$1–$1.50	Daily pay for common laborers
$.65	Amount paid by the contractor to the state per day per convict laborer
$.50	Value state placed per acre on the 3-million-acre capitol reservation

CAPITOL TIMELINE

1875 New state constitution is written. Delegate J.R. Fleming proposes leveraging five million acres in the Panhandle to fund construction of a new capitol.

1876 **February 15**: Voters approve new constitution. Article XVI, Section 57, sets aside three million acres to finance new capitol.

1879 **February 20**: The legislature authorizes trading three million acres for a new capitol with an additional fifty thousand acres earmarked to pay for surveying the land.

April 18: Lawmakers pass legislation creating a capitol board and enabling it to oversee the construction process.

1879 J.T. Munson, with an escort of Texas Rangers, surveys ten Panhandle counties at a cost of $7,440 raised through sale of fifty thousand acres of state-owned land.

1880 Nimrod L. Norton and Joseph Lee are named building commissioners and Jasper Preston building superintendent. They serve at the pleasure of capitol board, which consists of the state's top elected officials

November: The capitol board publishes "Notice to Architects" seeking plans and specifications for a new statehouse.

1881 Of the eleven architects (only three from Texas), who submitted anonymous proposals, the drawing selected was that of Elijah E. Myers, a Michigan architect.

July 1: Ads seeking construction bids appear in state and national newspapers.

November 9: At 12:15 p.m., fire breaks out in the 1853 capitol and soon guts the structure.

1882 **January**: Having received only two bids, the capitol board awards the capitol project to Mattheas Schnell of Illinois. Schnell soon assigns his interest to four Chicago men: Abner Taylor, Amos Babcock, Charles B. Farwell and his brother John V. Farwell. Charles Farwell was a U.S. senator from Illinois and John a Chicago businessman. Taylor was a contractor and member of the Illinois legislature and Babcock a friend and political supporter of the other men.

January 18: The contract between state and Taylor, Babcock and Company (commonly referred to as the Capitol Syndicate) is signed.

February 1: To comply with the contract calling for construction to start on this day, with only a few citizens and no other state officials present, capitol commissioners Lee and Norton unceremoniously break ground for a new capitol.

February 20: Excavation work begins.

May: Workers use dynamite to blast a sixty-one-thousand-square-foot hole in limestone bedrock for the capitol basement. A local newspaper warns residents to watch out for flying debris.

June 20: Taylor, Babcock and Company assigns building project to Taylor as general contractor.

August 31: With excavation complete, Taylor awards Chicago builder Gus Wilke a subcontract to build the foundation and basement.

December: Construction office, housing for construction workers and other facilities are in place; as Christmas approaches, workers offer Austinites a "vocal concert."

1883 Much of year is spent in obtaining rights of way and building railroad tracks from a limestone quarry in Oatmanville (present Oak Hill), seven miles from capitol construction site, and on foundation work.

September: Annoyed by sightseers, contractor Taylor fences off the construction site and requires visitors to obtain permits.

1884 **February**: Several hundred large hunks of limestone are hauled by wagon to the construction site from the Oatmanville quarry.

March 4: With the railroad complete, sixty tons of limestone arrive at construction site from Oatmanville.

April 30: Building superintendent R.L. Walker (the third and final person to hold the job) rejects Oatmanville limestone for exterior use.

December 8: Walker recommends using granite on the exterior and limestone only for the foundation, basement and interior walls. Prison inmates in Rusk began making iron castings for use in building.

1885 **February 3**: Capitol architect Myers alters building plans to allow for using granite on the exterior, but the limestone versus granite issue is still being debated.

March 2: Granite cornerstone is laid. Governor John Ireland asks the crowd whether they prefer granite or limestone and gets his answer: granite.

July 21: Capitol Board approves using granite donated by rancher G.W. Lacy of Burnet County.

The state agrees to provide prison labor for use in quarrying limestone at Oatmanville and granite from near Marble Falls.

July 25: The capitol night watchman is arraigned before a justice of the peace, "charged with chasing his wife out of the house with an ax."

August: Subcontractor Wilke gets the contract to complete the building and begins construction of a sixteen-mile narrow-gauge rail line from Burnet to Marble Falls.

November: The rail line is nearly completed.

Reacting to the state's use of prison labor at the quarries, the International Association of Granite Cutters votes five hundred to one to boycott the capitol construction project. While convicts could blast and cut large chunks of granite, experienced stonemasons are needed to dress the rock.

1886 Wilke sends a representative to Scotland to hire stonemasons. Eighty-six men are induced to come to Texas, but after they reach New York, union representatives and a U.S. marshal inform them that it is against federal law to hire aliens. Sixty-four Scots decide to stay, while the others return.

This is the peak year of construction.

February: Exterior granite work is underway.

July: The first floor is completed.

October: Second floor is nearly completed.

1887 A contract amendment changes roofing material from slate to copper. The dome begins going up, and exterior ornamentation and walls are completed.

August: Austin federal judge finds Wilke guilty of violating the alien law and assesses a $64,000 fine plus costs. Six years later, fine is reduced to $8,000 and costs, and Wilke pays it.

1888 **January**: Construction is mostly completed.

February 26: The *Goddess of Liberty* is placed atop the dome.

April 20: The rudimentary electrical lighting system is switched on for first time.

April 21: The capitol opens to the public for the first time.

May 16: The capitol is dedicated.

September: Government moves into building, and contractor Wilke picks up the tab for moving the furniture of the House of Representatives from the temporary capitol to its new chamber.

December 8: The Capitol Board formally accepts the building after Wilke completes punch-list items, including fixing windows, roof leaks and other problems found by an inspector hired by the state.

1889 **January**: Lawrence Sullivan Ross becomes the first governor inaugurated in the capitol.

February: The first new desks, chairs and other furniture arrive, even though the legislature had been in session for months. Lacking sufficient funding, the state leaves thirty-seven rooms and nine larger halls unfurnished.

1890 An ornate metal fence mounted on granite is placed around capitol grounds.

1891 The Alamo Memorial, first statue on the capitol grounds, is erected.

1894 Powered by a seventeen-thousand-kilowatt generating plant, more electric lighting is installed.

1896 The San Jacinto battle flag is donated for display by the family of Captain Sidney Sherman, who received the banner for his valor in the pivotal engagement.

July 7: The Volunteer Fireman Memorial is dedicated.

1901 The Confederate Memorial monument is erected.

1903 The original post office on the second floor is renovated for use as Railroad Commission hearing room; Capitol Station moves to ground floor.

Marble statues of Stephen F. Austin and Sam Houston by famed sculptress Elisabet Ney are placed in south foyer.

1907 The Terry's Texas Rangers, CSA monument is erected.

1910 The Hood's Texas Brigade, CSA monument is erected.

An electric chandelier is hung in the rotunda.

1912	Driveways around the capitol are curbed and paved.
1919	A press room opens on the second floor.
1922	The first electronic voting system is installed in the House.
1925	Texas gains clear title to the capitol site after settling a claim for $25,000 with the heirs of Thomas Jefferson Chambers.
	Texas Cowboy monument is erected.
1929	**July**: As Austin grows, the people's ability to see their capitol becomes an issue for the first time when Travis County announces plans for a new, and significantly higher, courthouse where the old one stood at Eleventh and Congress. "It would be an aesthetic crime to erect a large building on the courthouse site, obstructing views of the capitol," Governor Dan Moody declared. Travis County opted not to cause a stink and built a new courthouse farther from the capitol—and not so high as to interfere with its view.
1934	A survey finds 409 rooms in the capitol (17 more than the original 392); the lieutenant governor's area is remodeled to add a kitchenette and bedroom.
1935	The legislature authorizes ornate terrazzo flooring for rotunda and first floor; Governor James Allred moves the governor's office from the first to the second floor, near the Senate chamber.
1936	The governor's office gets a window air-conditioning unit.
	A large state treasury vault is built in the basement.
	Renovation of Governor's Public Reception Room is completed.
1938	A twenty-year plan is created for capitol maintenance and renovation.
	An automatic sprinkler system is installed.
1939	The Forty-Sixth Legislature authorizes a bronze plaque in the south foyer commemorating "those patriotic citizens" N.L. Norton, W.H. Westfall and G.W. Lacy for donating granite used in the capitol.
1945	A tree is planted by the Texas Federation of Women's Clubs in soil from all 254 counties in memory of Texas World War II heroes.
1947	After an original glass skylight falls from the ceiling in the House chamber one weekend, lawmakers have the skylights removed from both chambers. Later, some of the skylights were replaced on the Senate side, but they were made with Plexiglas.
1950s	Renovation work continues, including replacing the copper roof (1949) and tile floors in all public spaces; removing original chandelier in rotunda; installing new a star beneath the interior

dome; new plumbing, electrical wiring and central air conditioning throughout the building.

1951 A Statue of Liberty replica is erected.

The Hiker, a monument honoring Spanish-American War veterans, is erected.

1953 Public access to fifth level of rotunda and dome ends for safety reasons.

1956 **June 4**: Governor Allan Shivers and Austin mayor Tom Miller throw the switch to bathe the capitol dome in newly installed powerful flood lights.

1959 Texas Thirty-Sixth "T Patch" Division monument is dedicated.

1961 Veterans of World War I monument is dedicated.

The Ten Commandments monument is dedicated.

1960s The ceiling in the old Supreme Court Room is lowered and acoustical tile added; glass-and-aluminum vestibules are installed at the main entrances; and automatic elevators are installed.

1963 Governor John Connally expands the governor's office into a second-floor Senate committee room, and large arched openings in the adjacent public lobby are replaced with standard doors and windows.

1965 The capitol view issue comes up again as plans are announced to build a twenty-four-story building just southwest of the capitol. Despite some resistance, the building goes up.

1969 **May**: A lighted star above the south entrance is removed by legislative order.

August 5: Article XVI, Section 57 of the Constitution (which set aside the land for the capitol in 1876) is repealed by voters as so much deadwood.

1970 The capitol is added to the National Register of Historic Places.

The building is so cramped for space that offices are set up in the basement, turning wide corridors into a bewildering series of narrow warrens. Size and location of members' office spaces hinge on their legislative seniority.

1973 The Freedom Tree monument is dedicated to prisoners of war and Texans missing in action.

1976 The U.S. Bicentennial Fountain is donated by the Texas Realtors.

A time capsule is buried on the grounds during the U.S. bicentennial celebration.

Six external circular granite panels above main entrances are filled with the seals of the six nations whose flags have flown over Texas.

1978 Voting in House of Representatives is computerized.

1980 The Disabled American Veterans monument is erected.

1982 **February 1**: The centennial of the beginning of the capitol's construction is celebrated.

 November: Two downtown high-rise buildings put up in the 1970s further decreased the capitol's prominence on the Austin skyline. Now, plans for a fifteen-story building at Tenth and Congress bring the capitol issue view to a boil. A group called Texans to Save the Capitol try to block the structure in court, but the builders ultimately prevail.

1983 **February 6**: A fire in the lieutenant governor's east-wing apartment causes extensive damage and kills one. Planning begins to restore capitol to its original design. The Texas Society of Architects ranks the capitol one of the state's twenty most significant architectural works of all time, in part because of its Renaissance Revival style.

1984 A city ordinance setting height limits for buildings within a quarter-mile radius south of the capitol is passed.

1985 **November 24**: The deteriorating zinc *Goddess of Liberty* is removed from the dome by helicopter.

1986 **June 14**: A new aluminum replica of the *Goddess of Liberty* is placed on the dome by a Mississippi National Guard helicopter; capitol is named a National Historic Landmark.

1987 Carpeting is replaced in the House chamber with a replica based on original carpeting visible in a 1905 photograph of Lyndon Johnson's father sitting at his desk while a state representative; venetian blinds are replaced with replicas of louvered blinds circa 1888; Austin Heritage Society restores the Governor's Public Reception Room.

1988 The capitol's centennial is celebrated.

1989 **April**: A master plan for underground extension is presented to the legislature.

 June: The legislature approves the expansion plan.

 A Pearl Harbor monument is dedicated.

1990 **May**: Excavation for the extension begins.

 December: Excavation is completed.

1991 **January**: Construction begins on the extension.

1992 **August**: Work begins on interior renovation.

1993 **January**: The underground extension is completed.

1995 Extensive interior and exterior renovations of the original capitol are completed.

1998 The Texas Pioneer Woman statue is erected.
 Tribute to Texas Children statuary erected.

1999 Korean War Veterans and Texas Peace Officer monuments are placed.

2013 Tejano monument dedicated.

2014 Vietnam Veterans monument dedicated.

2016 African Americans monument dedicated.

NOTES

Prologue

1. Goar, *Marble Dust*, 211–14. The state commissioned Ney (1833–1907) to create sculptures of Austin and Houston in 1892. Governor Sul Ross allowed her to use an empty room in the capitol basement to work on the pieces prior to completion of her studio in North Austin. The Houston statue was exhibited in the Texas Building at the 1893 Chicago World's Fair, but Ney had not been able to complete the Austin piece in time. Both works stood in her studio until they were moved to the capitol in 1903.
2. Al Eck is buried near other family members in the Teck Cemetery.

Chapter 1

3. Kerr, *Seat of Empire*, 184–85, 188. A boardinghouse owner named Angelina Eberly (1798–1860) has been credited with saving the archives—and Austin's status as capital city—by touching off a cannon and sending a load of grapeshot whizzing in the direction of the men busily loading records from the Land Office into wagons. Some historians question whether that actually happened, but Eberly has nevertheless been immortalized in a statue in the 600 block of Congress Avenue in downtown Austin.

Chapter 2

4. Ibid., 87–91. The limestone capitol, ordinary as it was, stood majestically in comparison to the structure it replaced, the capitol

erected in 1840 by the Republic of Texas at what is now Colorado and Eighth Streets. Built of pine planks on cedar framing, the one-story statehouse extended some 60 feet deep and 110 feet wide. A "dog trot," or porch, separated the Senate and the House, which was on the south side of the east-facing building. A covered front porch ran along the white-painted building's width. Seven sheds behind the capitol served as committee rooms. "A more unpretentious building for a law-making body could hardly be found," wrote German visitor Ferdinand Roemer. Since hostile Indians remained very much a threat to early day Austin, the city's first capitol did have one feature that distinguished it from its three successors: it was protected from attack by a moat-like ditch and log stockade.

5. Giraud went on to serve as San Antonio's mayor from 1872 to 1875. He died two years later.

Chapter 4

6. Franke, *Inheritance*, 90–130. The slain lawmaker is buried in the old Franke family cemetery near Black Jack Springs off Guettermann-Ehler Road and FM 609 in Fayette County. His family had a three-foot-high, eleven- by fourteen-foot sandstone enclosure constructed around the grave in 1875.

Chapter 5

7. Sharing a boardinghouse room with fellow delegate and future Texas governor Sul Ross, Fleming minimized his personal expenditures as well.

8. Born on January 19, 1829, in Bangor, Maine, Abner Taylor moved as a child with his parents to Ohio and, later, Iowa. By 1860, he was living in Chicago. He served as a colonel in the Union army during the Civil War and later as a U.S. Treasury agent. After that, he moved into business and construction contracting. For part of the time that he was involved in the building of the capitol, from 1884 to 1886, he also served in the Illinois House of Representatives. Less than a year after the capitol's dedication in 1888, he was elected to the U.S. House. On September 9, 1889, he married Clara Babcock, daughter of his Capitol Syndicate partner A.C. Babcock. After leaving Congress in 1893, Taylor returned to the construction business. He died in Washington on April 13, 1903. He and the subcontractor he hired, Gus Wilke, were the driving forces in building the capitol.

Chapter 6

9. Tolbert apparently had forgotten his 1959 interview of a ninety-year-old Austin woman who witnessed the fire as a girl of twelve. "She never heard of the arson plot, nor did anyone else I talked with in Austin," Tolbert wrote. "So this investigation was pretty much a waste of time," he concluded.

10. Given that McBride (born circa 1860) was a black man whose entire life was spent in the Jim Crow era, little is known of his background. An 1897–98 Austin city directory shows him living with his wife, Mary, at 1308 Angelina Street on the city's east side. At the time, he worked for Adjutant General W.H. Mabry.

Chapter 8

11. "The discipline at the quarries was good," noted a report from the superintendent of Texas penitentiaries on October 31, 1886. "There was little punishment of the prisoners, and escapes were very few."

Chapter 9

12. In buying the first 500 head of cattle for the ranch, XIT general manager "Barbecue" Campbell paid fifteen dollars a head for two-year-olds and eleven dollars for yearling heifers. The ranch sold its first cattle in 1887, trailing 716 head from Buffalo Springs to Higgins, where they went by rail to Chicago. There, they sold for ten to eighteen dollars a head.

13. Casad, *Farwell's Folly*, 64–67. The author wrote in her preface that she had been surprised to learn that so few people, including Texans, are aware of the XIT and the role it played in the state's history. Yet, she said, "the ranch is a sociologist's mother lode, a historian's hidden archives and a venture capitalist's textbook."

Chapter 10

14. Originally from Philadelphia, Myers moved to Detroit following the Civil War. Thirty-nine when the Capitol Board accepted his design, Myers already had a national reputation. As one writer later put it, he was "a talented, dishonest, hard-working, spiteful, clever, unbalanced, self-assured, self-destructive, hypochondriac whose story must be pieced together from fragments." He died in 1908.

Chapter 11

15. The dome is actually two domes, an outside dome and an inner dome. The outer dome gives the capitol its iconic profile (and similarity to the U.S. Capitol) as well as support for the inner dome, which shapes the ceiling of the rotunda. The outer dome is fashioned of wrought iron with a galvanized sheet metal covering and is supported by girders custom-made in Belgium. A spiral staircase goes from the fourth level and between the inner and outer domes to the rounded point on the top of the dome that the design calls the lantern. The *Goddess of Liberty* sits on that. From the moment the capitol opened to the public, making the arduous climb to the top of the building was highly popular with visitors. In the 1890s, when the state decided to close the dome on Sundays in deference to the Sabbath, a whirlwind of protest got the move reversed.

16. While details related to the building of the capitol are recorded in the annual reports of the capitol board, as well as in surviving correspondence and contemporary newspaper accounts, firsthand accounts by those who actually did the work are surprisingly scarce. One worker later talked about his experiences in newspaper interviews, but so far as is known, only one man, Gonzales, Texas native Gustave Birkner, ever wrote about his role in building the capitol. The son of a German immigrant to Texas, Birkner (1861–1956) devoted five double-spaced typewritten pages to his experiences at the statehouse job site in his unpublished 1940 memoir. In addition to the other work he did, he said that near the end of the construction project he spent eight days inside a six-foot-wide, three-walled brick airshaft during installation of a large metal rod that had to be added to repair a crack in the brickwork supporting the metal dome. The derrick used to lift construction materials for the dome was supported by guy wires that extended outward for one mile. In all, thirteen derricks were used in the building of the capitol, he wrote.

Chapter 13

17. Born on the Denton-Wise County line on May 2, 1861, C.V. Terrell gained admission to the bar in 1885. He served as Wise County attorney for four years before being elected to the state senate. Terrell was elected state treasurer in 1922 and after two years in that office became a member of the Texas Railroad Commission. He served on the commission for

fifteen years. He died in Austin on November 17, 1959, and is buried in the State Cemetery.

18. "Trip to Austin Dedication of the State Capitol," photocopy from handwritten diary in the author's collection, author unknown, 375–79.

Chapter 15

19. Mrs. R. Houy, letter to Betty Hudman, August 19, 1963, in the author's collection.

Chapter 16

20. Some 126 years after Lieutenant Governor Stockdale's death in 1890, someone attempted, at least in the figurative sense, to "assassinate" the official on October 9, 2016. Around 3:30 a.m., a Texas Department of Public Safety trooper assigned to the capitol saw a man climbing temporary scaffolding on the south side of the building. The man then broke a window and entered the statehouse. Before officers could get him arrested, he pulled the portrait of the former governor from the wall and tossed it over the railing in the rotunda to the ground floor three stories below, badly damaging the painting. The twenty-two-year-old suspect was jailed on charges of burglary of a building and criminal mischief.

Chapter 21

21. Valerie Bennett, e-mail to author, October 25, 2016. Bennett was curator of the O. Henry Museum from 1988 until her retirement in 2011.

22. The building accommodating the barbecue place incorporated an 1869-vintage stone house where Susana Dickinson (1814–1883) once lived. She and her young daughter Angelina were the most noted Anglo survivors of the Alamo massacre. When the restaurant was razed, the Dickinson house was reconstructed across the street on Brush Square, adjacent to the O. Henry house, and is operated as a museum by the City of Austin.

23. Clay Leben, e-mail to author, October 24, 2016. Dr. Leben is a longtime member of the Brush Square Museum Foundation, the successor of the Friends of the O. Henry Museum.

Chapter 22

24. Weddle, "Granite Mountain: A Rock for a Horse," *Southwest Heritage* (December 1968). George Washington Lacy, who came to Burnet County in 1858, traded a horse for the property and its granite.

25. A Marble Falls old-timer told a particularly outlandish convict story in 1932. "One on occasion," he claimed, "a convict capable of operating the…locomotive, and a few of his companions, seized some children of the captain of the guards, held them as shields, mounted the locomotive that was near at hand, and made for the outside world. They gave the guards a merry chase for a while, but I believe they were all captured. Possibly some of them were killed, but no harm came to the children."

26. Facing east, the marker reads: "Erected/By Their Fellow Workmen/ In Memory Of/George Mutch/Who Died 13th Of June 1886/Aged 23 Years/Also/John Smith/Who Was Drowned The 27th Of June 1886/ Aged 27 Years/Also/George Moir/Who Died 15th of October 1886/ Aged 22 Years/Cut Of Burnet Granite."

Chapter 28

27. "The Capitol Accident," *Galveston Daily News*, May 13, 1887; *Brenham Weekly Banner*, September 2, 1886. One laborer died of what likely was a heat stroke. Another was crushed beneath thousands of pounds of stone when a wrought-iron girder in the fourth-floor ceiling that was being used to support building material for use elsewhere failed due to the heavy weight and collapsed. The accident occurred on May 11, 1887. Less than a year before, the *Brenham Weekly Banner* observed: "The construction of the new capitol at Austin involves the use of a great deal of machinery and the result is that accidents—some of them fatal—are of frequent occurrence. The contractor should exercise great care." The third death may have been the carpenter rumored to have been poisoned by his wife. More likely he died from heat or natural causes.

Chapter 30

28. Morehead, *Richard Morehead's Texas*, 167. Veteran *Dallas Morning News* capitol bureau chief Richard Morehead, who covered the legislature in the 1950s, did not believe Morris's story. "If this ever happened, nobody around here knew it," Morehead wrote. "Apparently, it is just more barroom fantasy about how Texas laws are made."

SOURCES

Prologue

Austin American-Statesman. November 27, 1938.

"Leonard T. Eck." Austin (Texas) History Center biography file.

Smyrl, Vivian Elizabeth. "Teck, Texas." Handbook of Texas Online. Accessed September 9, 2016. https://tshaonline.org/handbook/online/articles/hwt01.

Texas Public Employee. "Capitol Loses Old Friend." March 1970.

Wightman, Marj. "Capitol Veteran! Al Eck Honored at 90." *Austin Statesman*, April 13, 1964.

Chapter 1

Cox, Mike. *Historic Austin: An Illustrated History*. San Antonio, TX: Historical Publishing Network, 1998, 21.

Hart, Weldon. "Austin Beat Out Tehuacana and Palestine for Capital Site 120 Years Ago." Austin: N.p., [1970].

Tolbert, Frank X. "Once Pronounced It 'Tiwockony!'" *Dallas Morning News*, December 29, 1958.

"To the Voters of the State of Texas," *Texas State Gazette*, February 16, 1850.

"When Austin Was Selected Capital of Texas." *Frontier Times* 10, no. 3 (December 1932): 104.

Chapter 2

Austin American-Statesman. "Firemen Fight in Vain to Save First Capitol and Contents." July 26, 1970.

Chabot, Frederick Charles. *With the Makers of San Antonio.* San Antonio, TX: Yanaguana Society Publications 4, 1937.

Connor, Seymour, James M. Day, Billy Mac Jones, Dayton Kelley, W.C. Nunn, Ben Proctor and Dorman H. Winfrey. *Capitols of Texas.* Waco, TX: Texian Press, 1970, 121–47.

Harris, August Watkins. *Minor and Major Mansions & Their Companions in Early Austin, A Supplement: Buildings of the Seat of Government 1840–1861.* Austin, TX: privately published, 1959.

Harrison, Charles A., to F. Giraud, November 14, 1851; December 30, 1851; and January 5, 185[2]. Texas State Library and Archives.

Ramsdell, Charles W. "The Legacy of F. Giraud." *Texas Parade*, April 1968.

"Resolution of the Senate." November 11, 1851. Texas State Library and Archives.

Williamson, Roxanne Kuter. *Austin, Texas: An Architectural History.* San Antonio, TX: Trinity University Press, 1973, 26–28.

Chapter 3

Austin American Statesman. "Tells Story of the Bandit Attempt to Rob Treasury and Battle Round Capitol." July 27, 1919.

Austin Southern Intelligencer. July 21, 1865; August 11, 1865.

Brown, Frank. "Austin in 1865." Chap. 24 in *Annals of Travis County and the City of Austin from the Earliest Times to the Close of 1875.* Austin, TX: Von Boeckmann, Schutze and Company, 1901.

Dallas Morning News. "The Looting of the Treasury." May 18, 1897; May 25, 1897.

———. "When the State Treasury Was Robbed." November 15, 1925.

Dealy, Edward M. "Outlaws Tried to Loot Austin Treasury 56 Years Ago." *Dallas Morning News*, November 13, 1921.

Freeman, G.R., to F.W. Emory, June 26, 1865. Records of the Adjutant General. General Correspondence, Archives and Information Services Division, Texas State Library and Archives Commission.

Houston Tri-Weekly Telegraph. June 16, 1865.

Streeter, Floyd. *Ben Thompson: Man with a Gun.* New York: Frederick Fell, 1957, 56–57.

Chapter 4

Austin Daily Statesman. February 20, 1873; February 22, 1873; February 23, 1873.

Birkner, Gustave. "Gus Birkner." Unpublished manuscript, 1940, 52.

Brewer, Anita. "Rock Mason Recalls Capitol Construction." *Austin American*, June 20, 1950.

Crider, Bill. *Texas Capitol Murders.* New York: St. Martin's Press, 1992.

Daily State Gazette (Austin, TX). February 21, 1873.

Dallas Daily Herald. February 24, 1873; March 1, 1873.

Franke, Gertrude, ed. *The Inheritance.* Austin: Nortex Press, 1987, 80–130.

Legislative Reference Library of Texas. "Louis Franke." Accessed September 27, 2016. www.lrl.state.tx.us/legeLeaders/members.

Chapter 5

Austin Weekly Statesman. September 16, 1875; January 20, 1876; March 27, 1879; October 9, 1879.

Dallas Weekly Herald. June 28, 1883.

Journal of the Constitutional Convention of the State of Texas. Galveston, TX: Galveston News, 1875, 527, 698–99.

Members of the Legislature of the State of Texas from 1846 to 1939. Austin: Texas Legislature, 1939.

Miller, Thomas Lloyd. *The Public Lands of Texas, 1519–1970.* Norman: University of Oklahoma Press, 1972, 62, 65–66.

Waco Daily Examiner. "From Comanche." October 1, 1878.

Chapter 6

Connor, Seymour, James M. Day, Billy Mac Jones, Dayton Kelley, W.C. Nunn, Ben Proctor and Dorman H. Winfrey. *Capitols of Texas.* Waco, TX: Texian Press, 1970, 121–47.

Cox, Mike. *Historic Austin: An Illustrated History.* San Antonio, TX: Historical Publishing Network, 1998, 37–38.

Tolbert, Frank X. "Tolbert's Texas: When Land Thief Burned Capitol." *Dallas Morning News,* January 4, 1975.

———. "Tolbert's Texas: Witness Doesn't Remember Firebug." *Dallas Morning News,* May 25, 1959.

Chapter 7

Cox, Mike. "Digging at Old Capitol Turns Up Political Dirt." *Austin American-Statesman*, February 20, 1973.

Miller, Thomas Lloyd. *The Public Lands of Texas, 1519–1970*. Norman: University of Oklahoma Press, 1972, 186–87.

Moore, Gary L., Frank A. Weir, John E. Keller, R. Whitby Jarvis, Cathrine H. Yates, K. Joan Jelks and Phillip A. Bandy. *Temporary Capitol of Texas 1883–1888: A History and Archeology*. Austin: Texas Highway Department Publications in Archeology, 1972.

Chapter 8

Austin Statesman. "Excursion to Oatmanville." February 24, 1884.

Bankston, James Scott. "An Informal Look at Oak Hill History." *Oakhill Gazette*, December 6, 2001.

Jackson, Jack M., and Elton R. Prewitt, principal investigator. "A Cultural Resource Evaluation of a Portion of the Convict Hill Quarry Site (41TV267), Travis County, Texas." Letter Report No. 308. Austin: Prewitt and Associates, Inc. Consulting Archeologists, June 1985.

Johnson, Mary M, ed. *Oak Hill–Cedar Valley Pioneers*. Austin: Oak Hill-Cedar Valley Pioneer Association, 1956.

Miller, Donna Marie. "Oak Hill's Old-Timers Tell Tales About 'Good' Ol Days." Accessed September 15, 2016. www.donnamariemillerblog.com.

Rips, Catherine. "Striped Shirts on the Hill." *Free & Easy (Austin, TX)*, March 15–April 15, 1976.

Wiese, Nanette. "Travelers Get History, Meals at Convict Hill." *Austin Citizen*, October 21, 1971.

Chapter 9

Dobie, J. Frank. *Cow People*. Austin: University of Texas Press, 1964, 25–37.

Casad, Dede Weldon. *Farwell's Folly: The Rise and Fall of the XIT Ranch in Texas*. Dallas, TX: privately published, 2012, 64–67.

Cates, Ivan. *The XIT Ranch: A Texas Legacy*. Channing, TX: Hafabanna Press, 2008, 9–14, 76.

Dalhart Texan. "XIT Brand Originator in Dalhart." August 6, 1938.

Fort Worth Daily Gazette. "The Panhandle." January 30, 1888.

Haley, J. Evetts. *The XIT Ranch of Texas and the Early Days of the Llano Estacado*. Norman: University of Oklahoma Press, 1953, 76–78.

Handbook of Texas Online. "Blocker, Abner Pickens." Accessed February 6, 2012. https://tshaonline.org/handbook/online/articles/fbl25.

Miller, Mick. "Cattle Capitol: Misrepresented Environments, Nineteenth Century Symbols of Power, and the Construction of the Texas State House, 1879–1888." Master's thesis, University of North Texas, 2010, passim.

Pampa (TX) Daily News. "Famed Driver Invented XIT Cattle Brand." September 13, 1938.

Chapter 10

Austin and Its Architecture. Austin: Austin Chapter American Institute of Architects/Women's Architectural League, 1976, 18–23.

Carefoot, Jean. "State Capitol Marks 100th Anniversary." *Texas Libraries* (Winter 1987–88): 99–111.

Fowler, Mike, and Jack Maguire. *The Capitol Story: Statehouse in Texas.* Austin: Eakin Press, 1988, 53–55, 66–68.

Miller, Mick. "Cattle Capitol: Misrepresented Environments, Nineteenth Century Symbols of Power, and the Construction of the Texas State House, 1879–1888." Master's thesis, University of North Texas, 2010, passim.

Williamson, Roxanne. *Austin, Texas: An American Architectural History.* San Antonio, TX: Trinity University Press, 1973, 90–95.

Chapter 11

Fowler, Mike, and Jack Maguire. *The Capitol Story: Statehouse in Texas.* Austin: Eakin Press, 1988, 68.

Galveston Daily News. "Concerning the Capitol, the Dome Matter Fully Discussed." December 6, 1887.

The Land Commissioners of Texas: 150 Years of the General Land Office. Austin: General Land Office, 1986, 38–40.

Walsh, W.C. "Memories of a Texas Land Commissioner, W.C. Walsh." *Southwestern Historical Quarterly* 44, no. 4 (April 1941): 481–87.

Chapter 12

Austin Weekly Statesman. "Mr. Wilke's Statement." May 3, 1888.

———. "Painful Accident." July 10, 1884.

Chicago Tribune. "The New Texas Capitol." February 9, 1888.

Fort Worth Gazette. "The New Capitol: The Blackmailing Controversy Comes to a Head on the Eve of the Acceptance of the Building." May 1, 1888.

Fowler, Mike, and Jack Maguire. *The Capitol Story: Statehouse in Texas.* Austin: Eakin Press, 1988, 84.

Galveston News. "Great Sensation in Austin Concerning the New State Capitol." May 1, 1888.

Miller, Mick. "Cattle Capitol: Misrepresented Environments, Nineteenth Century Symbols of Power, and the Construction of the Texas State House, 1879–1888." Master's thesis, University of North Texas, 2010, passim.

Chapter 13

Austin Statesman. "An Occasion of Gladness, the Granite Capitol Dedicated." May 17, 1888.

Gould, Lewis L. *Alexander Watkins Terrell: Civil War Soldier, Texas Lawmaker, American Diplomat.* Austin: University of Texas Press, 2004, 77–78.

Handbook of Texas Online. "Terrell, Charles Vernon." Accessed August 5, 2003. https://tshaonline.org/handbook/online/articles/fte18.

Harper's Weekly. "The New State Capitol, Austin, Texas." May 12, 1888.

Rogers, Bob. "Terrell Sword Saw 'Service' in Capitol Rite." *Austin Statesman,* July 19, 1954.

Terrell, C.V. *The Terrells: 85 Years Texas to Atomic Bombs.* Austin: privately published, 1948, 214–15.

Texas Public Employee. "Capitol Dedication Was a Gala Day in 1888." August 1964, 5–7, 18.

Chapter 14

Austin Statesman. "Arbor Vitae on Capitol Grounds 'Shame,' Says Native-Bred Author." July 29, 1931.

Fowler, Mike, and Jack Maguire. *The Capitol Story: Statehouse in Texas.* Austin: Eakin Press, 1988, 91–93.

Giedraitis, John P. "Trail of Trees at the Capitol." Austin: Friends of the Parks, Inc., 1989.

Ward, Mike. "Restoring Texas' Great Walk." *Austin American-Statesman,* September 21, 1996.

Chapter 15

Raines, C.W. "The Alamo Monument." *Quarterly of the Texas State Historical Association* 6 (April 1903).

Shuffler, R.H. "Monument to Texas' Patriotism and Poor Taste." *Houston Chronicle Texas Magazine,* October 24, 1995.

Telegraph and Texas Register. March 24, 1836.

Chapter 16

Fowler, Mike, and Jack Maguire. *The Capitol Story: Statehouse in Texas*. Austin: Eakin Press, 1988, 92.

Handbook of Texas Online. "Henderson, James Wilson." Accessed October 3, 2016. https://tshaonline.org/handbook/online/articles/fhe15.

Chapter 17

Anderson, Jean. *The Texas Bluebonnet*. Austin: University of Texas Press, 1986, 13–16.

Dasch, Rowena. Interview with author, October 6, 2016.

Elliott, Janet. "How Bluebonnets Became State Flower." *Houston Chronicle*, March 23, 2008.

Chapter 18

Cox, Mike. *My Only Lasting Words*. Austin: Windmill Press, 1972, 6–9.

El Paso Herald. "San Antonio's Courier to Taft Reaches Austin." August 3, 1909.

Gardner, William H. "Just Like the Old Days: That Cloud Hanging Over the Legislature This Year Had a Familiar Ring." *Texas Star*, June 20, 1971, 10.

McKinney (TX) Weekly Democrat-Gazette. "O'Reilly Delivers Invitation." September 30, 1909.

O'Reilly, Tex, and Lowell Thomas. *Born to Raise Hell: The Life Story of Texas O'Reilly, Soldier of Fortune*. New York: Doubleday, Doran & Company, 1936, 159–60.

Chapter 19

Bryant, John. "Death Fall Is Recalled by Painter." *Austin American-Statesman*, October 6, 1968.

Presley, Merikaye. "Dizzying Heights Hazard in Capitol Dome Painting." *Austin American-Statesman*, October 6, 1968.

Chapter 20

Burka, Paul. "North Toward Dome." *Texas Monthly* (February 2007).

Caro, Robert A. *The Years of Lyndon Johnson: The Path to Power*. New York: Alfred A. Knopf, 1982, 298–301.

Cheavens, Dave. "Midgets on Honeymoon after Statehouse Rites." *Austin Statesman*, December 21, 1945.

Fowler, Mike, and Jack Maguire. *The Capitol Story: Statehouse in Texas*. Austin: Eakin Press, 1988, 171.

Ward, Mike. *The Capitol of Texas: A Legend Is Reborn*. Atlanta, GA: Longstreet Press Inc., 1995, 18, 162.

Chapter 21

Lubbock Avalanche-Journal. "Capitol Invaded, UT Demonstrators Routed at Austin." May 6, 1969.

Chapter 22

Debo, Darrell. *Burnet County History: A Pioneer History, 1847–1979*. Vol. 1. Burnet, TX: Burnet County Historical Commission, 1979, 53–58.

Harry, Landa. *As I Remember...* San Antonio, TX: Carleton Printing Company, 1945, 43–44

Myers, JoAnn. Interview with author, October 5, 2016.

Nash, J.P. "Texas Granites." *University of Texas Bulletin*, no. 1725 (May 1, 1917): 4.

Weddle, Robert S. "Granite Mountain: A Rock for a Horse." *Southwest Heritage* (December 1968).

Williamson County Historical Commission. "Granite for the State Capitol Historical Marker." Accessed August 26, 2016. williamson-county-historical-commission.org.

Chapter 23

"Celebrating the Texas Capitol: A Celebration Commemorating the 100th Anniversary of the Groundbreaking Monday, February 1, 1983–Austin, Texas." Texas 1986 Sesquicentennial Commission and the Texas State Library and Archives Commission, 1982.

Fehrenbach, T.R. "Capitol Captures Texas State of Mind." *Austin American-Statesman*, January 31, 1982.

Kuempel, George. "Capitol Centennial Celebration Set." *Dallas Morning News*, January 31, 1982.

Texas Highways. "Our Capitol Celebrates 100 Years." August 1988, 44–45.

Chapter 24

Austin American-Statesman. "One-Millionth Texas Capitol Holiday Ornament for Sale to Highest Bidder." December 12, 2013.

Chariton, Wallace Owen. *Texas Centennial: The Parade of an Empire.* Dallas: privately published, 1979, passim.

Colorado County Citizen (Columbus TX). "State Capitol Guardian Reminiscent." November 10, 1932.

Currens, Christopher (State Preservation Board). E-mail to author, October 11, 2016.

Galveston Daily News. "Capitol Souvenir." March 1, 1885.

Hoggatt, Philip. Interview with author, July 13, 2016.

Marshall, Howard C. "Souvenir Hunters Invade Capitol of Texas Recent Days." *Corsicana Daily Sun,* May 31, 1938.

State Preservation Board. "Capitol Artifacts and Documents Gallery." Accessed October 7, 2016. www.tspb.texas.gov.

Valley Morning Star (Harlingen, TX). "Capitol Dedication Souvenir Is Found." July 1, 1938.

Chapter 25

Abernethy, Francis Edward, ed. *Legendary Ladies of Texas.* Denton: University of North Texas Press, 1994, 57–58.

Fry, Dale. "Veil of Time Shrouds Origin of Capitol Statue." *The Highlander (Marble Falls, TX),* January 24, 1985.

"The Original Goddess of Liberty from the Texas State Capitol." Austin: Texas Memorial Museum, n.d. (circa 1995).

Sechelske, Ingood. "The Goddess: Myths and Mysteries." *Texas Historian* 47, no. 5 (May 1987): 11–12.

Texas Public Employee. "Mystery Shrouds Lady Atop Capitol Dome." April 1963.

Chapter 26

Associated Press. "Independence Day Is Celebrated at State's Capitol." March 4, 1930.

Austin Statesman. "Old Tools Found on Capitol Job." August 29, 1963.

Corsica Daily Sun. "Old Money Discovered." July 29, 1915.

Cox, Mike. "Those Who Helped Build Capitol Have 'Treasure' Beneath House." *Austin American-Statesman,* September 24, 1978.

Handbook of Texas Online. "McCallum, Jane Legette Yelvington." Accessed October 2, 2016. https://tshaonline.org/handbook/online/articles/fmc07.

———. "Texas Declaration of Independence." Accessed October 2, 2016. https://tshaonline.org/handbook/online/articles/mjtce.

Ward, Mike. *The Capitol of Texas: A Legend Is Reborn.* Atlanta, GA: Longstreet Press Inc., 1995, 86.

Chapter 27

Bowden, J.J. "Title Cloud Over the Texas Capitol." *Password* 19, no. 1 (Spring 1974).

Cofer, H.E. "The Chambers' Claim to the Capitol of Texas." *Texas Law Review* 9, no. 60 (1931).

Fowler, Mike, and Jack Maguire. *The Capitol Story: Statehouse in Texas.* Austin: Eakin Press, 1988, 20–22

Potts, Robert J., Jr. "Cloud Over the Capitol Grounds." *Texas Parade*, October 1963.

Chapter 28

Austin Statesman. "State Comptroller Love Shot to Death in Capitol." July 1, 1903.

Castro, April. "Spooky Politics: Texas Capital Home to Ghosts." *USA Today*, October 28, 2008.

Chariton, Wallace O., Charlie Eckhardt and Kevin R. Young. *Unsolved Texas Mysteries.* Plano, TX: Wordware Publishing, 1991, 57–66.

Chicago Tribune. "Murders Texas Official." July 1, 1903.

Handbook of Texas Online. "Love, Robert Marshall." Accessed August 31, 2016. https://tshaonline.org/handbook/online/articles/flo29.

Zeller-Plumer, Jeanine Marie. *Haunted Austin.* Charleston, SC: The History Press, 2010, 53–63.

Chapter 29

Frink, Cheryl Coggins. "Myth Meets History under the Dome." *Austin American-Statesman*, May 1, 1988.

Henderson, Jim. "Color of Capitol's Granite From Marble Falls Puts State Legend in Question." *Houston Chronicle*, March 9, 2003.

Selby, W. Gardner. "Letter Writer Says Texas Capitol Built Facing South in Memory of Battle at Goliad." *Austin American-Statesman*, July 24, 2015.

Texas State Preservation Board. "Capitol Myths and Legends." Accessed August 16, 2016. www.tspb.texas.gov.

Ward, Mike. "Capitol Legends Long on Life, Short on Fact." *Austin American-Statesman*, April 17, 1995.

———. *The Capitol of Texas: A Legend Is Reborn*. Atlanta, GA: Longstreet Press Inc., 1995, 93, 104.

Chapter 30

Airhart, Ellen. "Science Scene: Texas Capitol's Granite Emits Trace Radiation." *Daily Texan*, October 22, 2015.

Austin American. "Cooling Set for Capitol, Land Office." November 29, 1955.

Austin Weekly Statesman. "The Capitol Elevator." June 14, 1888.

Cox, Patrick, and Michael Phillips. *The House Will Come to Order: How the Texas Speaker Became a Power in State and National Politics*. Austin: University of Texas Press, 2010, 157–61.

Dewlen, Al. *The Session*. Garden City, NY: Doubleday, 1981, 45.

Fowler, Mike, and Jack Maguire. *The Capitol Story: Statehouse in Texas*. Austin: Eakin Press, 1988.

Kuempel, George. "Halls of Capitol Brothel Site?" *Austin American*, August 15, 1970.

Leiss, Karen. "Capitol Emits Radiation." *Austin Citizen*, April 9, 1979.

Pinckney, Roger. Interview with author, October 1, 2016.

Terrell, C.V. *The Terrells: 85 Years Texas to Atomic Bombs*. Austin: privately published, 1948, 212–13.

United Press International. "Smooching at State Capitol." August 16, 1970.

Wall, E.L. "Old 'Colonial Capitol' Plan Proposed with 2 Additional Wings." *Houston Chronicle*, March 2, 1958.

Ward, Mike. *The Capitol of Texas: A Legend Is Reborn*. Atlanta, GA: Longstreet Press Inc., 1995, 45–45, 61, 65.

BIBLIOGRAPHY

Government Publications

Beck, Leonora B., and Ralph Wright Steen. *The Texas Capitol*. Austin: State Board of Control, 1954.

Beyond Blueprints: The Texas Capitol Architectural Drawings. Austin: State Preservation Board, n.d. [1996].

Biennial Report of the Capitol Building Commission Comprising the Reports of the Commissioners, Superintendent, and the Secretary, to the Governor of Texas. Austin: Triplett & Hutchings, State Printers, 1883–88.

The Capitol Area Master Plan and Its Development, 1963. Austin: State Building Commission, 1963.

Hall, J.D., comp. *Description of the Capitol, Other State Buildings, and State Parks Copied from Seventh Biennial Report of the Texas State Board of Control for the Biennium Ended August 31, 1934*. Austin: Texas Library and Historical Commission, January 1934.

Jennett, Elizabeth LeNoir. *Texas, Description of State Capitol and the Governor's Mansion, Austin, Texas, and Brief History of the Various Capitols of the State*. Austin: Texas State Library, 1949.

Journal of the Constitutional Convention of the State of Texas. Galveston, TX: Galveston News, 1875.

Land: A History of the Texas General Land Office. Austin: Texas General Land Office, 1992.

Lone Star Treasure: The Texas Capitol Complex. Austin: State Preservation Board, 1998.

Mabry, Robert Smith. *An Archeological Investigation of the Texas State Capital Building Senate Wing*. Austin: University of Texas, 1984.

Members of the Legislature of the State of Texas from 1846 to 1939. Austin: Texas Legislature, 1939.

Moore, Gary L., Frank A. Weir, John E. Keller, R. Whitby Jarvis, Catherine H. Yates, K. Joan Jelks and Phillip A. Bandy. *Temporary Capitol of Texas 1883–1888, A History and Archeology*. Austin: Texas Highway Department Publications in Archeology, 1972.

Nash, J.P. "Texas Granite." University of Texas Bulletin No. 1725, May 1, 1917, Austin, Texas.

A Nobler Edifice: The Texas State Capitol, 1888–1988: An Exhibit. Lorenzo De Zavala State Archives and Library Building, 1201 Brazos, May 1988. Austin: Texas State Library, 1988.

The Texas Capitol: Building a Capitol and a Great State. Austin: Texas Legislative Council, 1975.

The Texas Capitol: A History of the Lone Star Statehouse. Austin: Research Division of the Texas Legislative Council, 1998.

Texas Capitol Preservation and Extension Project. Austin: State Preservation Board, 1995.

Your Window to Capitol History: Gallery Guide. Austin, TX: Capitol Complex Visitors Center, 1996.

Unpublished Manuscripts

Brown, Frank. "Annals of Travis County and the City of Austin from the Earliest Times to the Close of 1875." Austin History Center.

"Gus Birkner." Lockhart: privately published, n.d. Clark Library, Lockhart, TX. LHC 921BIR.

Jackson, Jack M., and Elton R. Prewitt. "A Cultural Resources Evaluation of a Portion of the Convict Hill Quarry Site (41TV267). Travis County, Texas." Letter Report No. 308. Austin: Prewitt and Associates, Inc. Consulting Archaeologists, June 1985.

"Statement of the Late Vernal Ray Ramsey on Death of Ed Wheeler." Typescript, n.d.

"Trip to Austin Dedication of the State Capitol." Photocopy from handwritten diary, author unknown. Author's collection.

Theses

Greer, Joubert Lee. "The Building of the Texas State Capitol, 1882–1888." Master's thesis, University of Texas, 1932.

Jones, Diane Susan. "The Preservation of the Texas Capitol." Master's thesis, University of Texas, 1980.

Mabry, Robert Smith. "Capitol Context: A History of the Texas Capitol Complex." Master's thesis, University of Texas, 1990.

Miller, Mick. "Cattle Capitol: Misrepresented Environments, Nineteenth Century Symbols of Power, and the Construction of the Texas State House, 1879–1888." Master's thesis, University of North Texas, 2010.

Books

Austin and Its Architecture. Austin: Austin Chapter American Institute of Architects/Women's Architectural League, 1976.

Baker, T. Lindsay. *Building the Lone Star: An Illustrated Guide to Historic Sites.* College Station: Texas A&M University Press, 1986.

Barkley, Mary Starr. *History of Travis County and Austin, 1839–1899.* Waco, TX: Texian Press, 1963.

Casad, Dede Weldon. *Farwell's Folly: The Rise and Fall of the XIT Ranch in Texas.* Dallas, TX: privately published, 2012.

Cates, Ivan. *The XIT Ranch: A Texas Legacy.* Channing, TX: Hafabanna Press, 2008.

Connor, Seymour, James M. Day, Billy Mac Jones, Dayton Kelley, W.C. Nunn, Ben Proctor and Dorman H. Winfrey. *Capitols of Texas.* Waco, TX: Texian Press, 1970.

Cox, Patrick, and Michael Phillips. *The House Will Come to Order: How the Texas Speaker Became a Power in State and National Politics.* Austin: University of Texas Press, 2010.

Duke, Cordia Sloan, and Joe B. Frantz. *6,000 Miles of Fence: Life on the XIT Ranch of Texas.* Austin: University of Texas Press, 1961.

Fowler, Mike, and Jack Maguire. *The Capitol Story, Statehouse in Texas.* Austin: Eakin Press, 1988.

Franke, Gertrude. *The Inheritance.* Austin: Nortex Press, 1987.

Goar, Marjory. *Marble Dust, the Life of Elisabet Ney: An Interpretation.* Austin: Eakin Press, 1984.

Gould, Lewis L. *Alexander Watkins Terrell: Civil War Soldier, Texas Lawmaker, American Diplomat.* Austin: University of Texas Press, 2004.

Haley, J. Evetts. *The XIT Ranch of Texas and the Early Days of the Llano Estacado.* Norman: University of Oklahoma Press, 1953.

Harris, August Watkins. *Minor and Major Mansions & Their Companions in Early Austin, A Supplement: Buildings of the Seat of Government 1840–1861.* Austin: privately published, 1959.

Kerr, Jeffrey Stuart. *Seat of Empire: The Embattled Birth of Austin, Texas.* Lubbock: Texas Tech University Press, 2013.

Landa, Harry. *As I Remember...* San Antonio, TX: Carleton Printing Company, 1945.

Miller, Thomas Lloyd. *The Public Lands of Texas, 1519–1970.* Norman: University of Oklahoma Press, 1972.

Morehead, Richard. *Richard Morehead's Texas.* Austin: Eakin Press, 1982.

Nordyke, Lewis. *Cattle Empire: The Fabulous Story of the 3,000,000 Acre XIT.* New York: William Morrow & Company, 1949.

Rathjen, Frederick W., Ruth Alice Allen, Robert C. Cotner and F.T. Fields, eds. *The Texas State Capitol.* New York: Pemberton Press, 1968.

The Texas State Capitol: Selected Essays from the Southwestern Historical Quarterly. Austin: Texas State Historical Association, 1995.

Ward, Mike. *The Capitol of Texas: A Legend Is Reborn.* Atlanta, GA: Longstreet Press, 1995.

Williamson, Roxanne Kuter. *Austin, Texas: An Architectural History.* San Antonio: Trinity University Press, 1973.

Zeller-Plumer, Jeanine Marie. *Haunted Austin.* Charleston, SC: The History Press, 2010.

Monographs

Andrus, M. Walter. "Behind This Cornerstone: The Story of the Texas Capitol." Austin: Chapman Printing Company, 1956.

Bateman, Audray, and Katherine Hart. *Waterloo Scrapbook: 1972–1976.* Austin: Friends of the Austin Public Library, 1976.

Quinan, George. "Address Delivered by Honorable George Quinan of Wharton: At the Laying of the Cornerstone of the New Capitol at Austin, Texas, March 2, 1885, the Anniversary of the Declaration of the Independence of Texas." Galveston, TX: Clarke & Courts, 1885.

"Report of the Ceremonies of Laying the Corner Stone of the New Capitol of Texas, Austin, March 2, 1885." Austin: Warner & Company, 1885.

"Texas Capitol Restoration Celebration April 1995." Austin: GSD&M Advertising, 1995.

Journal Articles

Allen, Ruth Alice. "The Capitol Boycott: A Study in Peaceful Labor Tactics." *Southwestern Historical Quarterly* 42, no. 4 (April 1939): 316–26.

Bowden, J.J. "Title Cloud Over the Texas Capitol." *Password* 19, no. 1 (Spring 1974).

Harper, Marjory. "Emigrant Strikebreakers: Scottish Granite Cutters and the Texas Capitol Boycott." *Southwestern Historical Quarterly* 95, no. 4 (April 1992): 465–87.

Roberts, O.M. "The Capitals of Texas." *Texas State Historical Association Quarterly* 2, no. 2 (October 1898): 117–23.

Magazine Articles

Carefoot, Jean. "State Capitol Marks 100th Anniversary," *Texas Libraries*, Winter 1987–88.

Chicago Illustrated Graphic News. November 1, 1887.

Cofer, H.E. "The Chambers' Claim to the Capitol of Texas." *Texas Law Review* 9, no. 60 (1931).

Fields, F.T. "The Texas Capitol: A Tour of the Treasures." *Humble Way* 11 (January–February, 1956).

Fowler, Gene. "A Capitol Celebration." *Texas Highways* (March 1995), 5–13.

Harper's Weekly. "New Capitol of Texas." May 12, 1888, 341–42.

Maguire, Jack. "The Texas Capitol, You Can Take It for Granite." *Texas Highways* (February 1982): 2–9.

Pollard, R.M. "The Evolution of a Great State's Capital." *Illustrated American* (January 16, 1897): 108.

Potts, Robert J., Jr. "Cloud Over the Capitol Grounds." *Texas Parade* (October 1963).

Steely, Jim. "A Capitol Idea." *Texas Highways* (May 1998): 20–29.

Texas Libraries. "The Biggest Thing in the Biggest State." April 1953.

Newspapers

Austin American-Statesman
Austin Daily State Gazette
Austin Southern Intelligencer
Austin Statesman
Brenham Weekly Banner
Chicago Inter Ocean
Chicago Tribune
Dalhart Texan
Dallas Daily Herald
Dallas Morning News
Fort Worth Gazette
Fort Worth Star-Telegram
Galveston News
Houston Chronicle
Pampa News
San Antonio Express-News
San Antonio Light
San Marcos Free Press
Waco Examiner

INDEX

ABOUT THE AUTHOR

An elected member of the Texas Institute of Letters, Mike Cox is the author of thirty nonfiction books. Over a freelance career of more than forty-five years, he also has written hundreds of articles and essays for a wide variety of national and regional publications. His bestselling work has been a two-volume, 250,000-word history of the Texas Rangers published in 2008. When not writing, he spends as much time as he can traveling, fishing, hunting and looking for new stories to tell. He lives in the Hill Country town of Wimberley, only thirty-nine miles from the historic structure he writes about in this book.